A PHOTOJOURNALIST'S
FIELD GUIDE

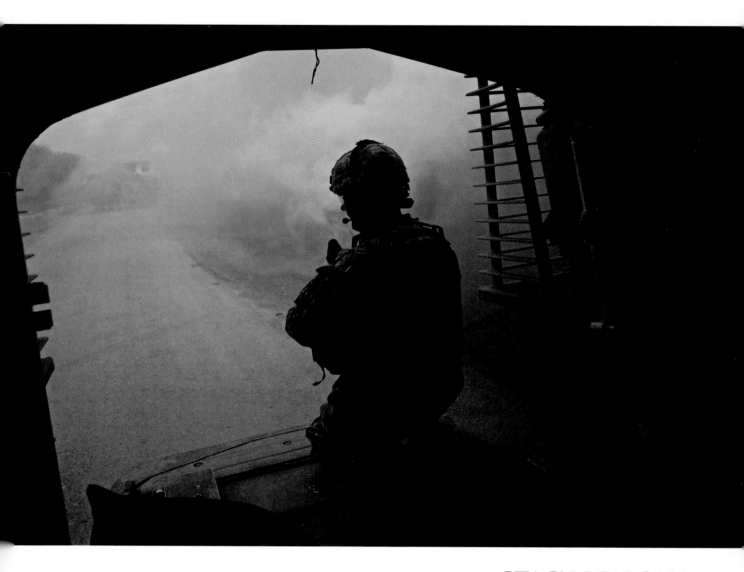

IN THE TRENCHES WITH COMBAT PHOTOGRAPHER **STACY PEARSALL**

Peachpit
Press

**A Photojournalist's Field Guide: In the trenches
with combat photographer Stacy Pearsall**
Stacy Pearsall

Peachpit Press
www.peachpit.com

To report errors, please send a note to errata@peachpit.com
Peachpit Press is a division of Pearson Education.

Project Editor: Valerie Witte
Production Editor: Katerina Malone
Copyeditor: Liz Welch
Proofreader: Erin Heath
Composition: WolfsonDesign
Indexer: Valerie Haynes Perry
Cover Photo: Stacy Pearsall
Cover and Interior Design: Mimi Heft

ISBN-13: 978-0-321-89661-2
ISBN-10: 0-321-89661-0

9 8 7 6 5 4 3 2 1

Printed and bound in the United States of America

I dedicate this book to the guy who said, "You need to go back and read your manual so you know how to operate your camera properly," and the man who told me, "Your compositions aren't too bad, but your exposures are way off," and the gentleman who admitted, "You're a wonderful photographer, and I'm so proud of you." That guy, that man, and that gentleman is my husband, Andy Dunaway.

Acknowledgments

There's a long and distinguished list of photographers—too many to mention here—who have facilitated my professional growth as a photojournalist. Those who have touched my life and career know who you are and should be aware that I greatly appreciate all you've taught me over the years.

One photographer I would like to mention by name, who just so happens to be my husband, is Andy Dunaway. He deserves a huge thank-you for putting up with my red-eye writing rages. He provided some much-needed calm and wisdom when I was on the brink of going insane from putting this book together. Thank you, darling.

Then there are the editors and production team at Peachpit who held my hand through the entire process, too: Katerina Malone, Liz Welch, Erin Heath, Valerie Haynes Perry, Mimi Heft, and the WolfsonDesign crew. I particularly want to thank my project manager Valerie Witte, who was incredibly obliging and patient when I bombarded her with one-liner questions in more than 100 emails. I'm grateful Peachpit decided to take on this project, as I believe there's so much information contained in these pages that can only benefit working photojournalists. Y'all are amazing.

Finally, I have to thank my photographer buddies and colleagues who graciously contributed their time, insights, and imagery to make this the best educational photojournalism handbook out there. Here they are in alphabetical order: Al Bello, Tom Bol, Michael Clark, Carolyn Cole, Andy Dunaway, Mirjam Evers, Enrico Fabian, Bill Frakes, Deanne Fitzmaurice, Steve Glass, Lucas Jackson, Yuri Kozyrev, Joe McNally, Win McNamee, Phil Pacheco, Eli Reed, and Bruce Strong.

Contents

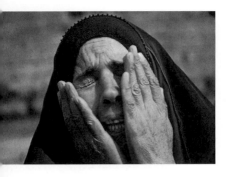

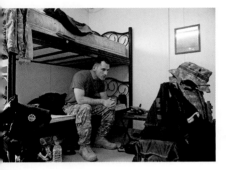

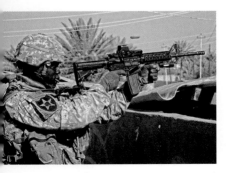

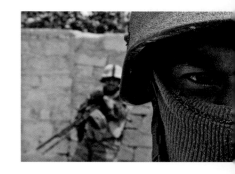

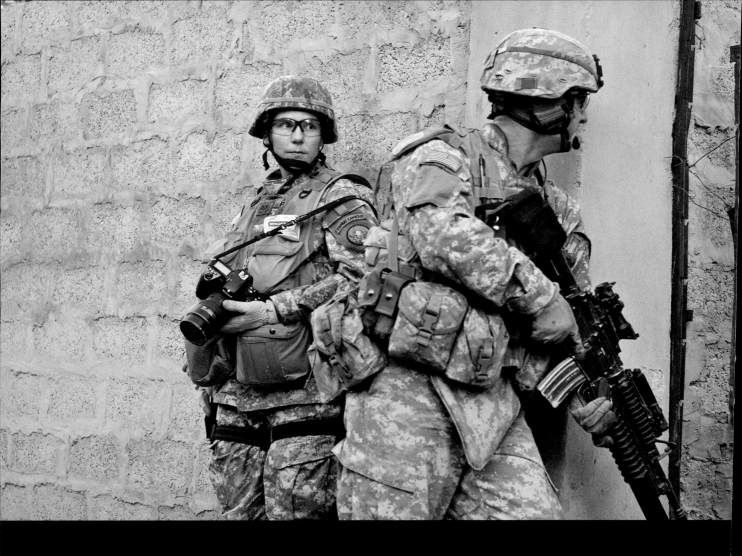

INTRODUCTION
IN THE TRENCHES

There's a lot I wasn't taught in the military or college regarding the business of photojournalism. As a young combat photographer, I had no field guide like this to help steer me through the daily minutia of the photojournalism profession, including the nonphotographic challenges. The training I received was often on the job or passed down from photographer to photographer, hands-on. I was given volumes of reading material issued to all Air Force photographers that had little to do with my specialty job as a combat photographer, so the only time I ever read it was when promotion time rolled around and I was required to. To be honest, I gained more insight through shadowing other, more experienced military photojournalists and simple trial and error in shooting.

This is an image taken of me during a combat patrol in Kahlis, Iraq. (Photo by Andy Dunaway)

Lens (mm): 55, ISO: 200, Aperture: 4, Shutter: 1/180, Program: Aperture Priority

Speaking from Experience

It's logical to question how someone like me, relatively young, has enough knowledge to sit down and write a book about photojournalism. Well, I guess the answer is I got an early start and haven't stopped since. Plus I've been lucky enough to gain worldly experience in a relatively short period of time. I've compiled all I've learned and experienced on domestic and international assignments and have translated these experiences into the valuable information found on these pages.

Starting somewhere

When I was 17, I never imagined where I'd be today. I was naive, energetic, and optimistic about my future. I lacked the talent of numbers and science, but I excelled at the arts. I studied my options and even looked at several art schools before deciding on the military as my career, which came as no surprise to my family because the majority of them served in one branch of service or another.

I enlisted in the U.S. Air Force as a basic still photographer. I went to basic training, also known as boot camp, and then to the Defense Information School (DINFOS). The brief photography course taught me how to process film of all types, black and white, C-41 and E-6. I learned to read light using a handheld meter and make a manual exposure with my Nikon camera. After studying the basics of camera operations, I learned the concepts of composition, content, and storytelling. The classes lasted 6 months, including a brief course on how to process U-2 reconnaissance aircraft large-format camera film. I loved the photography classes, but the film processing… not so much.

As luck would have it, the Air Force sent me to the Joint Intelligence Center to process thousands of feet of infrared spy plane film. As if that torture weren't enough, I had a follow-up assignment at the Joint Analysis Center for more darkroom shenanigans. Needless to say, I spent 4 years tucked away in a vault, within a vault, within another vault. For me, it was prison.

I knew I had to get out of the darkroom, so I plotted and planned my escape. During my research and scheming, I came upon one of the best-kept secrets in the Department of Defense: Combat Camera. I had not touched a camera outside of my own personal projects — that wasn't part of my official duty description. I scrounged together some pictures that resembled a portfolio and submitted them along with my military evaluation reports and full-length photo of me in uniform.

Becoming a Combat Cameraman

The Combat Camera unit was primarily made up of very talented male photographers with years of experience. There were a few ladies among the ranks, which gave me

hope that I too could be a combat photographer, but the biggest problem was that someone in the unit had to leave for a position to come available—they were coveted.

At the time, I was 21 with moderately acceptable quality images and no technical background at all. The odds were stacked against me, or so I thought. However, after the tragic events of September 11th, I received word that I had been accepted into the premier Combat Camera unit. Weeks later, as I was prepared to move from England to Charleston, S.C., I watched troops make their way into Afghanistan.

My first few months at "COMCAM" were the most challenging, both personally and technically. I learned how to ingest digital files from the camera and transmit them via satellite all over the world, how to take images from the open ramp of a C-17 Globemaster cargo aircraft at 14,000 feet; how to fire a weapon on a moving target; how to tactically drive armored vehicles; and how to navigate terrain using only a topographical map and a compass. I felt the pressure to perform without error, because I had the critical eyes of my peers watching me closely—ever ready for me to make a mistake. Whether that was reality or perhaps my perception of reality, it drove me to work harder and harder.

By the time I was considered combat ready, I was aerial qualified and had attended ground survival and evasion courses, prisoner-of-war training, water survival school, and close-quarters combat training. I was hammered with photography training and techniques, as well as workflow and image transmission using satellites. I was certified on multiple weapons and knew just about everything there was to know about war, without the real war experience.

Before going off to document the real combat, I was sent to South America and Southeast Asia to gain hands-on working experience. I also ran re-supply missions to the combat zone with a senior photographer. I was tested and grilled on every aspect of combat photojournalism. Basically, I had to prove that I could not only take pictures but also perform under fire when it really mattered.

Trial by fire

My first combat deployment was Iraq in 2003 followed by a series of assignments, which included the Horn of Africa, Lebanon, Yemen, and a couple more trips to Iraq. I spent 280 days a year away from home covering Special Forces operations and humanitarian relief missions. It was a far cry from my think-less and thankless days in the darkroom processing film. My primary goal was getting real-time combat imagery from the battlefield to the Joint Combat Camera Center in Washington, DC. The President, Secretary of Defense, and Joint Chiefs of Staff used my pictures to make informed decisions on military tactics and maneuvers in the battle space.

The photos I took on assignment were disseminated to news agencies such as the Associated Press and Getty Images and were picked up by several newspapers, magazines, and online news-gathering sites. All of the images I took while in

the military are considered public domain, so you, the taxpayer, own them. As a general rule, combat photographers adhered to the National Press Photographers Association's (NPPA) rules, guidelines regarding the photojournalism's code of ethics. I did my best to remain unbiased and document what unfolded in front of me without judgment or prejudice. Even though I wore a uniform, I strove to stay objective.

Getting good

As I gained more experience and grew more confident in combat, my outlook of photography began to grow and change. I was taking more risks and pushing myself photographically. During my basic courses, I was taught just that: the basics. I began to realize there was much more to understand in order to truly capture artful, colorful, and memorable pictures. After losing several friends in combat, I also realized that there was more to my pictures than just news worthiness. In many cases, I was the last person to take their pictures. That was pretty heavy stuff.

Once I grasped that concept, my vision as a photographer changed immensely. From the age of 21 to the age of 27, I captured more than 500,000 images from over 41 different countries. I was considered the best photographer in the military and was the first woman to have won the Military Photographer of the Year twice. I was giving the boys a run for their money. I was awarded one of the military's highest honors, the Bronze Star, for saving the life of several soldiers during an enemy ambush in Iraq.

A life-changing experience

After being hit by two roadside bombs and further injuring my neck saving a severely wounded soldier during an ambush, my combat photography career came to an end. My life had changed in an instant. I spent about 18 months recovering from my wounds, during which time I could barely lift a camera, let alone take a picture. It was determined I could no longer wear the 80+ pounds of body armor and tactical gear, which meant that I could no longer deploy to the combat zone. The Air Force retired me from service in August 2008; I was only 28 years old.

Simply because I was disabled did not mean I was unable. I didn't give up. I figured if I could survive 6 straight years of combat, I could survive this transition in my life. I brought my skills as a seasoned combat photographer to my photography assignments stateside. Specializing in the armed forces, I began to shoot commercial and editorial assignments related to law enforcement, emergency rescue, military, and other government agencies.

Because I trained apprentice military photographers during my time in service, it made sense that I'd continue to teach and prepare other photojournalists, both civilian and military, for similar assignment work. After all, my combat photography career was forged, molded, and guided by some of the best photojournalists and educators in this industry. All they asked is that I pass on the knowledge I've gained

as freely as I got it, and that's why I've tackled this book. Their influence has made an impression on me, and now I'd like to pay it forward by touching many more. Through my efforts as a volunteer mentor for the National Press Photographers Association, the Eddie Adams Workshop, and my own education facility, the Charleston Center for Photography, and now this book, I'm sure to.

Chapter Overview

To give you a clear idea of what to expect as you read the book, I wanted to break down each chapter a bit and explain what you'll be learning as you go. Think of the descriptive titles as image captions; they're the bare bones of each chapter's subject matter. There's a lot of information on each topic, so be sure to crack open each one and read it for the details.

1. Understanding Your Role

I've placed this up front, because it outlines photojournalists' day-to-day responsibilities and discusses the challenges you might encounter while on assignment. I present occupational vulnerabilities such as the fine line between fostering professional relationships with story subjects and developing full-fledged friendships, discussing the pros and cons of both scenarios and their impact on the storyline and you as an individual. Along with getting emotionally close to the story, I talk about when and how the story affects you—when you go from covering the story to becoming the story.

Because being a photojournalist requires physical and mental stability, I provide insights on keeping your body in shape through detailed exercises that will help build, strengthen, and maintain your body as you cover your assignments. I offer tips on how to identify and reduce stress in your personal and professional life, so you aren't overwhelmed when you're under pressure. Your home life directly impacts your professional life, so I give suggestions on how to maintain your personal household tasks so you can focus on your professional responsibilities.

2. Preparation: Everything but the Camera

Over the span of your career, it's likely you'll find yourself in risky situations, so I dedicated a to preparing for the unexpected. I've included information about specialized training for high-risk environment assignments such as first aid classes, hostage survival courses, and personal security training. And because some assignments are abroad, I discuss how to prepare for traveling overseas, from securing travel documents to receiving medical inoculations.

There's no telling where in the world you'll end up, or what challenges you'll face when you get there. I give tips such as how to wash your clothes in a plastic bag and shower with a string and water bottle. I provide a detailed list of personal hygiene items that travel well, from bar shampoo to travel towels. Whether you're covering a devastating natural disaster, famine, or war, these items will get you through your assignment.

But this isn't restricted only to photographers who intend to cover overseas stories. The insights highlighted here can be applied to domestic assignments as well. I've dedicated an entire section to noncamera equipment essentials I feel are important tools for every photojournalist, with explanations of why I bring each item and how I use it in the field. I even discuss body armor made specifically for women with tailored plates for women's body shapes and how to pick armor that's right for you—regardless of gender. Along with tangible items that are occupational essentials, I discuss the unseen necessities, such as insurance.

3. Gear Essentials

Sure, every photographer needs a camera, but there's more to our equipment than just a camera body and lens. In this chapter, I recommend my must-have lenses, explaining the perks of each and why I use them; camera and lens accessories that help keep precious gear safe; and lighting equipment that can enhance assignment work. I include images of the gear I use, along with explanations as to why I choose to use it, as well as several behind-the-scenes images from some of my past shoots that show the gear in use. Outside of the apparent camera kit equipment, I talk about the less obvious items such as rain gear to super clamps, showing you how to make use of them in the field.

I teach you how to develop an assignment gear list based on shooting requirements and how to properly invoice and pack your equipment for transport. I also provide a breakdown of my digital workflow, which covers the software I use and my process of downloading, file naming, captioning, transmitting, and archiving images. You'll learn all about the gear you need, but also how to inventory, maintain, store, and transport that gear.

4. My Shooting Methodology

In this chapter, I share my personal approach to the technical side of photography. Early on in my on-the-job training, I developed an acronym to help remind me of the steps I need to take to make solid exposures every time. I cover this system from start to finish, including images that illustrate the process. My system will keep you from making unnecessary technical errors while on assignment when the environmental pressures are bearing down.

I'm a firm believer that it takes both light and shadows to create a dynamic image; the combination of the two gives the picture dimension and feeling. I explore the best ways to exploit the available light and how to consciously make that light articulate certain messages. Then I fold in color theory, and I discuss how each color has a particular connotation and can be used to help the viewer infer the picture's true meaning.

I close with an important method of shooting I applied while documenting combat: the 10-Frame Methodology. Using this approach, I show you how to slow down and become more aware of your surroundings, to patiently survey a scene for the best subject or point of view, and to take the time you need to capture the right moments.

5. Covering All the Angles

Surviving in this career requires talent, drive, and foresight. In this chapter, I talk about what it takes to succeed as a photojournalist today. I include information on supplementing your income, internships, mentorships, personal projects, and continued education. Because our community is relatively small, I discuss the importance of building and maintaining professional relationships and teaming up with other photographers on special projects.

Photojournalism covers a wide variety of topics, from sports to war. That's why I discuss the idea of specializing in one of the many niches our profession offers, and then enhancing your final products within that area with video and multimedia components. I also offer tips on how to identify which style of documentation you like to shoot and how to make your product marketable. Many of my friends and colleagues who focus within certain genres have been gracious enough to contribute their insights into these fields, offer helpful tips, and share some images, too.

6. Putting It All Together

Creating a solid photo story is a large part of what we do. In this chapter, I talk about several story approaches, their advantages and disadvantages, and when and why you'd use them for different sorts of story subjects. Each approach has a visual example that corresponds with the text as well. Of course, you'll spend a great deal of time on visual variety and capturing the most compelling story possible—even if you've only got a couple hours to complete the assignment. Along with print-style photo stories, I dive into the world of multimedia.

Given that subject familiarity is important no matter which documentation style you choose, I provide interview suggestions to help you develop an appreciation of your story's subject and determine how to best tell the narrative. From there, I outline the audio and video gear I use when capturing multimedia stories and

describe how I approach the assignment, discussing the similarities to standard still photography documentation while paying particular attention to the unique aspects of audio and video recording.

7. Staying Above Board

What can I say; ethics plays a huge part in how we function as professionals. And whether we truly understand how these ethical guidelines may be applied in practical terms while on shooting assignments is a complicated matter. That's why I decided to share my most personal experiences regarding ethics in order to help you better understand the less cut-and-dried aspects of ethical behavior while documenting stories. Up until now, I haven't shared my individual ethical dilemmas with anyone other than my husband and those who were present at the events described. However, I feel these experiences are worth sharing and debating so you're aware that you're not alone when you have tough decisions to make.

Within our community, we have unwritten laws that govern how we should conduct ourselves, but there are also bona fide laws that outline *our* rights as journalists. I include a section dedicated to outlining our freedoms as news documentarians and journalists both domestically and internationally.

8. Staying Afloat

The days of getting a camera kit and company car from your newspaper are numbered. Hell, staff positions are rare. Most photojournalists today work on a freelance basis, which means you're the secretary, bookkeeper, marketer, negotiator, producer, and photographer. What's more, you have to be an entrepreneur, someone who can recognize a gap within the market and offer a product that fulfills that need. You've got to be motivated enough to learn new technology and embrace change to stay ahead of the industry and be diverse enough in your talents to stay competitive.

Because most artists aren't necessarily business minded, I've spelled out how to create a business plan of operation. This helps establish how much you have to earn in order to stay afloat financially. I include tips on how to negotiate pricing with customers and how to circumnavigate the "I don't have a budget" discussion with your clients. At the end of the day, you've got to get paid, so it's important to know what your talents are worth.

Let's Get Started

My objective with this book is to translate all I've learned through these experiences so that you can spend more time on what really matters—storytelling. Everything I write about in this book is based on my personal experiences, failures, and achievements. What you take away from it is up to you. Just know that my way isn't the only way, and you can modify anything I teach you to fit your own personal preference. Now let's get to it.

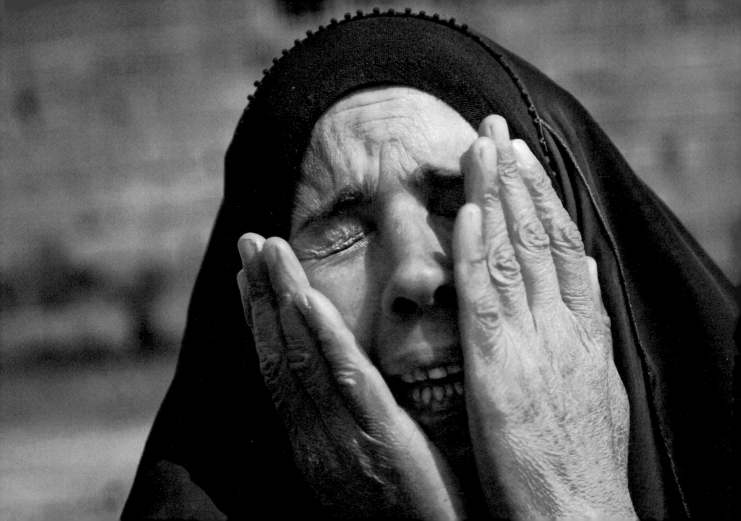

CHAPTER 1

UNDERSTANDING YOUR ROLE

The camera never lies, which is why the world relies on photojournalists to shoot compelling photographs of events they would not otherwise be exposed to—and to do so truthfully. After all, a camera feels no pain, has no prejudices, and holds no grudges; it simply records events. Between smart phones, the Internet, and digital photography, photojournalism has become more popular and accessible than ever. Granted, many people, myself included, still love to read articles that delve deeply into a topic. However, in most cases viewers don't need words to know the story. The picture says it all. For me, pictures speak louder than words.

An Iraqi woman weeps and covers herself in mud after members of the Iraqi Army take her husband for suspected involvement with launching mortars at American and Iraqi forces.

Lens (mm): 48, ISO: 400, Aperture: 2.8, Shutter: 1/6000, Program: Aperture Priority

Responsibilities of a Photojournalist

The camera may not lie, but it's only as honest as the person releasing the shutter. As trustees of the public, photojournalists have an ethical obligation to record events truthfully. We must produce images that are relevant to the event and society in order to be effective. Photographs must be accurate, informative, and able to convey what is happening during a particular moment in time. A true professional will take the time to view the story from every angle and highlight the important issues objectively. On top of all that, a photojournalist must also be an artist who can capture an aesthetically pleasing picture that viewers want to look at.

Photographers have come a long way since our predecessors hauled around glass plates and large-format cameras to stage pictures for newspapers. Nowadays, documentary photography is viewed as an art form. You can walk into galleries and see photojournalism on display next to oil paintings and sculptures. Our viewers, who are inundated with visuals on a daily basis, have set the new photojournalistic standard. They want to be engaged and catch a glimpse of the world through photographic perspectives they've never seen before. While consumers of photography have changed our way of doing business, I also like to think we as photographers and artists help evolve our craft, too. Now we deliver the news in a creative way while also entertaining viewers.

Photojournalists document events, helping communities connect with one another. Even years after an event is over, people will remember the event and the emotions involved just by seeing the photograph. This is why a photojournalist must be a well-informed individual with a finger on the pulse of what's happening in their area of operation, and on every topic imaginable. Being apprised on all fronts allows a photojournalist options when illustrating a story topic or feature. Also, knowing one's community and the news happening within it gives potential photo story subjects the understanding that you care about what's happening to them on a day-to-day basis—not just when the story breaks.

No matter a photojournalist's motivations—whether it's a sense of justice, public enlightenment, personal glory, or simply earning a living—they put their lives on the line. Every day, they risk their lives to keep the world's eyes open to the injustices of humanity—aggressively seeking out and digging up news in the making.

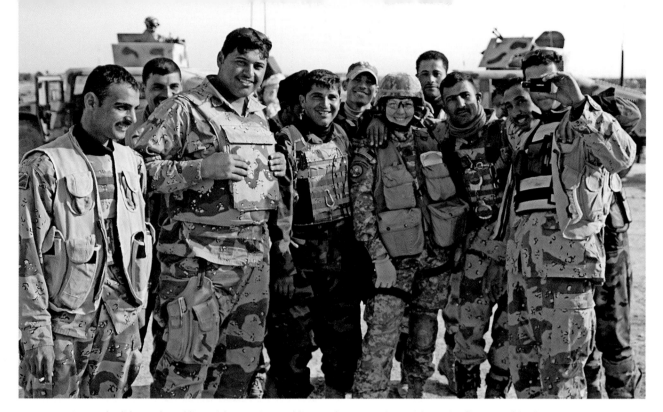

FIGURE 1.1 Not only did I work and live with American soldiers, I also spent time with Iraqi military. In this picture, you can see me wedged between soldiers from the Iraqi Army before we headed out on a three-day raid in Iraq.

Occupational Hazards

As a combat photographer, I lived, ate, slept, and battled alongside my subjects, the American soldiers. Civilian photojournalists would come through for a week or two and then would leave to cover another story somewhere else in the world, or report home to their respective news agencies. I stayed. It was a luxury and a curse. I knew just about every soldier I was assigned to document and, in most cases, the names of their spouses and children. I was familiar with their quirks and habits; I knew their preferred brands of cigarettes and favorite comfort foods. They knew mine, too. My understanding of them as human beings, and not just soldiers, gave me better insight as a photojournalist. I realized early on that if they were going to open up to my camera and me, I had to open up to them, too. After all, relationships, whether professional or personal, are two-way streets. My vulnerability and respect toward them allowed the barriers between us to crumble. After a mutual understanding was established, I could photograph nearly whatever I wanted, wherever I chose, and whenever I needed (**Figure 1.1**).

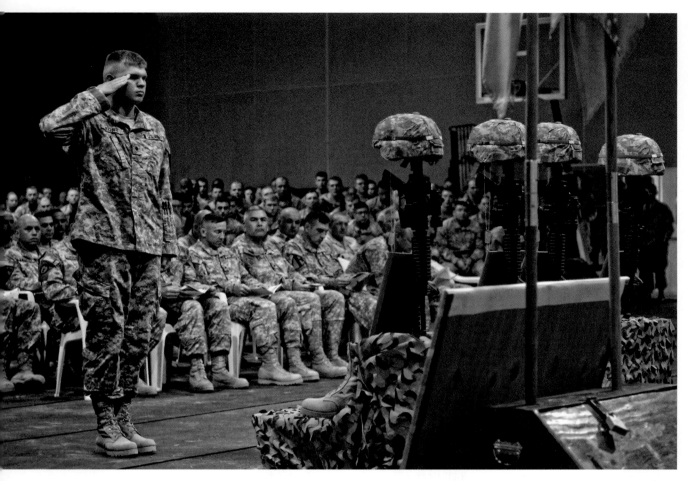

FIGURE 1.2 Getting to know subjects is essential but can also be an occupational peril, especially when work involves war. I made many friends and lost several over the years. I grieved alongside the other soldiers, but I did my best to never let them see me cry. Because of this, I've attended only two memorials in my military career—one in Africa and one in Iraq. This picture shows a soldier saluting his friends who've just been killed in Iraq.

Lens (mm): 48, ISO: 800, Aperture: 2.8, Shutter: 1/45, Program: Aperture Priority

As I said before, living with my subjects was both a luxury and a curse. I had the luxury of getting to know them well and having limitless access to their daily turmoil. However, I had the tough job of keeping my emotions in check when I had to document the story as it was happening, even the deaths of the soldiers I'd grown to be friends with. Thus is the curse of a photojournalist (**Figure 1.2**).

The Daily Grind

Depending on whether a photojournalist is a staffer or freelancer, everyday assignment requirements may vary in quantity and duration. Either way, photojournalists can expect to do a number of the same tasks for each assignment.

Tasks for a typical photojournalism assignment

- Receive assignment(s)
- Review assignment(s) with editor/writer
- Research assignment(s)
- Make contact with assignment(s) subjects
- Determine photography equipment needs
- Prepare and pack photography equipment
- Travel to assignment(s)
- Document the assignment(s)
- Gather critical caption information
- Download images
- Caption images
- Edit images (in some cases)
- Transmit images
- Review assignment(s) with editor

Because I was a photojournalist in the military, most of my assignments took place overseas. My day's schedule was often dictated by the operations being conducted or the major offensives being launched. I'd spend my day covering various assignments of newsworthy importance, from elementary school openings to transferring prisoners of war. These assignments became routine to me. It may seem strange to think combat can be routine, but there's something habitual in nature to daily combat assignments. Much like a daily newspaper photographer, I also had my lion's share of spot news events, which arose sporadically during all hours of the day and night.

Unlike daily photographers who may receive a story topic that directly correlates with a written news article, my assignments were a lot less defined. I'd often be assigned to cover a key battle and capture it as completely as possible from every achievable vantage. As a photojournalist, it was my job to figure out what the story was. I didn't have an editor to guide me. No matter what the story turned out to be, I was always drawn to the action (**Figure 1.3**).

Like other photojournalists, I realized the importance of documenting the story even though it endangered my life. I didn't view what I was doing as reckless—rather, just another requirement of being a news photographer. Take 9/11, for instance. We can all recall pictures of that day because they're seared in our mind's eye. Images of metal shards and debris falling from the burning buildings as people ran for their lives below. We do not appreciate the photographer who runs against the current of people, toward the buildings, the person who brought us those impactful photographs. The pictures those brave photojournalists captured brought us all to Ground Zero.

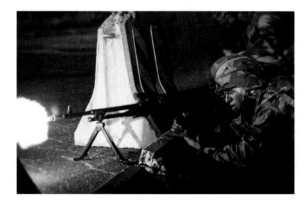

FIGURE 1.3 U.S. Marines engage in night combat exercises during a Homeland Security training operation in Charleston, South Carolina.

In the Trenches: Night Watch

I was getting some much-needed sleep after patrolling the skies of Baghdad all day taking pictures of the damage caused by the "Shock and Awe Campaign," when the giant speaker screaming, "All EMEDS personnel must report to work!" startled me awake in my tent.

I jolted up from my cot, threw on my boots, and stumbled out of my tent, where I saw medical personnel in their pajamas running from their tents into the late-night darkness. I followed closely behind with my camera in hand toward the hospital tent.

"We have a traumatic amputee inbound!" yelled a medic manning the radio. The lead surgeon stood at the head of the empty bed, looking toward the tent entrance. I made photographs of the sterile white walls of the tent and the tension on the doctor's face. I'd met and photographed the doctor previously during less anxious times, and he'd grown accustomed to my presence.

I found an opening at the foot of the surgical prep table where I knew I could get shots of the medical staff working without impeding their progress (**Figure 1.4**). Everyone waited in position for the critically wounded to arrive. The lead nurse made final preparations just before the ambulance backed up to the tent's front entrance. The plywood double doors swung open, and several meds rushed through, tightly gripping a litter. They laid the most critical patient on the bed before me. The other two patients were taken to the back to be stabilized.

The only light in the tent came from florescent bulbs, so it was limited. Using a small camera flash was out of the question, because it would have been too distracting during the chaos. At the time, I was shooting with a Nikon D1X camera and its low-light capabilities were weak. I set my ISO to 800 because any higher ISO setting would have rendered the images pixilated, discolored images. My shutter speeds were painfully slow, so I did my best to brace my elbows against my body to prevent camera shake. Everyone was moving quickly, so many of the figures were blurry. It was a tough shooting situation.

From my vantage point, I photographed the medics, nurses, and doctors as they worked to stabilize the young soldier (**Figure 1.5**). The patient's body twitched in pain as the nurse anesthetist moved hastily to sedate him, and the nurse checked the patient's airways and inserted a tube to help him breathe. Minutes later, the patient fell asleep from the anesthesia.

I stepped forward to photograph the soldier's badly wounded legs as the X-ray team maneuvered a giant portable radiograph machine and took several exposures. The surgeon inspected the patient's legs and prepared him for surgery. Upon command, the staff tending the patient grabbed the litter and marched toward the operating room.

I spent the next few hours photographing other parts of the hospital, which wasn't necessary because I'd just completed a photo story on their unit a few days before. However, I wasn't allowed in the operating room, and I wanted to know how the soldier was doing.

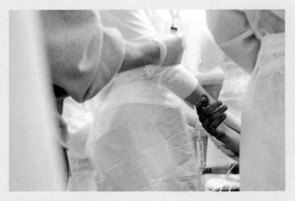

FIGURE 1.4 An Air Force medic holds the blood-covered arm of a wounded soldier.

Lens (mm): 52, ISO: 800, Aperture: 2.8, Shutter: 1/20, Program: Manual

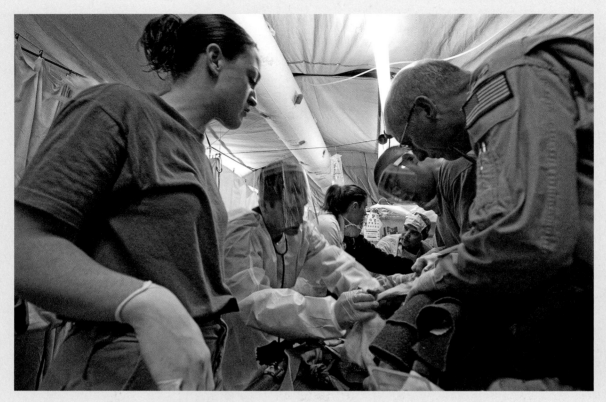

FIGURE 1.5 Air Force medical personnel work simultaneously to prepare a soldier for amputation surgery in Baghdad, Iraq.

Lens (mm): 12, ISO: 800, Aperture: 4, Shutter: 1/25, Program: Manual

Eventually, the door from the operating room opened, and the medical staff filed out. I stopped the surgeon and asked if he could spare a moment of his time. I inquired about his patient and he said, "I had to amputate his leg, but the soldier is doing well and will be transferred to Germany on the next flight. I was looking for every reason not to take his leg. But there are three things I look for: nerve injury, soft tissue and bone damage, and no pulse. This kid had [all three]. Losing a limb is not ideal, but if I didn't take [his leg] and it got infected, he would've died. Besides, that's what we are here for; the reason we are in the military medical field is to take care of the troops."

With that, we stepped out of the hospital tent into the cold night, still in our pajamas, and parted ways—he to his sleep tent and I to my workstation. I felt the heat of the desert sun radiating off the tent walls of my makeshift office as the sun began to rise. I hit the send button on the satellite to transmit the night's pictures back to the States.

Shortly after that night, the pictures I took were featured in a magazine, along with a written story about the surgeon and his medical staff, which eventually raised national awareness about the importance of their role in the combat zone. I'm glad I was there in that moment to document and share their story with the American people, who would otherwise never have seen their bravery in action.

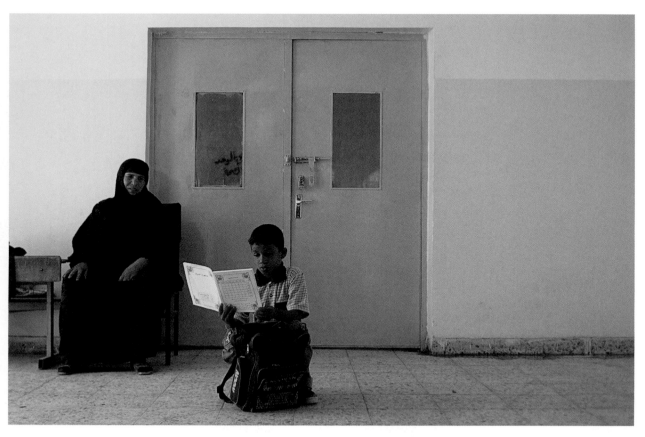

FIGURE 1.6 A mother watches her son read in the halls of a newly renovated elementary school in Baghdad, Iraq.

Lens (mm): 28, ISO: 400, Aperture: 2.8, Shutter: 1/500, Program: Manual

When You Become the Story

When you're documenting the story, sometimes you become the story. I was assigned to cover the rebuilding of Makasseb Elementary School near Baghdad, Iraq, over the course of several months (**Figures 1.6** and **1.7**).

Before the war, the Makasseb community was largely supportive of the Saddam regime and outwardly hostile to American and coalition forces. U.S. patrols were often met by groups of rock-throwing children and young adults. I did my best to document local tribal leaders and Iraqi government officials' perspectives while not getting myself smashed in the face by rocks. It was a challenge.

On the day of the grand reopening, I accompanied the Army Civil Affairs unit to capture what was to be the logical end to my photo story. Our convoy arrived at the

FIGURE 1.7 A young Iraqi boy watches his father hang drywall during renovations of the Makasseb Elementary School in Baghdad, Iraq.

Lens (mm): 50, ISO: 200, Aperture: 2.8, Shutter: 1/160, Program: Manual

front entrance of the new school. There was a large amount of construction debris and remnants of the old building piled high along the sides of the road, some of which made parking the Army humvee vehicles tough.

Unlike past visits, Iraqi children danced and sang, ate cake, and cheered. The local mayor cut the ribbon and announced the school officially open for education. As such a landmark event early on in the war, other news crews were there to document

FIGURE 1.8 During my frequent visits to the school, I made several acquaintances. Among them were young girls of the village who were as fascinated by my American customs as I was by theirs. I made several self-portraits, like this one, over the course of the rebuilding.

the historic occasion. NBC Nightly News had a crew conducting interviews, and other photographers walked around taking pictures of the joyous occasion (**Figure 1.8**).

The Army unit I traveled with was finished and ready to depart, so I took my seat in the humvee I arrived in. Because it was early in the war and the desert heat was oppressive, the soldiers opted to remove the doors from the humvees to increase airflow. This was great for me because I could photograph from the vehicle with little disruption. As the convoy slowly began to depart, I took pictures of children yelling out for candy from the passing soldiers. I also observed the NBC crew interviewing the mayor.

As our humvee passed the entrance to the school, a tremendous explosion rocked our vehicle (**Figure 1.9**). The concussive wave was so immense that it shattered the humvee window and blew a hole in the side of the truck. Our vehicle was dead and could not be restarted.

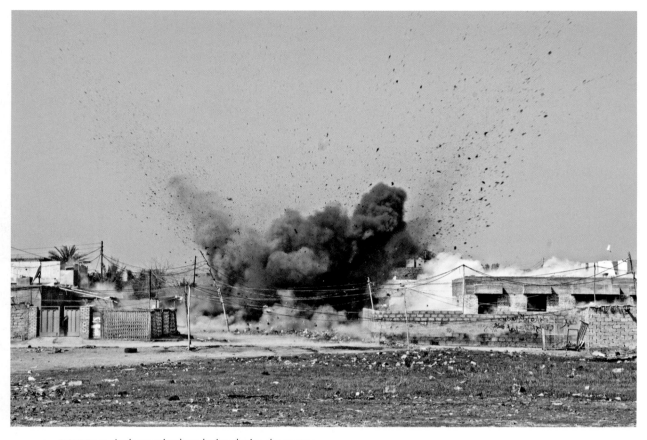

FIGURE 1.9 An improvised explosive device detonates.

Lens (mm): 55, ISO: 100, Aperture: 11, Shutter: 1/100, Program: Aperture Priority

The NBC crew turned their cameras from the mayor to us. I went from covering the story to becoming the story. They documented the improvised explosive device detonation, our response to the bombing, the vehicle recovery, and the evacuation, and aired it on national television in the United States that evening.

I didn't do anything to draw attention to myself; it was simply the result of the circumstances of the situation. Many photojournalists find themselves in similar positions. Pulitzer Prize–winning photojournalist Nick Ut's story of rescuing Kim Phuc after she'd been covered with napalm during the Vietnam War is still legend. Even the world-famous Robert Capa became the news after he was tragically killed in Vietnam. More recently, acclaimed documentary filmmaker Tim Hetherington and award-winning photojournalist Chris Hondros were killed while covering the war in Libya. Their stories transfixed millions of people around the world and grabbed headlines on every major news outlet in America.

As a photojournalist, you cannot control what happens. All you can do is be in the moment and react to events as your principles dictate, whether you're behind the camera or in front of it.

Mastering the Art of Multitasking

News events have no clock, which is why photojournalists have such crazy schedules. My assignment durations were as long as the humanitarian missions, training exercises, and combat operations I was covering lasted, which varied from 2 days to 6 months. I had no set schedule. It's safe to say that the majority of photojournalists operate under the same timetable. For this reason, it's important to be prepared for anything (**Figure 1.10**).

Streamline your home life

When I first started traveling around the world on assignment for the military, I was still writing checks and paying my paper bills by mail. Archaic, right? The power company didn't care whether I was stuck in the middle of Chile with a bunch of airborne soldiers because our transport plane broke down and it was going to take several days to fix—they just wanted their money. And so off went the lights, again. With the advent of online banking, my ability to multitask my personal life and work became much easier. I no longer had to worry about coming home to a powerless house. Still, there were other facets of my life I needed to keep in balance too.

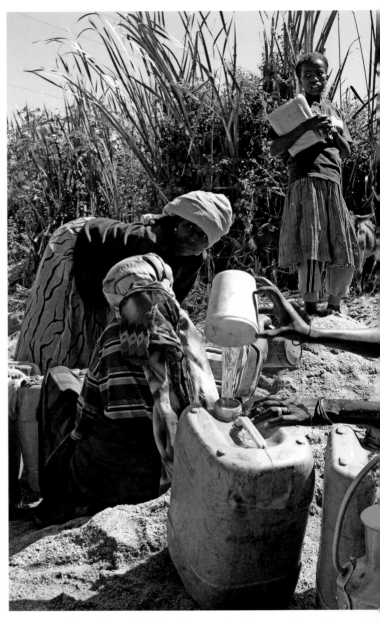

FIGURE 1.10 Regardless of whether it's convenient for you, there will always be stories that need to be documented. I'd just purchased my first house, adopted a puppy, and become engaged, but I still went to Djibouti for nearly five months to cover humanitarian operations in the Horn of Africa.

Lens (mm): 34, ISO: 200, Aperture: 13, Shutter: 1/80, Program: Manual

I began to simplify my home life to make it more manageable for the long spells I was away. I made a list that identified what was most important to me and downsized everything else. I cut down my chores by hiring a lawn care professional, automated my bills, and asked a neighbor to grab my mail while I was away. If important mail came, like jury duty notices or property tax statements, they'd drop me an email (**Figure 1.11**). I found a friend I trusted to drive by my house to be sure everything was in order and start my car once a week.

FIGURE 1.11 Building a relationship with a nearby neighbor is beneficial so you can feel comfortable when you're on the road, knowing they are there to check your mail, watch your house, and start your car so the battery doesn't die.

Things to do around the house before leaving for an assignment:

- **Turn down heating/air conditioning.** One of the most inexpensive and effective ways to reduce your air conditioning and heating costs while you're away is to adjust your thermostat setting. You may achieve significant savings by minimizing the amount of air conditioning or heating you use while you're away. For each degree you raise or lower your thermostat setting, you can reduce seasonal cooling and heating costs by an estimated 6 to 8 percent.

- **Unplug electronics.** Having electrical devices on a switch can make it convenient to cut power to electrical devices, and cutting power to electrical devices when you're not using them saves money. The problem is that most of our electrical devices are not hooked up to switches. Instead they sit there, plugged in, sucking down some amount of power all the time. It only takes five seconds to plug in and unplug each device, so it's worth unplugging everything while you're away.

- **Lock all windows and close the blinds.** Windows are often the weak link in the home security chain. Intruders can break glass or pry windows open to get into your home. Some sliding windows can be lifted out of their tracks, even when locked. Close and lock all possible entry point windows when you leave the house. Install skylights so that they cannot be opened or easily removed from the outside. Don't give burglars an advantage—close curtains so they won't know what to expect if they break in.

QUICK TIP

It doesn't hurt to bring your helpful neighbor back a trinket or two from your exotic assignments to say thank you.

- **Clean the house.** No matter where you live, all sorts of bugs are attracted to dirty spaces. Be sure your pantry, kitchen counters, cooking surfaces, and floor are free of crumbs, and wash dirty dishes right before leaving for long-term shooting assignments. Don't forget to take out the trash.

- **Tune up the car.** If you want your car to run after you return home from a long trip, be sure to prep your auto before you leave.

- **Alert the phone tree.** A phone tree is a great tool when you're in a hurry to get out on assignment and need to contact key people who help you while you're away. Phone trees are pre-arranged pyramid-shaped networks of your set of contacts. You start by calling the first person on the list, and they call people below them, and so on. This disseminates information quickly without requiring you to make all of the calls.

The absentee homeowner

I live in the South where the humidity can mold drywall in just a few days, which is why I keep my air conditioner or heater going while I'm away, depending on the season. I keep it set low to save power but also maintain airflow in the house. I unplug electronics to minimize unnecessary use of power and to prevent electronics from any possible power surges during storms.

I keep a car in the driveway to detract would-be robbers from raiding my house. Having a trusted friend start the car and move it in the driveway once a week gives the appearance of life at the residence, too.

I recommend taking out the trash and washing dishes for two reasons: it keeps the pests at bay,

and coming home to a clean house puts your mind at ease. There's nothing worse then returning home with jet lag and facing a messy house that requires a deep scrub. If you clean before you leave, you can relax when you return.

Lastly, I would create a list of telephone numbers that includes immediate family and those who help me keep my life straight during my absence. As I prepared for a trip, I had a thousand other things on my mind like camera gear, underwear, passport, body armor, and toothpaste. By having my must-call people listed on paper, I wouldn't forget to phone any of them.

Whatever way you choose to help simplify your life, just make sure it's routine and puts your mind at ease. Having balance between life on the road and life at home is essential. Minimizing the stress of travel helps you in the long run.

Tips for the traveling photojournalist:

- Don't let mail or newspapers overflow.
- Use timers for your lights.
- Keep the lawn mowed or hire a lawn service.
- Don't hide a key in an obvious place—try a keyless entry pad for your garage.
- Do not check in with your neighbors or friends on social networks; eyes are watching.
- Monitor your house with your smart phone.
- Keep your blinds closed.
- Don't change your answering machine message.
- Move expensive items out of sight.
- Keep the police in the loop.
- Install good outside lighting.

Insights: Prepping Your Car for Long-Term Assignments

Keep It Clean: Chemicals from the road, bird droppings, and water stains all can eat away at your paint and cause damage over time, so take your car to the wash. Add a coat of wax for extra protection.

Oil Change: If your assignment is 30 days or longer, I highly recommend getting your oil changed before you leave. Old, used oil acquires contaminants that could damage your engine over time.

Fill the Tank: Again, this is for trips longer than 30 days. Filling your gas tank will prevent moisture from accumulating inside the tank and keep the seals from drying out. For added protection, consider using a fuel stabilizer to help prevent the gas from deteriorating for up to 12 months.

Start It Up: If left for too long, your battery will lose its charge. Have a neighbor or friend start your car every week or every other week, and if they have time, drive it for about 10 minutes. By having someone drive the car, you will maintain the battery's charge and keep other engine components lubricated.

> ### QUICK TIP
>
> If you cannot arrange for someone to start the car, there are two other options. The low-tech solution is to disconnect the negative battery cable. You can also purchase a battery tender that hooks up to your car battery on one end and plugs into a wall outlet on the other. This may be a costly solution, though.

No Brakes: Don't use the parking brake for long periods of time. There's a chance that the brake pads and the rotors may become fused if they sit in contact with each other for too long. As an alternative, you can use a wedge to keep the car from rolling.

Flat Spots: Check your tire pressure to be sure it's at the recommended PSI. Vehicles that sit for long periods develop flat spots due to the weight of the vehicle pressing down. Having a neighbor or friend drive your car for 10 minutes every other week will help prevent flat spots. In some cases, however, the flat spots become permanent and require tire replacement.

No Solicitors: Keeping your car in the garage may invite rodents because it's a temperature-controlled shelter with plenty of places to nest. Strategically cover any rodent entry points such as the exhaust pipe and spread out some mothballs around and underneath your car. I keep my car in the driveway to help reduce rodent infestation and also to aid in the security of my house.

Insurance: Do not cancel your insurance when you leave for long periods. While it may save you money, there is a chance that the insurance company will raise your rates due to the gap in coverage, which could cost you more in the long run. And if your car gets jacked, you're out of luck.

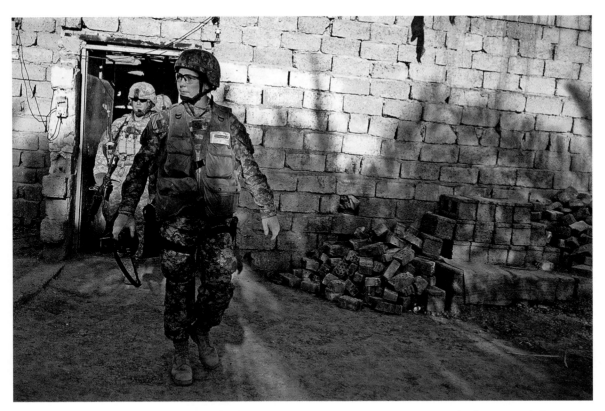

FIGURE 1.12 This picture shows what I carried for daily routine combat patrols in Iraq. I wore body armor, a helmet, a shooter's vest, two cameras, batteries, a notepad, lenses, ammunition, and a weapon. I also had a supply of water and other odds and ends, depending on the mission. The gear weighed in at approximately 80 pounds.

In Good Shape

Photojournalism is a physical occupation. You must have endurance, strength, flex-ibility, and speed. If a photographer is not in peak physical condition, they face back and neck pain, sore joints, and fatigue. We're required to carry our camera gear with us at all times, or risk not getting the photograph at the decisive moment. Despite the advancements in camera gear technology, the equipment has not substantially decreased in weight, which is why good physical fitness is required. A lack of fitness may result in injuries and disability severe enough to limit, or even end, shooting careers. By making time for physical fitness, you'll be increasing work stamina and valuable production hours to your day. In short, treat your body as good as, or better than, you treat your camera gear (**Figure 1.12**).

Insights: Ways Cycling Benefits Photographers

- Building strength and muscle tone so you can carry more gear farther distances.

- Increasing muscle tone. Regular cycling strengthens leg muscles and is great for hip and knee joint mobility. This will give you stronger legs to get up and down after taking low-angle shots.

- Developing stamina, which can keep you going during long days on assignment.

- Improving cardiovascular fitness. Studies have shown that cycling to work will increase cardiovascular fitness by 3-7 percent.

- Burning calories and losing unwanted pounds. As a photographer, you're already toting around enough weight in gear, so you want to be as lean as possible. Steady cycling burns approximately 300 calories per hour. If you cycled for 30 minutes every day, you would burn 11 pounds of fat in a year.

- Maintaining good heart health and cycling just 20 miles a week can reduce the risk of coronary heart disease by 50 percent.

- Enhancing coordination of the whole body, thereby improving arm-to-leg, feet-to-hands, and body-to-eye coordination.

- Reducing stress. Any regular exercise can reduce stress and depression and improve well-being and self-esteem.

Stick to the fitness basics

Before embarking on an exercise and diet regimen, consult your doctor. He or she will help assess any preexisting injuries or personal limitations and determine a program that best suits your body.

Fitness impacts your photography by giving you the stamina to go further and gain better access to remote locations because you can travel greater distances with your gear. Being fit helps you stay on assignments for longer periods without fatiguing and go multiple days without rest. Most importantly, recoveries from physically demanding assignments are quicker.

During my time in the service, I worked out 5 days a week with the rest of my unit. Our physical training averaged an hour and consisted of various strength-building exercises, weights, core work, and, most importantly, cardio. I still maintain that physical fitness regimen, but I've also built in new techniques to improve my photography. I'm not in my twenties anymore and I'm beat up from years of combat documentation. Countless injuries have wreaked havoc on my body. I have cervical spine impairment because of combat trauma. Multiple improvised explosive device encounters weakened the muscles and tendons in my neck and also caused traumatic brain injury (TBI). I also have to contend with right arm nerve damage that often impedes my ability to keep my camera elevated for prolonged periods of time. I've had to adapt my exercises to my new physical condition and to help strengthen my weak spots. Every morning, I wake up at 5:30 and exercise, no matter where I am.

My typical workout schedule

- Monday: bike and run
- Tuesday: swim and strength training
- Wednesday: run and core training
- Thursday: bike and run
- Friday: swim and strength training

Establish a practical workout regimen

With the guidance of my doctor and the help of a physical trainer, I've developed a workout schedule that's right for me and is beneficial to enhancing my occupational abilities. I've come a long way since being wounded in action when I was told by doctors that I couldn't run, carry anything over 5 pounds, or even do photography anymore—when I was only 27. At the time, my body was not strong but my mind was. I knew that if I stayed strong and worked hard, I could still be a photojournalist. And I'm still here.

If you don't have an hour to dedicate to physical fitness, doing something is better than nothing at all. If you have 30 minutes, then you can at least add calisthenics to your daily routine, which will help strengthen your body and does not require a weight room or gymnasium.

Here are six military-style calisthenics that I recommend for photographers on the go, demonstrated by photojournalist Alice Keeney-Wiggans.

Push-ups

Push-ups are one of the most fundamental exercises and can be valuable in that they work out all the muscles in the upper body and build strength in the forearms, wrists, upper arms, shoulders, and chest. This will help your strength when it comes to carrying around all of your camera gear.

1. Start facedown on the floor with arms extended and shoulder width apart, back flat, and feet together (**Figure 1.13**).

2. Lower your body down until your chest just touches the floor while keeping your back parallel to the floor (**Figure 1.14**).

3. Push your body back to the starting position slowly and with control until your elbows are fully extended. You can also try doing "knee" push-ups (**Figure 1.15**).

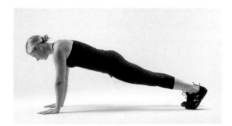

FIGURE 1.13 Push-up start point.

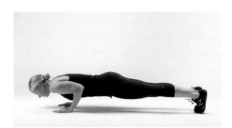

FIGURE 1.14 Down position of the push-up. According to the military, common errors that happen while doing traditional push-ups involve bad hand position. You may not be able to lift yourself off the floor while attempting a push-up if you place your hands too far forward of your chest. You can look left and right while you are in the down position of a push-up to check if your hands are too far forward.

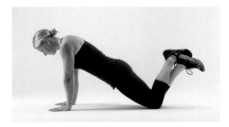

FIGURE 1.15 "Knee" push-ups are a version of the traditional pushups that may be seen as more difficult, but different people have different muscle strengths. If your core and legs are weak but you have good upper body strength, this may be the push-up method for you.

QUICK TIP

Your hands are too high if you can see them next to your face while you are in the down position.

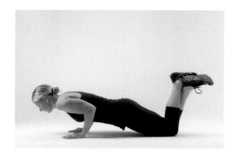

FIGURE 1.16 An illustration of the knee push-up.

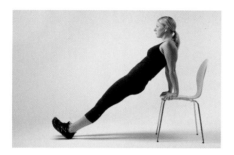

FIGURE 1.17 Tricep dip starting position. The chair dip is a convenient exercise to include in your workout because it doesn't require any special equipment. You can do chair dips at home, at the office, or in a hotel room when you are traveling.

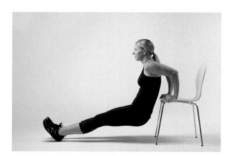

FIGURE 1.18 Tricep dip in the down position. With your legs extended straight out in front of you during the chair dip exercise, try bending your knees at a 90-degree angle. This will reduce the amount of body weight you're pushing up.

4. To do a knee push-up, lie belly-down on the ground and cross your legs at the ankles, and bend your knees so your ankles are in the air (**Figure 1.16**). Keep your hands palm-down under your shoulders, fingers pointing forward. Keep your torso, bottom, and upper legs in a straight line as you use your arms to push yourself up.

Tricep dips

Tricep dips are a compound push exercise with a small range of motion that focuses mainly on your triceps but also works your biceps, forearms, shoulders, chest, and lower back. An easy and convenient method of working your triceps is the chair dips method.

1. Position your hands shoulder-width apart behind you on a secured bench or stable chair (**Figure 1.17**).

2. Straighten out your arms and keep a little bend in your elbows in order to keep tension on your triceps and off your elbow joints.

3. Slowly bend at your elbows and lower your upper body toward the floor until your arms are at about a 90-degree angle (**Figure 1.18**).

4. Once your arms reach the bottom of the movement, slowly press off with your hands and push yourself straight back up to the starting position.

Crunches

Crunches can improve your tone and strengthen the muscles in your stomach. You don't need any gym equipment to perform crunches, and you can do them any time or anywhere, which is good for the life of a photojournalist on the road.

1. Start on your back with your knees bent and feet flat on the floor (**Figure 1.19**).

2. Cross your arms over your chest.

3. Lift your shoulder blades off the floor by flexing your abdominal muscles (**Figure 1.20**).

4. Concentrate on shorter, more intense abdominal flexions.

5. Touch your elbows to your knees.

6. Slowly lower your shoulder blades to the floor. For more of a challenge, try a crossover crunch. This is a great beginning exercise that targets the abdominal and oblique muscles, as well as the muscles in the lower back. Weighing your body down with camera gear can cause low back pain, and this exercise is not only effective in strengthening these muscles, but can also aid in the treatment and prevention of lower back pain (**Figure 1.21**).

7. Flex your abdominal muscles by curling your torso off the floor, and then simultaneously pull your left knee in toward your chest as you extend your right leg straight out at a 45-degree angle, rotating through your trunk to bring your right elbow to your left knee.

8. Pause briefly. Return to the start position and alternate sides (**Figure 1.22**).

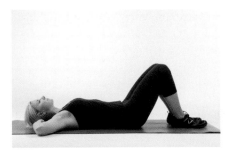

FIGURE 1.19 Starting position of the crunch. Having strong abdominal muscles helps stabilize your pelvis and spine as you run around taking pictures. Without sufficient abdominal strength, your body automatically recruits other muscles to compensate for their lack of strength. That can have a domino effect on other muscle systems, causing aches, pains, or outright serious injuries.

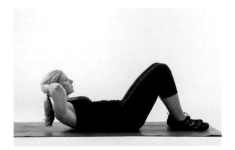

FIGURE 1.20 Up position of the crunch. Strong abs help ward off injuries and aches and also improve your alignment and posture. You can maintain good strength for longer distances and time before you begin to tire. You waste less energy and won't wear out as fast. This is good for long days of shooting.

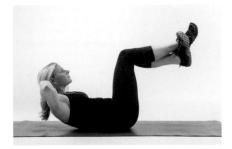

FIGURE 1.21 To perform a crossover crunch, lie on your back with your knees bent at a 90-degree angle with your ankles crossed. Place your hands behind your head, elbows held wide.

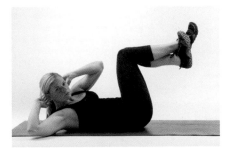

FIGURE 1.22 An illustration of the crossover crunch.

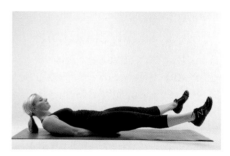

FIGURE 1.23 Flutter kicks start position. Flutter kicks are done by moving the legs and feet in a quick up and down motion, side by side. The faster you flutter, the more calories you'll burn.

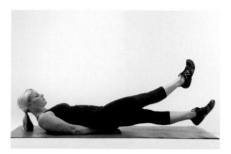

FIGURE 1.24 Flutter kicks movement. When you combine the action of holding your legs off the ground with the movement of fluttering, you can nearly double your caloric burn.

Flutter kicks

Flutter kicks are a great way to add variety to any abdominal routine while helping you improve your core and upper leg strength.

1. Start on your back with your legs straight out.

2. Place your hands under your buttocks (**Figure 1.23**).

3. Keeping your legs straight, raise your feet off the ground (**Figure 1.24**).

4. Move your legs in a scissor motion.

Squats

Squat exercises thoroughly engage the quadriceps, hamstrings, and calf muscles, helping to tone and strengthen the legs. Slowing down the motion makes the workout that much more intense. The ankles, knees, hips, and lower back are all utilized in the squatting motion. Keep in mind that squats are a motion that your body employs in everyday life; whenever you kneel down to shoot, you'll be happy you're doing squat exercises because you'll have the strength and flexibility to get the photography assignment done.

1. Stand with your feet shoulder-width apart (**Figure 1.25**).

2. Place your hands on your hips or straight out in front of you.

3. Keep feet planted firmly on the floor, and bend at the knees to a 90-degree angle (**Figure 1.26**).

4. Slowly raise yourself back up.

Lunges

The basic lunge is one of the few exercises that work both the hamstrings and the quadriceps, as well as the glutes. This is why it is so common in military exercise programs. It is also good for improving your balance and agility. If you have vertigo like me, or struggle with balance, then do it next to something you can put your arm on for stability.

1. Stand with your feet shoulder-width apart and your chest and back straight (**Figure 1.27**).

2. Place your hands on your hips.

3. Bring one leg forward until you're almost kneeling on your back leg. The front leg should be at a 90-degree angle (**Figure 1.28**).

4. Stand up and alternate legs.

Cardio

I can't stress enough the importance of cardio to a photojournalist's work. If you can manage to add 30 minutes of cardio to your routine, you'll be all the better for it. Try a jog or bike ride outside. If you're on the road in a hotel, try an elliptical trainer or treadmill. No matter what, just get physical. Lack of activity destroys the physical condition of every photographer, whereas movement and methodical exercise can save it.

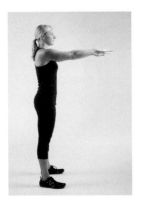

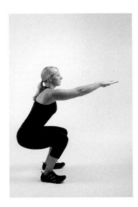

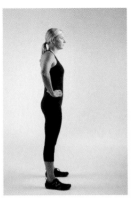

FIGURE 1.25 Squats starting position. Nearly 90 percent of bodily injuries involve the weaker stabilizer muscles, ligaments, and connective tissue. By performing regular squat exercises, you'll do a lot to reduce the risk of injury.

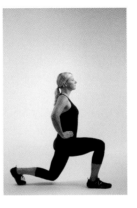

FIGURE 1.26 Squats down position. Strengthening your lower body through squat exercises helps fortify the system of nerves that control movement in that area. This allows you to keep the natural sense of equilibrium that complements fluid movement.

FIGURE 1.27 The lunge starting position. The start position has you standing with your legs approximately shoulder-width apart. Correct form enables you to work your legs without damaging any of your joints.

FIGURE 1.28 The lunge extension movement. It's essential to have good technique when performing the lunge. You don't want to extend your knee past your toes. It's also important to keep your back straight and not to lean forward as you lunge.

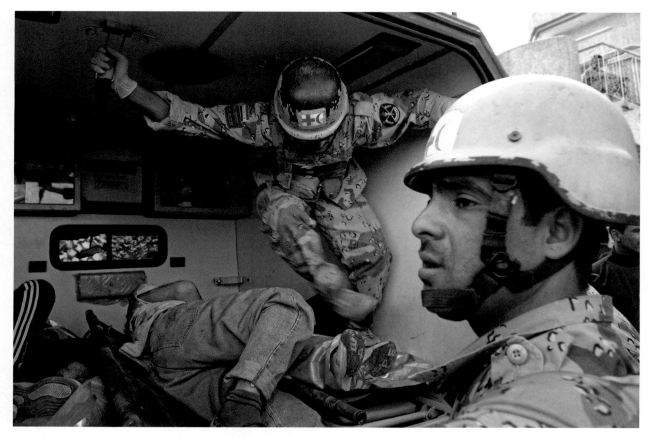

FIGURE 1.29 Iraqi Army soldiers load the bodies of deceased enemy forces into a waiting ambulance in Baqubah, Iraq.

Lens (mm): 17, ISO: 160, Aperture: 5.6, Shutter: 1/45, Program: Aperture Priority

Staying Sane

A photojournalist will bear witness to some of the worst and most horrific atrocities imaginable, so it's important to be emotionally stable as well as professionally competent. You may be required to photograph accidents, homicides, natural disasters, famine, war, and death, all while under extreme conditions. It's not surprising to have a physical reaction while covering stories surrounding mass casualties or critical incidences. You may feel faint at the site of blood or overwhelmed at the smell of human decomposition. It's imperative to find methods of coping with those feelings so you can continue to cover the story thoroughly and objectively. You do not want to become a hindrance to the story by becoming a casualty, too. No matter what, remain calm—and remember to breathe (**Figures 1.29** and **1.30**).

Photojournalists, especially those who are in close contact with the victims, are not immune to the impact of the human suffering we document. After covering traumatic events, it's only natural that the impact of the event will linger in your mind and you may have trouble processing what happened, resulting in a stress-induced response. For some, the symptoms can be severe initially and go away after a few weeks. This is referred to as acute stress disorder (ASD). When symptoms persist for a prolonged period, it might be Post-Traumatic Stress Disorder (PTSD).

Symptoms to look out for

- Reliving the traumatic events or repeated visions of the scene

- Frightening and/or intrusive thoughts

- Difficulty sleeping

- Bad dreams

- Feeling tense or on edge

- Strong feelings of guilt, depression, or worry

- Shortened temper and/or angry outbursts

Most people associate PTSD with battle-scarred soldiers such as myself. However, PTSD can be caused by any overwhelming life experience, especially those of which are unpredictable and uncontrollable, like spot news assignments. It develops differently from person to person and often in the hours and days that follow exposure to traumatic events. For others it may take weeks, months, or even years to appear.

No one is above having a human reaction (**Figure 1.31**). Although most photographers do not report chronic distress associated with their occupation, you aren't any weaker or less capable of a journalist if you suffer from psychological distress.

I was diagnosed with PTSD in the spring of 2004. I'd just returned from a tour in Iraq and trying my best to reintegrate back home. Prior to my

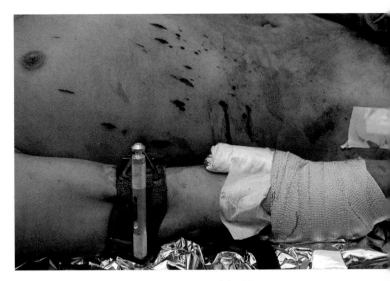

FIGURE 1.30 An Iraqi Army soldier is treated for blast wounds sustained after his vehicle was hit by an improvised explosive device in Baqubah, Iraq.

Lens (mm): 24, ISO: 640, Aperture: 2.8, Shutter: 1/100, Program: Aperture Priority

FIGURE 1.31 A Seabee from Camp Lemonier stands during the playing of Taps at a memorial ceremony for a fellow sailor who was killed during military operations in Kenya.

Lens (mm): 400, ISO: 400, Aperture: 5.6, Shutter: 1/400, Program: Manual

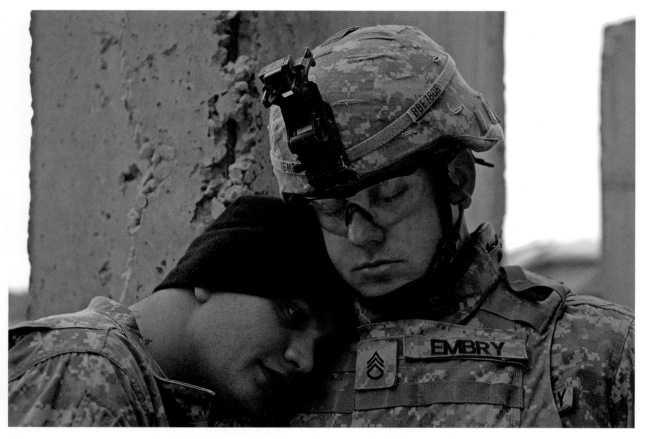

FIGURE 1.32 U.S. Army soldiers take a moment to embrace and comfort one another before heading out on patrol in Buhriz, Iraq.

Lens (mm): 48, ISO: 400, Aperture: 2.8, Shutter: 1/1000, Program: Aperture Priority

return, friends had moved my personal belongings into a new townhouse. When I came home, the power and water had not been turned on and my life's possessions were stuffed in cardboard boxes stacked to the ceiling. The only thing accessible was my couch. I sat in the dark with nothing to reflect on but my memories of war.

The pictures I took during my time in Iraq would flash through my head and I could hear the screams as if they were in the room. In an attempt to block out the noise in my head, I began to busy myself with unpacking my boxes and buried myself in work. However, I learned quickly that I could not run from my dreams. The nightmares began to become more intense and soon escalated into night terrors. I'd see the faces of the dead and sometimes wake up crying. I had no idea what was happening to me. I didn't want my fellow combat photographers to think less of me, so I didn't talk about it. After all, they didn't seem to be having any trouble.

I traveled to Washington, DC, for a military photographers' workshop about 3 months after I got home. By that time, I wasn't sleeping at all. I had the jitters and couldn't concentrate, and everything seemed to piss me off. I withdrew from

my social circle because I was afraid they'd notice something was off about me. Apparently my best efforts of concealing my stress were not good enough.

A combat photographer from the Vietnam era pulled me aside and said, "Hey, kiddo, you don't look so good." Without my prompting him, he began to tell me what PTSD was and that it's all right to feel mixed up inside. He confessed to me that he'd sought counseling to resolve emotions that stemmed from traumatic events in Vietnam. I was shocked and relieved. He was the first photographer to reveal anything of that nature to me. He vowed to help me seek counseling, and he did. I began therapy for PTSD a few weeks after we talked.

Allowing myself to be consumed by stress was not my intention. Once I was on the path to healing, I swore an oath that I'd care for my mental health as well as my physical self. To this day, I'll self-identify my emotional triggers. If I feel my symptoms increasing, I seek help.

I'm not a doctor, which is why I suggest seeking professional help if you feel like you're suffering from traumatic stress. Think of a mental health care provider as your general practitioner for your mind. An annual physical is always good, so why stop there—get an annual mental health screening, too (**Figure 1.32**).

Techniques for surviving stress:

- Talk with someone you trust about your feelings. If you can't verbalize them, then I suggest keeping a journal. It is better to get your feelings out than to internalize them.

- Do not lock yourself away or consume yourself with work; either extreme is unhealthy. Find a happy balance.

- Lean on others for support.

- Be sure to make time in your life for hobbies you enjoy. Pleasant recreational activities help distract from intrusive memories. Be sure to remind yourself that that's all they are—memories.

- Eat healthy food, and exercise regularly.

- Learn relaxation skills: breathing, meditation, or listening to music, for instance.

- If you wake up from night terrors, remind yourself that you are reacting to a dream. The dream is why you are panicked, not because of real danger.

- Remind yourself that all of the feelings you have inside are natural reactions to trauma. You should not feel guilty for something you cannot control.

Finding Your Beat

A *beat* in the news world refers to a journalist's specialized genre of reporting (**Figure 1.33**). Sports, science, business, crime, politics, and military are all examples of individual beats. Each beat distinguishes itself from another by topic, and some even have their own lingo and jargon. Many daily paper photographers are required to photograph multiple beats, which necessitates being versed in a variety of occupational cultures and aware of each beat's particular protocols.

Take politics, for instance. There's never a day when there isn't something substantial to report, such as party politics, election coverage, and other political undercurrents. Most photographic opportunities on this beat are prearranged, which means a photographer will have to contend with many other photojournalists jockeying for a good shot, especially when relocated to a press pool. Coordination with the event planners and media

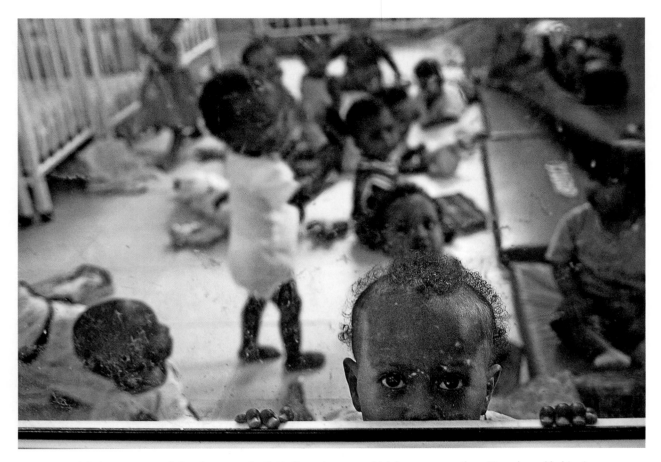

FIGURE 1.33 A baby peers out of the playroom of a Catholic orphanage, which houses more than 40 orphaned babies in Djibouti, Africa.

Lens (mm): 28, ISO: 800, Aperture: 2.8, Shutter: 1/15, Program: Aperture Priority

access passes are often a requirement. If and when you're allowed to move about, it is often up to the onsite security team whether you can get close the political official. Then there's a matter of protocol. If you are able to interact with the public figure, you should address the politician by the title of his or her highest elected position. It would be Senator or Congressman So-and-so, not Mr. or Mrs. So-and-so. This barely scratches the surface of all that's required of a political beat photographer.

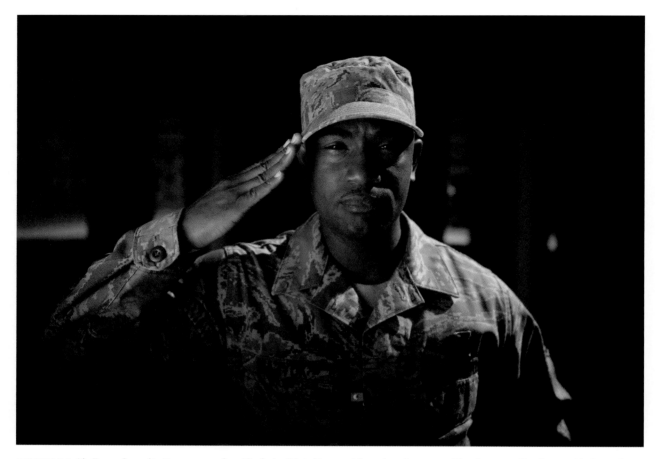

FIGURE 1.34 Air Force Security Forces member, Technical Sgt. Damon Mazyck, salutes an officer's car at Charleston Air Force Base, South Carolina.

Lens (mm): 34, ISO: 200, Aperture: 2.8, Shutter: 1/4000, Exp. Comp.: -1.0, Program: Aperture Priority

As a combat photographer, I was only required to be fluent in the language of the military, and even that took months, if not years. We had a class in basic training, which taught us military customs and courtesies. Plus, we had to recall many of them on the fly in the field for practical use and even on written tests for rank promotion. Take something as simple as a military hand salute. In the military culture, it's a sign of respect and a greeting. But did you know there are about 20 rules pertaining to the salute alone? I'm not going to saddle you with all the particular rules regarding the salute because, unless your beat is the military, you'd never need to know them. However, as a photojournalist in the military, it was my duty (**Figure 1.34**).

Like any modern-day city in the United States, the military has thousands of people in a variety of occupations, from dentists and firefighters to lawyers and pilots. Because my job as a photojournalist was to tell the entire military story, I was required to know many beats within military society. Although most of my assignments were straightforward combat coverage, I did have several other photo stories unrelated to war.

I once documented a group of Congresswomen as they toured women's health facilities in Baghdad, Iraq. I covered a Tuskegee Airman reunion. I also photographed the evacuation of hundreds of American citizens from Lebanon (**Figure 1.35**). I even photographed a soccer tournament. Each story was as unique as the beat and genre it fell into, and the subjects involved in the stories spoke jargon directly related to their occupations. Much time was spent on my part translating exactly what the subjects meant when they used acronyms, technical terminology, and slang. The more I covered beats and educated myself, the easier understanding my subjects became. The minute I could casually hold a conversation without being held up by language barriers, I gained crucial access and also the respect of my subjects in the process. I took a genuine and vested interest in learning more about their culture and cared about the assignment I was given. My subjects appreciated it.

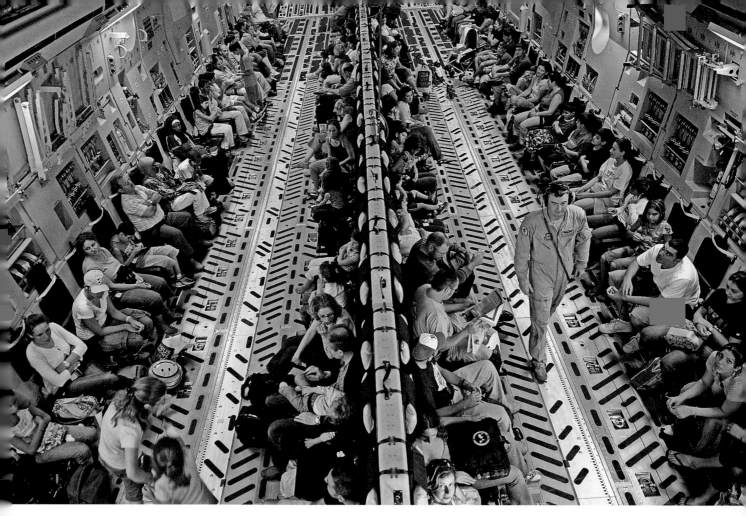

FIGURE 1.35 Air Force loadmaster Airman First Class Jarod Lambert walks among 99 American evacuees from Lebanon aboard a C-17 Globemaster aircraft on its way to Ramstein Air Base, Germany.

Lens (mm): 17, ISO: 500, Aperture: 2.8, Shutter: 1/50, Program: Aperture Priority

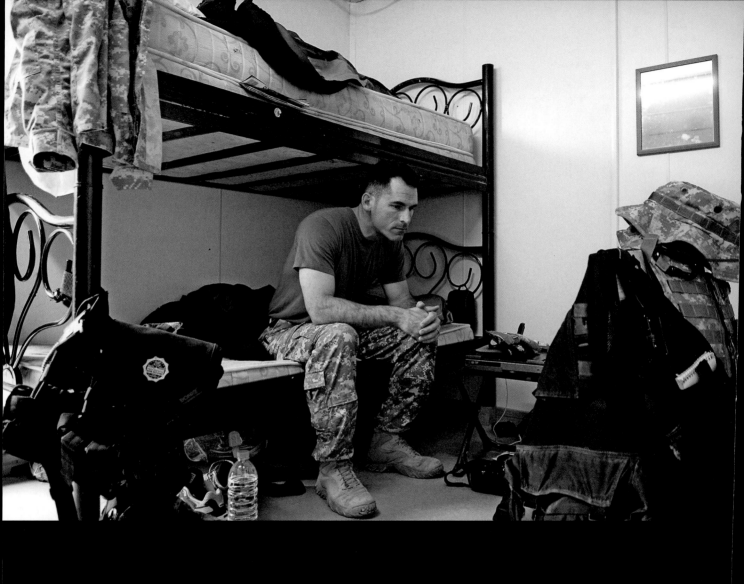

CHAPTER 2

PREPARATION: EVERYTHING BUT THE CAMERA

Let's be realistic. There's more to preparing for an assignment than just having the right camera equipment. As photojournalists, we have to consider where the assignment is located, the duration of the story, the political climate we'll be operating under, the level of threat the assignment presents… and the list goes on and on. Through my experiences and stories of those I've worked with, I've developed a series of key points and checklists that may help make your life easier and keep you safe as you venture out on your next project.

U.S. Air Force photojournalist Andy Dunaway downloads images after a combat operation in Iraq. His living quarters are also a space where he processes and transmits his pictures from the field and where he stores his equipment between shooting assignments.

Lens (mm): 17, ISO: 320, Aperture: 4, Shutter: 1/40, Program: Manual

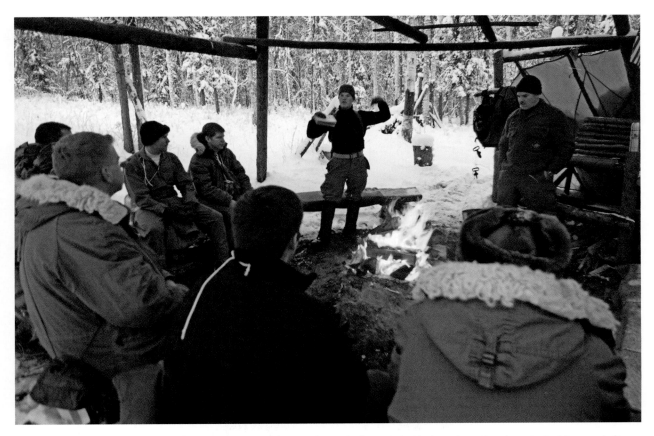

FIGURE 2.1 U.S. Air Force combat photographers attend an arctic survival course in Alaska, where they learn to build snow shelters, start fires, hunt for food, and navigate arctic terrain. (Photo by Andy Dunaway)

Lens (mm): 16, ISO: 400, Aperture: 4, Shutter: 1/20, Program: Manual

Foundation Training for High-Risk Environments

Before you set boots in the danger zone, it's imperative that you arm yourself with the necessary training so you're prepared for the unexpected. In the end, knowledge is the most powerful weapon a photographer can bring to any conflict. It's what may save your life if the situation turns dire. There are a number of dedicated war training courses that will teach you basic medical techniques, survival skills, and situational dangers you may encounter while on assignment. It doesn't matter whether you're going to document war, or photographing a street riot in your home city; in dangerous places, you must protect your life.

In many countries around the world, photojournalists put themselves at high risk each day covering stories such as drug trafficking, anti-government militias, protests, violence, and war. I suggest that those who are covering dangerous stories receive special, military-inspired training so they can render first aid to wounded, evade imminent danger, and properly identify the sound of gunfire.

The majority of my survival courses, like the one depicted in **Figure 2.1**, were mandatory training for military combat photographers. Though they were often long and sometimes felt like death by PowerPoint, they proved to be worthwhile in practical real-world scenarios. After the classroom portions, we'd go into the field and apply what we'd learned.

Several private firms, such as Centurion Risk Assessment Services and AKE Integrated Risk Solutions, specialize in similar survival and war training. Both are run by ex-British military personnel. There are also nonprofit organizations that offer low-cost or free training in countries where there is conflict or violence against photojournalists. These firms and organizations offer a variety of lecture-based and practical application courses that teach you to understand hostile environment risk assessment, to recognize threats, and to evaluate a given situation. You may be presented with scenarios you'd likely face while on assignment in high-risk situations such as military checkpoints, machine gunfire, improvised explosive device detonations, and minefields (**Figure 2.2**).

You may think this is excessive, but it's reality. It's important to know what a rocket-propelled grenade looks like, as well as its range and blast radius, so you can achieve the proper distance or coverage to protect your life. You should learn how to evade capture and survive hostage abduction. You should be well versed in personal body armor, protective equipment, and proper weaponry recognition skills.

FIGURE 2.2 A large improvised explosive device made of homemade bomb materials was discovered by Iraqi troops in a small village road before enemy fighters had a chance to detonate it.

Lens (mm): 48, ISO: 100, Aperture: 2.8, Shutter: 1/2500, Program: Aperture Priority

Of course, a photojournalist is not a soldier, and it's not your aim to act like a combatant. But you must be able to protect yourself. A soldier knows how to move under fire and is aware of enemy threats. Like a soldier, a photojournalist must determine the source of the threat to avoid ending up as collateral damage (**Figure 2.3**).

QUICK TIP

The private firm Centurion Risk Assessment Services hosts courses in the United States and the United Kingdom, which include discussions and practical exercises on land mines and booby traps, weapons and ballistics, emergency navigation, kidnapping, personal security, and field emergency first aid training. Their instructors are former military personnel with approximately 20 years' experience each, and they hold civilian instructor and assessor qualifications, including the teaching of first aid.

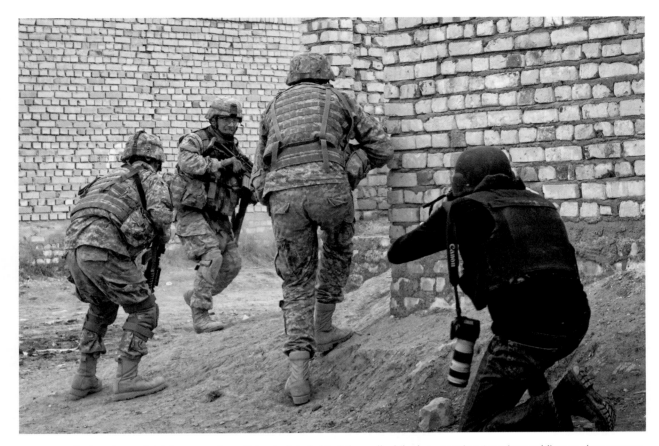

FIGURE 2.3 A photojournalist takes cover from flying bullets behind the wall while documenting American soldiers as they engage in a battle with foreign fighters on the streets of Buhriz, Iraq.

Lens (mm): 55, ISO: 400, Aperture: 8, Shutter: 1/125, Program: Aperture Priority

Classes to check out:

- **Emergency first aid:** First aid training teaches you the skills you need to respond to an emergency and potentially save someone's life. The chances of someone recovering more easily, or surviving an accident or injury, increase greatly if you immediately apply first aid knowledge to help those who have been hurt.

- **Land navigation:** Navigating with a compass and map is an essential skill for many incident positions. Confidence in navigation skills often impacts how a person performs during a crisis—which can lead to very different outcomes.

- **Personal security:** Knowing self-defense can help you get out of challenging conflict situations, such as encounters with multiple opponents and armed attackers.

- **Hostage survival:** The risk of kidnap and extortion of photojournalists overseas has never been greater. How a hostage behaves in captivity can literally mean the difference between life and death, for both the individual and fellow captives.

- **Weapons orientation:** While photographing in hostile environments, you may be exposed to small arms. At the very least, you should be oriented with firearms recognition, safe handling, and terminology.

Location, Location, Location

It's important to do your research before you pack your bags. Each assignment location presents unique hazards, whether environmental or manmade. When possible, it's best to identify and counteract potential threats in advance of your assignment. There may be pre-trip medications you're required to take or clothing considerations that may require a stop at the store. Some tasks, such as obtaining body armor and passport visas, may necessitate more time and work.

Make your travel arrangements

Depending on how remote your assignment is, you may need to arrange special types of transport in addition to the usual flights and car rentals. In cases such as these, get yourself a travel advisor. I know the Internet makes travel arrangements seem more accessible and expedient, but when trip-planning gets problematic, it's best to leave it to the experts.

The bottom line is that travel agents know more than you do. They have better connections, access to local venders, competitive rates—and if that isn't enough, they supply a safety net during your trip that you simply do not have by booking yourself online. Travel agents can handle every aspect of your trip, from airline tickets to lodging, ground transportation, and more. They will provide you with an array of options and price quotes from a variety of travel suppliers, giving you the upper hand when making your final travel decisions. Additionally, they can advise you on the necessary travel visas and documents required for your assignment.

FIGURE 2.4 Media specialist Chuck Rohrig sits with the leftovers after eating a traditional Yemeni lunch in Sana'a, Yemen.

Lens (mm): 12, ISO: 400, Aperture: 4, Shutter: 1/180, Program: Aperture Priority

Travel agents can help you:

- **Avoid bad food:** Agents can give you some forewarnings so you don't accidentally order something too exotic (**Figure 2.4**).

- **Decide what to wear:** Some countries have local dress codes and restrictions. They'll help bring you up to speed on the local customs.

- **Learn about local crime:** They are up-to-date on crime and will advise you on the questionable parts of town, offering tips on what to look out for.

- **Understand local laws:** Many countries have laws that are different from your own. Travel agents can give you a quick rundown of what you need to be aware of before you go.

- **Charter private vessels:** Their connections make securing unique modes of travel, such as boats, trucks, helicopters, and ATVs, much easier.

- **Avoid scams:** Contrary to popular belief, what you see on the Internet isn't always true. Agents will link you up with legitimate hotels, car rental services, translators, and security services, if needed.

- **Rearrange your travel:** If you're on assignment and are required to cover a breaking news story in a neighboring country, for example, they can change your travel plans more quickly and easily than you could from an Internet café. Plus, more than likely, they won't incur any extraneous travel penalties.

Prepare documents and securities

Each country's requirements for travel documents are unique. Some require that you have a certification of various vaccinations before traveling to their country; for some you need a visa, and others require only a valid passport.

To be prepared, you can visit the website www.Travel.State.gov to view country-specific requirements for Americans traveling abroad. This site provides information about the country, travel safety, crime, locations of U.S. embassies, visa requirements, health and medical conditions, and localized hazards and threats. This is a good place to start learning about where you are going.

Whether you're traveling abroad only once, or you spend your life on the road, I highly suggest registering with the Smart Traveler Enrollment Program (STEP). STEP is a free service provided by the U.S. government to U.S. citizens who travel to or who live in any foreign country. It allows you to enter information about your upcoming trip abroad so the Department of State can better assist you in an emergency. STEP also allows Americans residing abroad to get routine information from the nearest U.S. embassy or consulate.

The purpose of STEP is to notify U.S. citizens in the event of a disaster, emergency, or other crisis, and for evacuation coordination. The information you provide is distributed to appropriate agencies—whether federal, state, local, or foreign—to assist the Department in the evacuation or provision of emergency service to U.S. citizens, or for law enforcement purposes. The information is also made available to private U.S. citizens, known as wardens, designated by U.S. embassies to assist in communicating with the American community in an emergency.

QUICK TIP

The Bureau of Consular Affairs issues up-to-date travel warnings, travel alerts, and threat levels for every country around the globe. Alerts ranging from typhoons, hurricanes, terrorists threats, and military coups are posted on their Worldwide Caution website. Travel alerts are issued to disseminate information about short-term conditions, either transnational or within a particular country, that pose significant risks to the security of U.S. citizens.

Inoculate and medicate

If your assignment is abroad, you may not have access to the type of health care you're accustomed to. Before your trip, be sure to make an appointment for a routine physical exam with your primary care physician. While there, be sure to update your vaccinations and get inoculated for any regionally required vaccines. Some countries require Tetravalent Meningitis vaccinations, whereas others may recommend a course of prescribed anti-malaria pills. Request a copy of your vaccinations and prescriptions for travel, and keep them in a safe place on your person. If you have any life-threatening allergies, be sure that is noted on your record, too.

FIGURE 2.5 Military photojournalist Jake Bailey checks in for a flight to Alaska. (Photo by Andy Dunaway)

Lens (mm): 12, ISO: 400, Aperture: 4, Shutter: 1/80, Program: Manual

Fright or flight

Getting to your assignment well rested is imperative, so choose your seat thoughtfully and well in advance of your trip (**Figure 2.5**). For long flights, I like to sit near the window, so I lean my travel pillow up against the bulkhead and take a snooze. The only downer is when I need to visit the ladies' room, I have to climb over the others in my row. If it's a short ride, I opt for the isle so I don't have to play "stomp the neighbor."

QUICK TIP

If you have a chronic illness such as diabetes, or perhaps a life-threatening allergy, you should consider wearing a medical alert bracelet on your wrist so emergency responders are aware of your allergy danger. You can also procure a bracelet with your blood type on it so that you can receive a blood donation more expeditiously in the event that you need one.

Generally speaking, you'll have a quieter, less turbulent ride if you sit near the front of the plane. For those of you who get air sick, this may be the best place for you. Another advantage is that exiting the plane is quicker. Also, the toilets tend to be located in the middle or rear of the plane, so sitting up front distances you from them. The only downside is you may be placed up against a bulkhead, which means you can't have any bags by your feet and you'll have limited legroom. If it's legroom you want, then perhaps an exit row is what you need. However, you'll probably be next to the wing, which places you in direct earshot of the churning jet engines.

QUICK TIP

You can find airport delay information for departure and destination airports by visiting a special Federal Aviation Administration (FAA) website: www.Fly.FAA.gov. For more detailed information, including current average delay times and the reason for the delay, just click on the airport.

If you are a frequent traveler, don't forget to take advantage of the travel miles programs offered by all air carriers. Choose a carrier you like, and try to book all your flights through them. By accruing miles, you can achieve preferred travelers status that includes perks such as boarding priority, free checked baggage, and flight upgrades. I also opted for a lounge pass, which gives me access to a quiet retreat where I can caption images, catch up on emails, eat some food, and get a coffee between flights.

Where and Wear

Many people, when getting ready for work, stand in front of their closet for what seems like ages and agonize over which outfit will look the best, convey the right message, or hide those extra pounds. That's not me. It's function over fashion and durability over designer.

I'm not too adventurous with my clothing, so offending someone with my wardrobe is unlikely unless they're the fashion police. However, it's important to consider the customs of the people you're photographing and dress accordingly.

One leg at a time

No matter the location's environment and climate, I always wear pants. I crouch, kneel, squat, crawl, and lie in all types of debris while I shoot, so I protect my legs with durable textiles such as rip-stop or tear-resistant polyester and cotton blends. Even when I travel to certain conservative religious countries that require I wear a full-length, non-figure-revealing dress, I still wear pants underneath. This is just my opinion, but shorts don't appear professional and skirts are impractical.

In the Trenches: My Girlish Figure

While on deployment, I wore an Army Combat Uniform (ACU), which was standard issue for both men and women. As a woman, this allowed me to blend in better with my male counterparts. I kept my hair in a fixed bun hidden below my Kevlar helmet, and my breasts were tightly concealed under my body armor. The only shapely female identifier anyone could see were my assets—if you know what I mean. Yes, my hips and butt. However, I also wore a drop holster for my Beretta M9 pistol that wrapped around the middle of my thighs and cargo-style pants. This further hid my contours (**Figure 2.6**).

Most people didn't realize I was a woman until I spoke. This startled more than a few men, and delighted even more women. I want to make it very clear that I'm not ashamed of my gender. I'm tremendously proud to be among the many talented women in our profession. However, I do not see cause to bring my gender to everyone's attention arbitrarily. Doing so would be counter to what I do as a photojournalist and draw attention to myself. In combat, male infantry from many countries surrounded me all the time. To best blend in, I simply dressed down my looks.

In some cases when I wasn't wearing body armor, particularly in Iraq, it became hard for local nationals to ignore my gender. I experienced my share of wandering hands while in crowds. Some were looking to steal my camera gear, and others just wanted to cop a feel. I've had vile hand gestures of various sexual acts mimed to me. Some were even bold enough to yell audible insults in my face. I'm a tough lady, though, and I managed to stand my ground on every occasion. I took shit from no one. There have been tragic cases where women haven't been so lucky.

The unique difficulties female photojournalists face working in high-risk environments are sometimes unavoidable. As women covering conflict-laden atmospheres, men often outnumber us. This can be precarious, given the emotions evoked by those who are involved in violent acts such as riots, looting, protests, and war. However, there are techniques you can use to get around the trouble. Reducing your profile and blending in by masking your gender is sometimes essential to get the job done. If you're a lady wishing to conceal your gender from the masses, a worn ball cap can functionally camouflage your hair and obscure your face. Keep away from fitted clothing. Don't wear makeup or perfume, as these are obvious gender identifiers. A feminine tone of voice may be easily recognized, so avoid needless conversations or speaking loudly in public forums.

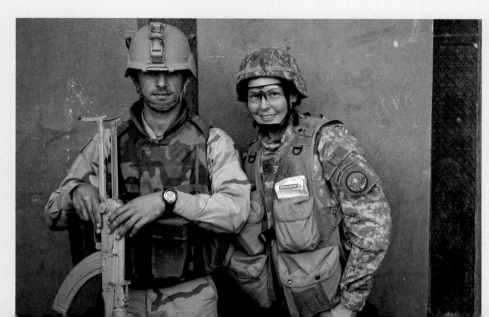

FIGURE 2.6
A portrait of an Iraqi soldier and me during a foot patrol in Iraq. Although I couldn't very well walk around wearing a ski mask to hide my face, I feel the androgynous armor, helmet, and vest helped me keep a low profile.

Lens (mm): 12, ISO: 400, Aperture: 2.8, Shutter: 1/800, Program: Aperture Priority

Insights: Tru Spec

Tru Spec makes my favorite brand of trouser. They are tough as nails, yet lightweight and breathe in hot weather. In other pants, I'm prone to plumber's crack when I kneel to get low-angle shots. My Tru Spec pants, as you see in **Figure 2.7**, have a soft waistband with comfort Tru-Fit technology that hugs my body. Most cargo pants have a tendency to be baggy and heavy, but these pants are neither. The six expandable pockets with Velcro flap are well thought out and I fill them with my flash cards, batteries, pens, paper, and whatever else I need. The double reinforced knees help keep my legs from getting scratched or bruised when I kneel down for a photograph. Plus, they don't look overtly military or tactical and come in a variety of colors. I'm pretty plain and usually stick to tan, black, or navy blue.

FIGURE 2.7 Here's a picture of my favorite navy blue Tru Spec pants.

It's a cinch

Plumber's crack can be an occupational hazard, so be sure to include a good belt with your attire. But there's more to wearing a good belt then just keeping your butt from hanging out of your pants. You can attach drop pouches for lenses or a first aid kit, or even a place to affix a multitool or knife. In keeping with my military background, I opt for a more robust waistline security system such as a rigger's belt like the one you see in **Figure 2.8**.

FIGURE 2.8 Most rigger's belts are made of nylon webbing and can be the difference between life and death in emergency situations. They're designed to be the ideal backup for a tactical harness used during airframe tie-ins. In layman's terms, there's a built-in "D" ring that first responders can use to airlift you out of bad situations.

Frock and roll

Avoid wearing bright colors or shirts with controversial messages, both of which would draw unwanted attention regardless of the location you're traveling to. Because of religious law, certain items of clothing may be discouraged—particularly for women. I usually pack a scarf to cover my hair and plenty of long-sleeved shirts, just in case.

I wear long-sleeved shirts that can be rolled up and converted to short sleeves. This gives me the option to have the sleeves down to protect my skin from sunburn, insects, and other environmental hazards. If the situation allows, I can roll the sleeves up to cool off like Andy has his in **Figure 2.9**. I shop for neutral-colored, collared shirts that have zippered or Velcro pockets, vent systems, sun protection, and insect blocker technology. I may appear to be on my way to a fly-fishing tournament, but one thing's for sure: I won't be exposed to the elements. I've contracted the West Nile virus from a mosquito bite before, nearly costing my life, and once is enough.

My other suggestion is to wear a plain cotton T-shirt or tank top under your long-sleeved shirt. That will help draw and collect the sweat from your body and regulate your temperature. If you're wearing body armor, a cotton T-shirt will also provide a little bit of padding between the rigid plates of the vest and reduce chaffing. You may be tempted to try a synthetic sweat wicking T-shirt, but be cautious. There have been cases of people who've received burn injuries that were further complicated when their non-fire-retardant moisture wicking technology shirt melted to their skin. Some companies now offer a synthetic blend that's fire retardant, but I stick to good ol' cotton.

Boots on the ground

During basic training (also known as boot camp), I was issued a standard pair of black leather combat boots. They were heavy and clunky, and took some getting used to. However, I quickly learned they provided a winning combination of grip, ankle support, stability, and foot protection, essential for crossing all types of terrain on foot. Eventually, I went out and purchased a number of my own more fashionable boots from various private vendors such as Danner, Oakley, Blackhawk, and Merrell (which you can see in **Figure 2.10**). I paid a good chunk of change, but they offered improved ventilation systems, softer inserts, winter choices, desert options, and even jungle styles.

I'm not suggesting you slap on some combat boots and march out the front door, but I do advocate combat boot–inspired footwear such as a solid hiking boot. Nowadays, you can shop through a number of good-looking boots that will guide you comfortably and safely over any type of landscape. There are conservative style options for the business casual assignments, too.

FIGURE 2.9 Andy Dunaway demonstrates what he typically wears while on nonhostile photographic assignment. His pants are cargo style with plenty of pockets for batteries and flash cards, and his shirt is convertible from long to short sleeve.

FIGURE 2.10 These are a pair of Merrell hiking boots that offer high ankle support for uneven terrain and deeper tread for better grip on unstable ground—ideal for assignments in mountainous regions.

Insights: My Tootsies

I've tried a number of boot designs by various brands, and I happen to be partial to Danner. All of their boots have solid, durable, and lightweight platforms with mildew-resistant, breathable materials. They come in a variety of color combinations or standard solid color options, too. Depending on your needs and preference, you can get short hiking shoes or taller, military-style boots. My Danner boots have lasted a long time, and I've put them through the ringer. If they can survive me, they can survive anyone.

Cross your heart, ladies

Having an uncomfortable bra will definitely impact a lady's photography. Considering the number of times we put our arms up and down, the likelihood of developing blisters due to an ill-fitted, poorly designed bra is increased. With the added pressure of body armor on top of that, the chances multiply. I've found the best bras for work in the field are cotton blend, seamless, and wire free. I once had an underwire break free and puncture deep into my skin, but I couldn't do anything about it because I was documenting a combat patrol, and there was no place to stop, take off my body armor, remove my shirt, and pull out the rogue wire. Instead, the wire burrowed deeper and deeper the more I moved and photographed. That's when I made the change. As I've said before, stay away from synthetic blend textiles as best you can. Since the bra is closest to the skin, you want to reduce the threat of burn by melting material should you be caught near fire. There are plenty of brands to choose from that make solid, supportive cotton, wireless bras. Check out Fruit of the Loom, Bali, Playtex, Jockey, and Hanes to find the one that's just right for you.

Prepare your accoutrements

Accoutrements are the pieces of a soldier's outfit, usually not including clothes and weapons. These optional accessories will help diminish preventable injury or illness while you cover stories in high-risk locations.

Protect your moneymaker

Don't shoot your eye out, kid. Protect your moneymaker with a pair of glasses like the ones seen in **Figure 2.11**. No, you don't have to wear your sunglasses at night. There are specially designed shatter-proof, ballistic specs with lenses in a variety of tints like clear, yellow, orange, brown, and black. Law enforcement and the military have been using them for years and have prevented eye injuries such as small particles or objects striking or abrading the eye.

FIGURE 2.11 These are a pair of Wiley X protective glasses with clear lenses. Wiley X offers a variety of interchangeable lenses, including prescription versions, tinted, and amber.

Please note that the proper use of safety glasses prevents most eye injuries, but they are not 100-percent effective. Because all materials, including plastic, have a yield point, it is possible for an object moving at a sufficiently high speed to penetrate the glasses. Even if a pair of safety glasses passes rigorous safety testing, there are limits to what safety gear can withstand.

However, I'd rather minimize the risk, so I've kept up the habit of keeping my glasses close. However, it's your sight; it's your choice.

Hear no evil

Where are your earplugs, silly? I wish I'd been more attentive to my ears. I now wear hearing aids because I failed to keep my ears protected from noisy environments. Of course, being in close proximity to massive bomb explosions and constant exposure to machine gunfire didn't help, either. Just remember, once you've killed the nerve endings in your inner ear, you can't bring them back to life; it's permanent damage. The longer you're exposed to loud noises without hearing protection, the worse your hearing loss can become.

The reason I neglected to wear earplugs is that the squishy foam variety, like those featured in **Figure 2.12**, irritated my skin and caused painful pressure. However, I now have custom-made earplugs that are molded for my ears and are made of a soft, nonirritant material I can stand. Although the up-front cost is more than generic earplugs, the long lifespan, comfortable fit, and ease of use of custom earplugs makes them worth the investment. After all, I have to protect what hearing I have left.

At a juncture

Let's face it; we spend a lot of time on our knees. I know that sounds bad, but get your mind out of the gutter. The knees are highly prone to injury, because they are the primary weight-bearing joints in the body. Photographers kneeling down force the knees into flexion, and that puts pressure on the bursas, ligaments, menisci, tendons, and bones of the knee.

When you kneel, help reduce the impact of hard or abrasive surfaces on your knees by wearing a pair of kneepads similar to those featured in **Figure 2.13**. Or you can get pants that have special built-in pockets where small kneepads can be slipped in such as the Tru Spec pants I referenced earlier.

FIGURE 2.13 These are military issue strap-on style kneepads that you wear over the pants. You can get them in nonmilitary camo-patterned materials such as black and brown.

FIGURE 2.12 The disposable orange and aqua style foam earplugs can be purchased at any drugstore nationwide. If your ear canals aren't sensitive, they can be an inexpensive alternative to custom-made earplugs.

Insights: Navigating New Territory

When it comes to navigating locations you've never traveled before, there's one important thing to remember: navigate before you go off course. Get your hands on a map of the local area, because by the time you realize you're disoriented, it's a lot harder to work out where you are and how you'll get back to where you started. It's much easier to navigate as you go, so plan ahead as best as possible. Then, in theory, you shouldn't get lost at all. Have a compass nearby and check it from time to time. I wear a watch with a built-in compass so I know how much time I have and where I'm headed.

I.D. pouch

Securing your personal documents such as a passport, vaccine records, and driver's license is essential. Let's not forget money, too. Using a wallet or purse can be an occupational hindrance, and it can leave you vulnerable to pickpockets. There are several I.D. and passport pouches that can be worn around your neck, underneath your clothing. By selecting a subdued colored pouch and wearing it under your clothes, you decrease its visibility to thieves. A good travel document holder will have an area for passports and itineraries and a wallet area for folding money, coin change, and credit cards.

Watch out

In our world, timing is everything. Even though watches are becoming a rarity these days with the ubiquity of cell phones and other personal electronics, it's nice to have a reliable timepiece while on assignment. There are some cool tech watches out there worth having on your wrist, albeit more for the bonus features than telling time.

If you're on assignment in the middle of nowhere, it's nice to have a watch with a compass, at least. There are more elaborate models like the one pictured in **Figure 2.14**, which boast altimeters, barometers, calculators, timers, altitude alarms, thermometers, chronographs, and even GPS.

FIGURE 2.14 This watch is made by Suunto and features a mineral crystal, tough plastic case, and elastomer strap that can withstand rugged outdoor use and is good in depths of water up to 30 feet.

Take cover

Depending on your shooting environment, you may need a floppy hat to shield your head from the sun or a stocking cap like the one in **Figure 2.15** to keep your ears warm from the cold. Also, if you're in the field for any length of time without a shower, your hair is going to be nasty, greasy, clumpy, and unmanageable. Simply throw a hat over the mess and worry about it later.

Like a glove

As a photojournalist, you may cover stories of wildfires, uprisings, famines, and war. Given the high probability of unsanitary conditions and elevated potential of contracting a disease or infection through cuts on the hand, I advise wearing gloves. Furthermore, when you're in the moment with your camera to your face, you may not be as conscious of your surroundings and accidentally place your hand in broken glass, on hot medal, or in a thornbush.

From a photographer's equipment perspective, body oils and sweat that accumulate on your hands, coupled with dirt and other debris you pick up along the way, can make camera components and lenses soiled and unusable. You can reduce the exchange of debris from hands to lenses by donning a pair of gloves.

FIGURE 2.15 This traditional fleece ski hat is designed to cover your ears and protect you from the elements. It also comes with a matching fleece face scarf for added warmth.

> ### QUICK TIP
> Nomex is a flame-resistant material used to make clothing and outer garments worn by racecar drivers, firefighters, and military pilots. Wearing a Nomex glove can help prevent unnecessary burns that may lead to a hospital visit.

Light the way

Don't get caught in the dark. Depending on where in the world your assignment is, you may have to navigate in blackout conditions, perhaps find gear buried deep in bags, or check your camera settings at night. Don't worry; flashlight technology has come a long way. It seems that not too long ago, a foot-long mag-light style flashlight was considered state-of-the-art. Today's modern flashlights like those shown in **Figure 2.16** are much smaller and more powerful than the flashlights of years past. The flashlight technology has gone from a standard incandescent filament bulb to the more desirable high-power LED bulbs. LED bulbs are definitely the way to go, because they offer longer battery life and are usually up to five times brighter than standard filament bulb flashlights.

FIGURE 2.16 Flashlights like these are activated by a classic tactical tailcap switch, so you press the back button for momentary-on and twist for constant-on. They usually last up to 10 years.

Insights: Don't Draw Fire

A flashlight can be helpful, but it can also be dangerous in hostile environments. If you're holding a flashlight in a dark place, the only thing an aggressor can see is where the source of light is. It's safe to say they'd opt to shoot their weapon at the illumination. If you have the light out in front of you at waist level, it could end in disaster. Try the hands-apart technique to help prevent marking your position. Basically, you'll use intermittent light at random heights—away from your midsection. Activating the light away from centerline, at intermittent and irregular intervals, while alternating the light position from low to high, will confuse your aggressor and also make it harder for them to determine your position.

A headlight-style flashlight like the ones featured in **Figures 2.17** and **2.18** can be handy in our profession for many reasons, but one good motivation is to keep your hands free for the camera. You can affix the headlight to head, hat, or helmet, and most models have a pivoting head with four light output options— including the tactically preferred red filtered illumination. After all, the human eye is more sensitive to some visible wavelengths than others. At night, white light causes the pupil to shrink, thus impairing night vision. Red light does not cause such pupil contraction, so night vision won't be decreased.

FIGURE 2.17 Energizer has numerous lighting products such as this headlight. For general-purpose, hands-free lighting, this light is a great value for the money.

FIGURE 2.18 The red LED light switch is located conveniently on top of the headlight and is great for night vision retention. The on/off switch is sturdy and water resistant and will not turn on accidentally when jostling around your head or in your pack.

QUICK TIP

If you don't have a flashlight or you lost it, don't despair. In addition to being red and grayscale sensitive, your eyes' rods are wired to your brain so they're especially good at perceiving motion. Cones are concentrated in the center of your retina whereas rods are in the periphery, so your peripheral vision really is a different vision mechanism and much more efficient for night viewing. Try this: Avert your direct gaze from where you're trying to see and use your peripheral vision instead. You can't achieve daylight vision results in the dark, but you can get a good bearing and a feel for the relative range.

Five knives and a set of pliers

Though carrying a full-sized toolbox with you to the field is out of the question for photojournalists, everyone can carry a multitool (such as the one featured in **Figure 2.19**) that includes most of the common tools used in normal life. Actually, you can find multitools with knives, saws, screwdrivers, rulers, scissors, can openers, wire strippers, files, electrical crimpers, and more to get some serious MacGyver stuff done. As you can imagine, all of these tools can help you deal with any number of calamities, such as prying a cracked UV filter off a lens. The multitool is also useful in more critical situations; you can snip through barbed wire and shred bandages, for instance.

FIGURE 2.19 This multitool is made by SOG, which makes the only one-handed flip opening and gear-driven multitool. They come in a variety of shapes and sizes, from miniatures to industrial models.

First aid kit

Always have your medical supplies close at hand. You can purchase a first aid kit at drugstores, online retailers, or your local Red Cross office, or you can make one of your own. If you decide to make one, be sure your kit is durable, easy to carry, and simple to open. Try a pouch kit that attaches to your belt. That way, if the time comes, everything you may need is right there in the pouch (**Figure 2.20**).

What to include in your first aid kit

* Medical gloves
* Tourniquet
* Primed compressed gauze
* Medical tape
* Emergency bandages
* Alcohol wipes
* Iodine ampules
* Antibiotic ointment

FIGURE 2.20 This is my Elite First Aid 44-piece Individual Military First Aid Kit. You can purchase one like this at an Army surplus store or online at several outdoor sports shops. I take the contents out of the plastic box and put them in a big Ziploc, which then goes in a pocket of my shooter's vest.

Cover your noggin

Protective helmets are one of the oldest forms of shielding equipment. Modern-day helmets use state-of-the-art Kevlar to provide better protection against bullets, particularly those fired from handguns. Helmets weigh about 3 pounds and are designed for comfort. Believe it or not, they use the same padding and cushion systems as those found in bicycle helmets. The advanced combat helmet models are the latest and greatest designs. They are lighter and smaller than previous designs and have better shock absorption capabilities (**Figure 2.21**).

QUICK TIP

Proper helmet size, fit, and stability are critical to your mission and safety. If the helmet sits too low on the head, it interferes with your eyewear and field of vision. If it rides too high, you increase your risk of getting wounded by shrapnel from an explosive or a mine. If it's loose and unstable, it's a constant hindrance.

Steps for getting sized up:

1. Measure the length of your head by using a caliper measurement device. Place one leg of the caliper between your eyebrows and the other on the back of your head. Slide the caliper up and down the midline of your head until you find the greatest length.

2. Use the same caliper to measure the width of your head. Place the caliper legs on either side of your head and measure the greatest width.

3. Wrap a measuring tape around your head just above the eyebrows and ears. Pull the take snug for better accuracy.

4. Use these combined measurements to select the proper helmet size. If you fall between sizes, choose the next size larger.

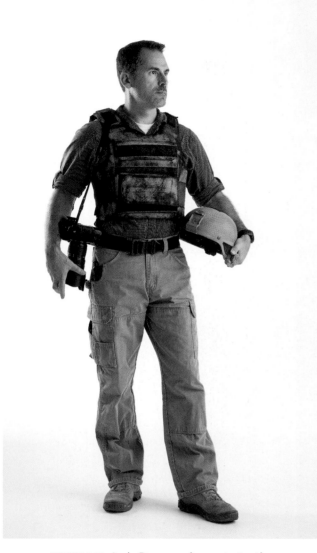

FIGURE 2.21 Andy Dunaway demonstrates the armor and helmet he typically wears while in high-risk environments on assignment. He has opted to paint his black helmet a desert tan pattern to reduce the heat absorption from the sun and improve environmental amalgamation. He also has glued Velcro patches to the outside so he can affix infrared (IR) glow squares and blood type patches. IR patches can protect you from friendly fire in the battle space at night by showing up brightly on night vision equipment used by military soldiers and aircraft.

5. Be sure the helmet's inner padding touches your head. Ill-fitted padding can cause unnecessary rotation when you move.

Individual Body Armor

Individual Body Armor (IBA) is a modular system that consists of an outer vest, ballistic plates, and attachments that increase the area of coverage. IBA increases survivability by stopping or slowing bullets and fragments and by reducing the number and severity of wounds.

Most body armor systems are made up of two modular components: the outer tactical vest and small arms protective inserts, or plates. Most are unisex and equipped with removable throat and groin protectors, as well as front and back removable plates. They vary in weight and protection, depending on the type.

QUICK TIP

Small Arms Protective Insert (SAPI) plates provide additional protection for vital organs. They are individual ceramic plates placed into special pockets in your IBA. SAPI plates worn in your IBA come in front and back plates, which are identical, and smaller plates to cover your sides. More advanced plates such as the ESAPI and XSAPI help prevent injury from even higher velocity threats and provide more coverage.

Photojournalists in dangerous areas tend to wear traditional bulletproof vests that surround the torso and core of the individual, protecting the vital organs. Most aggressors have been taught to shoot for the center of mass, or the center of the chest, to strike vital organs where a miss of several inches can still incapacitate the target. Additional armor can always be helpful at times in these environments, but the drawbacks are additional weight, less mobility, and increased heat (**Figure 2.22**).

FIGURE 2.22 As the Army unit she's documenting takes a break during a combat patrol, military video journalist Kathryn Robinson rests her back to relieve the pressure caused by SAPI plates pressing into her lower abdomen.

Lens (mm): 26, ISO: 200, Aperture: 2.8, Shutter: 1/350, Program: Aperture Priority

Insights: Vests with Cup Sizes

Most vests on the market are considered unisex and can cause much discomfort for women who are more endowed in the chest region. That's why I suggest armor that's tailored for females. SAVVY body armor makes a vest that has the contours of breasts built into their designs. They call it Radial Offset Pleating, and it's amazing—no more smashed boobs and shallow breathing. Plus, the shoulders are narrower, torso lengths are shorter, and the waistlines are tapered—all to accommodate a woman's build.

Other types of body armor

- **Kevlar stab-proof vests:** The stab-proof vests will prevent you from becoming injured if you are in close contact with someone who is trying to stab you in the abdomen or chest. If you work in close proximity to people who could try to injure you in such a way, the stab-proof vest may be ideal for you. They are lightweight, come in different sizes, and are available in many colors. They will allow you to move freely and not feel bogged down.

- **Rifle round protection:** The rifle round protection will ensure that someone is as protected as possible from the rifle assault and will be able to still react to the situation. The rifle round protective body armor is a bit heavier than most body armor because it offers more protection.

- **Kevlar soft armor:** The Kevlar soft armor vests are ideal for anyone who wants protection from small arms fire without everyone knowing they are wearing the protection. The soft armor comes in a variety of colors and is made to fit both male and female physiques.

Many people are not sure how to choose the correct size of body armor for themselves. A normal bulletproof vest is designed to protect just the wearer's vital organs from attack, not their complete torso. As such, a bulletproof vest should normally hang to around your navel area, not down to your groin. People are often surprised when they first try on a piece of body armor, as they expect them to be a lot longer than they are. Obviously being shot or stabbed in the lower stomach area would not be a pleasant experience, but it would also not be a life-threatening one. Another reason for the armor only reaching the naval area is for comfort and mobility (**Figure 2.23**).

FIGURE 2.23 Personal body armor can be heavy, and coupled with constant physical exertion and added weight of camera gear, it can tire even the most young and fit photojournalist, like military video journalist John Hoffmann. That's why it's even more imperative to get the best-fit armor for your body type.

Lens (mm): 19, ISO: 200, Aperture: 7, Shutter: 1/200, Program: Aperture Priority

Steps for getting sized up:

1. With arms at your sides, measure completely around the chest at nipple height. Be sure to keep the tape at an equal height around the chest. Wider vests give more coverage, but less freedom of movement and less ventilation.

2. Measure completely around your waist just above belt height. Stand normally and do not suck in your stomach or hold your breath. The idea is to have the front and back panels close to touching at the sides. You may want an inch or so of overlap on the sides to get more side coverage, plus extra blunt trauma protection with the stronger overlap connection between the front and back ballistic panels. This is standard for tactical-style armor worn on the outside, and popular with concealable vests worn for shorter periods of time.

3. For the torso, measure from the second button on your shirt to above your belt in sitting position. Sit comfortably. Do not sit slouched or rigidly upright.

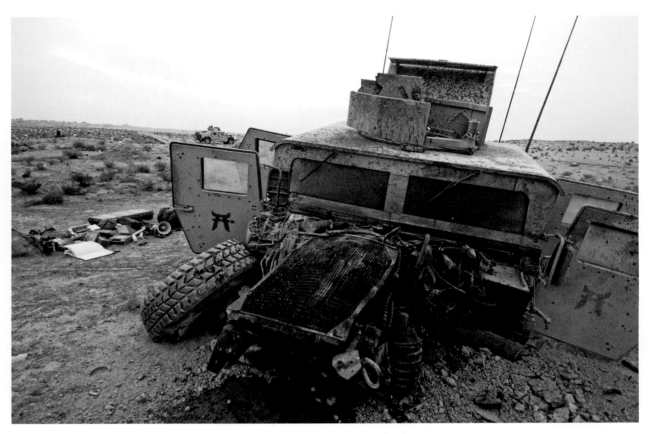

FIGURE 2.24 An improvised explosive device (IED) destroys a military tactical vehicle while traveling a dangerous road in Iraq. IEDs are easy and cheap to build and can be made with simple ingredients such as fertilizer. They are nondiscriminatory and hit military and civilian vehicles alike. Injuries sustained from IED blasts such as this one can result in the loss of limb, brain trauma, and, in some cases, your life. (Photo by Andy Dunaway)

Lens (mm): 14, ISO: 800, Aperture: 4, Shutter: 1/60, Program: Manual

Insured Out the Wahzoo

Don't be a fool; insure your tool. It would be naïve to think a camera could shield you from harm. I should know; I've been wounded in combat twice. That's why it's important to have a good insurance plan before you leave home. Depending on which level of insurance you choose, coverage may include worldwide assistance, medical expenses, personal assistance, travel incidents, legal assistance, bail, non-professional acts liability, loss, theft or destruction of luggage, and accidental death or disability (**Figure 2.24**).

Types of insurance to consider:

- **War risk and terrorism coverage** provides otherwise unavailable insurance for acts of war, terrorism, or kidnap and ransom in areas of political unrest. This type of insurance is also referred to as special risk insurance. Be sure your policy covers accidental death and dismemberment due to acts of war.

- **Emergency evacuation and repatriation coverage** provides for medically necessary evacuation to a medical facility, medically equipped flights to return home, or the repatriation of mortal remains to your primary residence.

- **Disability income insurance** helps pay your bills by replacing a portion of your income in the event you are injured on assignment. It can help you maintain your current lifestyle and help protect you and your family from going into serious debt.

- **Public liability insurance** is vital if you come into contact with members of the public during the course of your work. If you cause injury to a person or damage to their property while you are working, public liability insurance can cover the cost of a claim made against you.

- **Worldwide camera property insurance protection** is designed to protect the described property against all risks of direct physical loss or damage with the customary policy exclusions.

QUICK TIP

By completing a legitimate survival course, you may be eligible to receive a reduction in personal hostile environment insurance rates, accident insurance policies, and medical repatriation benefits.

Personal Hygiene and Comfort

Personal items taken on long assignments away from home may make life a little better. What you pack, and the amount that you pack, may be influenced by personal preference, type of assignment, trip location, and the number of times you are required to change locations. My recommendations are simply general suggestions for long assignments abroad.

QUICK TIP

Apple's iPhone has a variety of applications and features at your fingertips. In addition to running a large number of photography-friendly applications, the iPhone allows you to make international calls. You can use international calling on an iPhone if your carrier and plan, as well as the cellular network of the country you are in, supports international cell phone calls.

FIGURE 2.25 Military video journalist James Monk finds an opportunity to use a land line to call home and talk with his family while in Iraq. (Photo by Andy Dunaway)

Lens (mm): 20, ISO: 400, Aperture: 4, Shutter: 1/15, Program: Manual

FIGURE 2.26 Amusement doesn't have to be limited to tablets and Walkmans. If you have a gaming handset you like or a musical instrument that's small and portable, think about packing it, too. Since his assignment in Iraq was over 4 months, military video journalist James Monk brought his small guitar to practice his music and stay entertained between stories. (Photo by Andy Dunaway)

Lens (mm): 17, ISO: 400, Aperture: 4, Shutter: 1/40, Program: Manual

Bring tools for downtime

You'll want to be sure you have the ability to call back home, whether that's to your editor or your family. Some cell phones now allow you to make international calls for a chunk of change, but nothing beats an old reliable phone card. You can purchase a variety of prepaid phone cards for discounted call rates. The biggest draw of prepaid calling cards is their convenience. They can be used anytime, anywhere. You can be at home, in your office at work, in your hotel room, or even at a pay phone. An additional convenience that prepaid phone card suppliers offer is that you can purchase an international phone card on the Internet, which can mean instant phone card activation. And with this system, you don't even need a card—all you need is your access number (**Figure 2.25**).

Some remote locations don't have accommodations with televisions, so bring a digital tablet such as an iPad, Nook, or Kindle with movies, games, and books to keep you entertained during travel and downtime. Aside from visual media, I usually have an MP3 player with my preferred playlist for when I work out, edit photos, and sleep. I've bunked with a roommate who snores and have had to drown out the symphony. I suggest you have one, too, in case you run into the same problem. There are plenty of reasonably priced MP3 players on the market such as an iPod, Sony Walkman, or SanDisk Sansa Clip Zip (**Figure 2.26**).

Bed, bath, and beyond

Some locations may not have brick-and-mortar facilities like the one featured in **Figure 2.27**; they may be tents or perhaps have no showers at all. In cases like these, you can make a simple and convenient shower so you can stay clean on your assignment.

Insights: iUse

I use Apple products. The convenience of having one charger that fits on my phone, MP3 player, and tablet reduces the amount of cords and docks I have to lug with me on the road. I also know they're compatible with my Mac laptop, should I have to do any software updates.

FIGURE 2.27 At a military compound in Iraq, someone bathes in a shower facility. (Photo by Andy Dunaway)

Lens (mm): 19, ISO: 100, Aperture: 4, Shutter: 1/125, Program: Manual

Steps for making a quick shower:

1. Find a large bottle, preferably one liter or bigger.

2. Fill the bottle water with potable water, if possible.

3. Let it sit in the sun to warm.

4. Get rope, like a 550 cord or a long shoelace, and tie one end to the top of the bottle.

5. Hang the bottle from a tree branch, pipe, or whatever you can find that's high enough to stand under and that secluded enough to give you some privacy.

6. Use a knife or multitool to poke small holes in the bottom of the bottle and wash fast.

Toiletries

The traditional "Dopp kit" was created in 1919 by Jerome Harris and is a folding leather toiletry case. It grew popular during World War II, when the U.S. Army issued millions of them to soldiers. Its compact case makes it ideal for packing and travel, and you can fill the reusable small-sized containers with your favorite brands of soaps and shampoos. You don't have to get a Dopp kit per se, but you can make your own, tailored for your specific needs. I have a nylon toiletry bag with several pockets for all my items, and a hook to hang it in the bathroom. It easily folds and zips for secured, compact travel.

Items to consider for your toiletries case:

- **Bar soap with protective container:** First of all, bar soap takes up less room than a plastic bottle and can be stored in a plastic travel box between uses. It also comes in a huge variety of options, but I suggest sticking with a soap that has little fragrance because some smell may attract the local bugs. Instead, go for a bar soap that promotes antibacterial properties such as Dial, Lever 2000, Cetaphil, or Safeguard to help wash away those unseen health hazards.

- **Shampoo/conditioner:** Some products on the market combine shampoo and conditioner, so you can conveniently eliminate one extra step in the shower while also saving room in your toiletry kit. If you're working in a desert environment, or perhaps high altitude, you may consider getting a 2-in-1 that's medicated to help prevent scaling and dryness.

QUICK TIP

Just like bar soap, there are shampoo and conditioner bars that are compact, store easily, and travel well. They come in condensed solid bars that last for ages. You don't have to worry about a plastic bottle cracking or leaking all over other personal items.

QUICK TIP

When water isn't available, try a waterless shampoo. This foam product "refreshes" your hair by removing excess oil, impurities, and odor while moisturizing it, too. It's no replacement for using soap and water, but it will get you through in a pinch.

- **Antiperspirant/deodorant:** Let's face it, you're going to be running around taking pictures and working up a sweat. Don't end up smelling like a bologna sandwich because you forgot to pack deodorant.

- **Nail clippers and file:** Keep your nails short while operating in Third World environments. Nails can trap lots of germs that transfer to your mouth while eating or enter your body through open wounds or scratches. Some dirt carries roundworm larvae that can enter the body this way, too. These eggs can hatch and the larvae may penetrate the intestinal wall and enter the bloodstream in the veins. In summation, keep your nails short and your hands clean.

Ladies, I suggest removing artificial nails before heading to the field on assignment. The glue used to adhere the fake nail to your real nail is stronger than the natural connective tissues between your real nail and the nail bed. Therefore, if you accidentally jam a finger you run the risk of causing injury or ripping a nail off altogether. Tears to the nail bed caused by fake nails can lead to the growth of fungus, bacteria, and infection, none of which are easy to treat in austere conditions.

- **Toothbrush with protective cap:** Routine toothbrushing and toothbrush maintenance are important considerations for sound oral hygiene. Depending on the location of your assignment, you may not have potable drinking water, so I recommend brushing your teeth with bottled water instead. Be sure to rinse your brush thoroughly, shake off the excess water, and store it in a vented protective container.

QUICK TIP

Soaking toothbrushes in an antibacterial mouth rinse after use also may decrease the level of bacteria that grows on toothbrushes.

- **Toothpaste:** Keep bacteria in check by brushing well twice a day with a good toothpaste, and floss once. Also, reduce the amount of fermentable carbs you eat such as sweets, chips, crackers, and other refined foods.

- **Dental floss:** A healthy mouth can help prevent serious diseases, some of which can be life threatening. Unlike a toothbrush, which cleans the tops and outer surfaces of the teeth and gums, floss can reach the tight spaces between the teeth and the gap between the base of the teeth and the gums.

- **Brush/comb:** If keeping your lovely locks in place is a priority, don't forget to bring a brush. There are some great options out there that combine a mirror, comb, and brush into one unit. Salon Selectives, Goody, Denman, and HairArt all make various styles of brush/mirror combinations.

In the shower

You may end up in a location where towels and washcloths aren't available, so I suggest packing your own just in case. The downsides to packing regular house towels are their bulk and that they take forever to dry. Try a travel towel. They weigh less, dry faster, and are significantly smaller in width and length than regular towels. They come folded and compact with their own travel pouch.

There are alternative towel solutions such as McNett MicroNet Advanced Microfiber, Aquis Adventure Microfiber Towel, and the Sea to Summit DryLite towel. The microfiber towel is smaller than a regular bath towel but bigger than the average travel towel. Its material can be a little sticky when you're drying your body, and it is not the softest fabric. The Aquis is the closest to a real towel you're going to get, and it absorbs a lot of water. However, it can take the longest to dry. The DryLite is a soft travel towel that's lightweight and dries quickly.

QUICK TIP

Travel towels are generally small, so you most often have to go up a size larger to get the sized towel you're accustomed to. XL really isn't a plus-sized beach towel—it's a smaller one that just wraps around your body.

On top of having a good quick-dry towel, I highly advise getting a pair of flip-flops—and not for the beach. I suggest wearing flip-flops in foreign and public showers for many reasons. Showers are an ideal place for bacteria and fungi to grow. They're moist environments where athlete's foot and other crazy foot conditions can lie in wait for you. You aren't at home, and there's no way to know what other people do in the shower—and you probably don't want to know because some people have *really* disgusting shower habits. You can pick up a cheap pair of plastic flip-flops for next to nothing. Wear them in any bathroom environment to protect yourself. After you've showered, set them out to dry to prevent the growth of bacteria.

Lastly, you might want to consider a shower caddy. If you're living in a tent city situation, you may be showering in a community-style wash area where you're required to haul your shampoo, soap, razors, and other bathroom items back and forth from your living area to your shower tent. A small plastic shower caddy may make this routine easier. Most caddies have ample room for your shower soaps, a handle for you to grip, and several holes for the water to drain. This gives you the ability to take your caddy right into the shower with you and then store it fully stocked between uses.

Other hygienic matters to consider:

- **Feminine hygiene products:** For the most part, a woman can find places to purchase feminine hygiene products no matter where they are in the world. However, because of religious restrictions or other customs, some countries may not carry tampons. You may run into inventory shortage, or perhaps they won't have your preferred brand. I usually pack enough of my favored product to last for the length of my trip.

- **Razor and shave cream:** Your hair is going to keep on growing whether you're on assignment or not. For guys and gals, you may want to pack a disposable razor or two. I even recommend picking up an electric razor just in case there's a water shortage. After all, dry shaving is never pleasant (**Figures 2.28** and **2.29**).

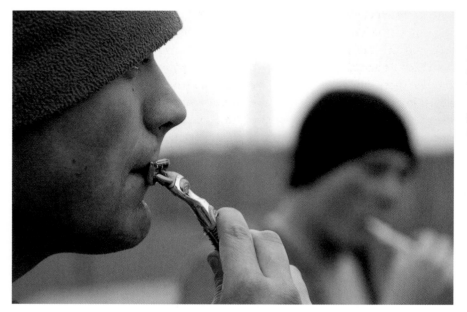

FIGURE 2.28 On a cold morning in Iraq, a soldier shaves his face with a disposable razor, cold water, and no mirror.

Lens (mm): 55, ISO: 640, Aperture: 2.8, Shutter: 1/400, Program: Manual

FIGURE 2.29 Because water is scarce and bathroom facilities are a far distance to travel on foot, James Monk uses a cordless electric razor to shave his face in his temporary living quarters. (Photo by Andy Dunaway)

Lens (mm): 22, ISO: 400, Aperture: 2.8, Shutter: 1/50, Program: Manual

FIGURE 2.30 Without any vanity mirrors in the shower tent, Jessica Young uses a handheld mirror to pluck her eyebrows in her tent at a U.S. camp in Harar, Ethiopia.

Lens (mm): 70, ISO: 400, Aperture: 2.8, Shutter: 1/400, Program: Manual

◆ **Lotion:** If your body isn't accustomed to a certain climate or altitude, you may end up with scaling or flaky, dry skin. I suggest packing an oil-based lotion such as argan oil, coconut butter, or shea butter.

◆ **Lip balm:** Your lips endure the brunt of sun, wind, cold, and dry air exposure, which may lead to chapped lips. Once moisture is drawn from your lips, they become fragile and may develop tiny splits and cracks. These tiny tears are what make chapped lips so painful. To best keep your lips saturated and protected, keep a tube of UV protection, moisturizing lip balm in your pocket.

◆ **Bug repellent:** Insect repellent helps reduce your exposure to mosquito bites that may carry West Nile virus or other diseases, and allows you to continue to work outdoors with a lower risk of disease contraction. I like repellents that use at least 20 percent DEET. The Repel brand makes all types of DEET-based repellents in convenient travel-sized spray bottles or wet wipes.

◆ **Camping mirror:** If you need to see your face while you shave, a mirror might be helpful. There are small, portable, collapsible camping mirrors such as the one made by Coleman that can be hung, clamped, or stood on just about anything (**Figure 2.30**).

◆ **Powder:** Body powders such as Gold Bond and Shower to Shower are designed to relieve itching and keep your body cool and dry when you perspire. Several types of body powders are available such as medicated, original, and extra strength. Some powders you can use on your entire body, including your unmentionables and your feet.

◆ **Hair ties:** Elastic bands, or ponytail holders, can break or get stretched and unusable over time. Pack a couple extra in your bag or wrap them around the handle of your hairbrush for safekeeping.

In the Trenches: Aunt Flow

Guys, you may want to skip this section entirely. However, ladies may find this educational. As a woman working in remote locations, I know the unique challenges ladies face when Aunt Flow comes to call. If you're a guy and still reading this, "Aunt Flow" is a nickname for a woman's period. At any rate, my assignment demands didn't diminish because my period came, so I had to be creative in how I was going to deal with the "changing of the guard."

Before I'd head out on assignment, I'd set out a box of small plastic sandwich bags, a box of tampons, and a box of tissues. I'd take one bag and stuff it with a new, unwrapped tampon and four tissues. Then I'd press all of the air out until it was as thin as paper. If the combat operation I was documenting lasted an entire day, I'd prep four or five of these to-go bags. However, if the assignment were multiple days, I'd prep accordingly and stick the smaller individual plastic bags in a larger bag. I'd store the to-go bags in a front pocket of my shooter's vest, next to my spare camera, for easy access.

While the opportunity presented itself in the field, I'd take my little to-go bag to a private area, whether outside or in a bathroom, and make the change. I'd wrap the soiled item in one tissue and place it in the plastic bag, then use the rest of the tissue on my person. I'd seal the soiled contents tightly in the plastic bag and place it back in my bag. This sounds disgusting, but I had little other option. Because I was in Iraq, the plumbing systems couldn't handle flushing down the bulk of a tampon, nor was I going to leave a mess behind in someone's backyard if I was forced to go outside. I just held onto my waste until I found a proper receptacle and discarded it then.

Insights: Monistat

For long trips, I used to pack athlete's foot cream and yeast infection cream just in case. However, after reading the active ingredient in both tubes was Miconazole, I figured I wouldn't double my efforts anymore. Instead, I opted to just bring a larger tube of Monistat. On one trip in particular, the community showers in tent city were backed up with standing water and I contracted athlete's foot. I began a daily regime of rubbing Monistat between my toes and it cleared over time. I never did need it for the other purpose, but I felt comforted by knowing I could treat myself if the problem arose.

FIGURE 2.31 This is a sketchy bathroom facility located somewhere in Afghanistan that American personnel share when nature calls. If you're stuck on the toilet because you didn't bring antidiarrheal pills, you and a toilet like this may become longtime friends. (Photo by Andy Dunaway)

Lens (mm): 17, ISO: 400, Aperture: 2.8, Shutter: 1/40, Program: Manual

Medicine cabinet

As you pack, be sure to consider what ailments you might face on the road. I'm not a hypochondriac, but I do play it safe. I suggest getting your preferred medications stashed in small bottle and keep them with your toiletries. However, be sure to grab a few dosages and keep them with you for the trip. After all, you never know when a headache or diarrhea will strike (**Figure 2.31**).

Basic over-the-counter medication checklist:

- Aspirin, Tylenol, or Motrin
- Decongestant like Sudafed
- Antihistamine such as Benadryl
- Antidiarrheal treatment similar to Imodium
- Antacids in the vein of Tums

FIGURE 2.32 Military video journalist Mike Hasenauer prepares to wash laundry in Baghdad, Iraq. He uses a simple white polyester bag that holds a giant load of laundry. It has a drawstring closure and an easy-carry handle so laundry days are less of a hassle. The polyester mesh fabric allows air to flow through to help eliminate smells and dampness, and it's machine washable. (Photo by Andy Dunaway)

Lens (mm): 17, ISO: 400, Aperture: 2.8, Shutter: 1/40, Program: Manual

Out on the line

As you dirty clothes, I suggest storing them in a breathable laundry bag—the mesh kind you can stick straight into a washing machine like the one in **Figure 2.32**. This helps keep your dirty clothes segregated from your clean items. Also, be sure to bring powder laundry detergent, which you can store in a plastic bag for travel. Your other option is to try laundry soap sheets. Most laundry soap sheets come with enough for 50 washes and are stored in a compact carry-on compliant container. Weighing less than 1 ounce, they're biodegradable soap sheets that are easy to use when hand-washing clothes in sinks, tubs, buckets, or bags.

If you're traveling in well-developed countries, you will most likely be able to use a laundry service such as the one featured in **Figure 2.33** or find a self-service laundry facility. However, sometimes you will not be able to do your laundry, so it pays to know the best ways to wash your clothes while traveling. You can use a bucket with soap, scrub your clothes in the shower, or use a watertight bag such as an aLOKSAK.

aLOKSAK bags are element-proof storage bags featuring a hermetic seal. No water, air, dust, or humidity permeates the enclosure. They are puncture-resistant and come in a number of sizes, but I recommend using the 12 x 12-inch bag to wash your undergarments—socks, bras, and underwear. You can get a larger bag if you want to wash larger garments as well.

FIGURE 2.33 Choukri Ibrahim Bouh checks the inventory list as she takes the clothes out of the laundry bag and puts them into the washing machine at the KBR laundry facility located on Camp Lemonier in Djibouti, Africa.

Lens (mm): 12, ISO: 800, Aperture: 4, Shutter: 1/20, Program: Manual

aLOKSAK hand-washing technique:

1. Toss your dirty clothes into an aLOKSAK; be sure to leave enough room for water. If you have a lot of clothes, you'll probably have to do more than one load.

2. Fill your aLOKSAK with enough water to soak the clothes.

3. Drop in a laundry soap sheet or laundry powder.

4. Kneed the clothes for 2–3 minutes, or longer if you prefer.

5. Leave the clothes in the aLOKSAK for 10 minutes.

6. Rinse the clothes.

7. Once you have rinsed your clothes, twist them to extract as much water as possible. Roll up your clothes up in a towel and step on them to remove the water that's left.

8. Hang your clothes to dry. I recommend travel clotheslines. They are essentially two long elastic ropes twisted around one another, and you pinch and hang your clothes between the cords—no clothespins required. String your line outside in the sun if possible or near a breezy window.

CHAPTER 3

GEAR ESSENTIALS

You don't have to use the latest and greatest cameras on the market as long as what you have produces decent quality photographs and fulfills the requirements of assignment demands. After all, it's hard to "keep up with the Joneses" on a photojournalist's budget. However, it's important to have a solid, operable camera kit because in most cases, you can't run to the store and pick up a replacement part or substitute lens.

This picture was taken during a shoot on the flight line at Charleston Air Force Base, South Carolina. Taking well-exposed portraits of aircrew members in front and inside their aircraft required the use of portable studio lights.

Lens (mm): 32, ISO: 200, Aperture: 2.8, Shutter: 1/5000, Program: Aperture Priority

FIGURE 3.1 This picture was taken while I was on assignment to document the Ordinance of Secession Gala in Charleston, South Carolina, and the subsequent protest march by members of the National Association for the Advancement of Colored People. Since the events were happening simultaneously and I had to move from location to location, I used two cameras and my camera backpack, where I stored my spare batteries, flash cards, and some small strobes. (Photo by Andy Dunaway)

Two Camera Bodies

I shoot with two camera bodies (**Figure 3.1**). The principal reason for this is that in case my primary camera breaks, I have another lens at the ready on the secondary camera for a varied focal length option. I'm a Nikon shooter, but it doesn't matter whether you prefer Nikon or Canon; the point is to always have a backup. Your two camera bodies should be the same frame size. For example, I have two full-frame (FX or FF) sensored cameras that operate with the same battery system. Shooting with two cameras allows me the convenience of using the same FX lenses on both bodies while requiring only one battery charger. In short, there are no adaptability problems and I pack fewer cords.

Three Essential Lenses

Some photographers prefer to use prime lenses because they're shorter and lighter, and they come in wider aperture options such as f/1.4. I have my own inventory of prime lenses I like to shoot with when I'm on assignment here in the states. They challenge me to think in terms of fixed focal length and to use my feet to zoom in and out. But when I travel abroad on assignment, I don't lug around any lenses that I may use only once or twice. I choose to take what's necessary to achieve the story.

For foreign editorial assignments, I shoot primarily with three well-rounded, fixed f/2.8 aperture lenses—the Nikkor 14-24mm, 24-70mm, and 70-200mm lenses. I keep the 24-70mm lens on my primary camera and the 70-200mm lens on my secondary body. The 14-24mm lens is stored in the front pouch of my shooter's vest, ready when I need it.

Wide-angle lens

When I refer to wide angle lenses, I do not mean fisheye lenses. I prefer to shoot with a Nikon 14-24mm lens, which maintains straight lines even at its widest focal length. With my wide-angle lens, I can follow the story into the smallest rooms and document the entire setting. I can also find a high vantage point to cover the overall picture of the scene, also known as an establishing shot.

Normal lens

If you are shooting a full-frame camera, a normal lens would be considered 50mm, so the 24-70mm zoom lens encompasses a normal view perspective while also covering other angles. It's my go-to primary lens for this reason. I've always preferred to shoot the story as I see it through my eyes, and I find the 24-70mm helps me best achieve my vision.

QUICK TIP

In photography, a lens with a focal length about equal to the diagonal length of the film or sensor format is considered a normal lens. For FX cameras, that would be 50mm and for smaller, DX sensors, that would be about 28mm.

Telephoto lens

There are times when you just can't get close enough, or perhaps the background is too distracting. The best alternative is to shoot with a telephoto lens, which is why I keep my Nikon 70-200mm lens on my secondary camera at all times. If the maximum focal length of 200mm isn't enough, try adding a 1.4 or 1.7 teleconverter.

A teleconverter increases the focal length of your lens and mounts between your lens and camera body. A 1.7 teleconverter will multiply the focal length of your lens by its magnification. Thus a 200mm lens becomes a 340mm lens. In addition, teleconverters cut the amount of light by whatever their factor is, so a 2x teleconverter takes away 2 stops of light. However, a teleconverter is a smaller, lighter-weight alternative to a 400mm lens.

QUICK TIP

Invest in a telephoto lens with a fixed aperture of f/2.8 and vibration reduction (VR). When your adrenaline is flowing, your hands have a tendency to tremble. VR can help reduce the vibrations of your hand tremors, plus the farther the distance you are zooming, the more shake there will be. The fixed f/2.8 aperture will also give you the extra bit of light you need to hold the long, heavy lens for longer exposures in dark environments.

In the Trenches: Shrapnel Catcher

I was on a mission with an Army unit in Iraq. Their goal was to take control of a small building that housed suspected al-Qaeda foreign fighters and apprehend the men who occupied the premises for questioning. It was going to be a precision operation: Get in, clear out. But before we even dismounted the vehicles, one of the trucks in our convoy rolled over an improvised explosive device (IED), and gunfire rang out from the direction of the suspected terrorists' headquarters. American soldiers began popping yellow and purple smoke to mask their movements as they disembarked from their vehicles.

I had one camera around my neck, another over my left shoulder, and my right hand free to grab my gun that was holstered on my right thigh. I ran along with the squad I was assigned to document during the operation, and we made our way from the vehicles to a house situated adjacent to the target. The soldiers cleared each house nearby from ground level to roof, just to make sure there were no fighters attempting to flee or hide (**Figure 3.2**). As we made our way closer to the target building, the threat from small arms fire, mortars, and rocket-propelled grenades (RPGs) intensified. I heard the distinct whiz and clack sound of bullets flying past my head and hitting the walls behind me.

With heavy resistance slowing progress, the soldiers decided to stop at a nearby house to better observe the situation. We breached the outer courtyard gate and entered the front yard garden. I heard a high-pitched whistle over my shoulder heading in our direction, and I knew immediately I needed to haul ass. Just as I stepped through the entrance of the house, an RPG impacted the side of the dwelling. It scattered debris in all directions and threw shrapnel at lethal speeds. My lens, or at least my UV filter, was a casualty.

We hurried to the rooftop where the soldiers settled in to call in tank and air support. Meanwhile, I rendered first aid to my lens. My Tiffen UV Protector was shattered, but I was surprised to see that it didn't break apart. The filter's internal lamination prevented it from disintegrating into a thousand small shards and therefore thwarted any potentially irrevocable damage to my much-needed lens. I whipped out my multi-tool pliers and unscrewed the filter without incident. Luckily, I carried a spare UV filter in my shooter's vest. I got back to taking pictures just in time to document the detainment of the culprits who nearly ruined my favorite lens.

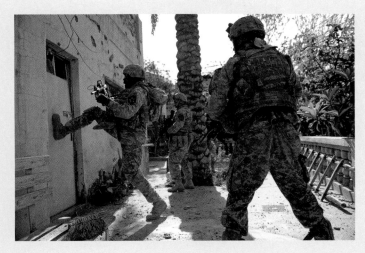

FIGURE 3.2 A U.S. Army soldier tries to breech a door by kicking forcefully while his teammates stand guard in Diyala Province, Iraq.

Lens (mm): 17, ISO: 100, Aperture: 2.8, Shutter: 1/800, Program: Aperture Priority

Filter from the Elements

Be sure to protect your lenses with a high-quality UV filter. As photojournalists, we expose our equipment to multiple hazards, from flying projectiles to excess dust and debris. Instead of allowing our expensive glass elements to take the brunt of the scratches, why not let a much cheaper filter take the hit? UV filters can be kept on your camera at all times and are ideal in helping to protect your lens against dust, moisture, fingerprints, scratches, and damage while also reducing UV light.

Speedlight

Depending on the assignment, I may be required to add a little light to a scene or perhaps take a portrait on the fly, as shown in **Figures 3.3** and **3.4**. That's why I always have a strobe or two handy. I'm not a big fan of on-camera flash, which is why I tend to use a two-light setup at least. My Nikon SB-910 AF Speedlight i-TTL Shoe Mount Flash allows me to set one as the master controller on my camera and the second as my remote flash off-camera. I either handhold the off-camera flash several feet away for more pleasing light direction, or place the strobe on a 175F Justin Clamp with flash shoe or one of my lightweight Manfrotto air-cushioned light stands like those in **Figure 3.5**. The Justin Clamp gives me the freedom to clip my flash on all types of objects such as light fixtures, tables, curtain rods—you name it. However, with the light stand setup, I can use bigger modifiers such as the Lastolite Ezybox Softbox. All three options offer their own unique advantages: by handholding the flash, you're able to move about quickly and change your angle of view; using a Justin Clamp gets the flash out of your hand and offers more lighting variety; and using a stand alleviates any concerns about finding a sturdy object to attach the Justin Clamp while also giving you the capability of employing more sophisticated light modifiers. As the photographer, it's your choice to decide what look you want to accomplish and what tools will help you achieve your vision.

While covering stories in the war zone, I rarely used a strobe. I kept one in my shooter's vest just in case the situation called for it. I can recollect one such time when I was documenting a mass casualty site, and I needed to be sure the bodies were lit evenly for forensic purposes. In this case, I wasn't worried about the style or direction of the light, or whether the pictures were "pretty." I simply needed to achieve accurate documentation of the scene.

Using flash in high-risk environments can be dangerous. By popping a strobe, you're giving armed assailants an easy target to spot; basically you're a neon sign flashing "Shoot here, shoot here!" Just be sure when you slip the flash on your hot shoe that it's the right time and place for it, and you're not going to endanger yourself or the others around you.

> ### QUICK TIP
>
> Most small strobes require AA batteries, so be sure to include them in your packing list. I suggest investing in rechargeable batteries so you don't have to worry about procuring any while on the road—you can simply stick them on the charger. I use the Maha PowerEx brand because they can withstand extreme temperatures, take multiple recharges, and last twice as long as other rechargeable batteries.

FIGURE 3.3 Under a carport at a local veteran's homeless shelter and transition program, I set up a white background with a collapsible Manfrotto Backdrop Stand and white paper. I used two small strobes on either side of the backdrop and aimed them at my subject's ears. This created an accent edge light. I then used a third small strobe with a softbox that I set up on the camera's right as my main light source.

FIGURE 3.4 This portrait of a homeless veteran was taken as part of a portrait series for a story about occupational rehabilitation programs.

Lens (mm): 70, ISO: 100, Aperture: 2.8, Shutter: 1/250, Program: Manual

FIGURE 3.5 I was given an assignment to document a physical therapist at her workplace, and the story required a portrait to accompany the piece. I didn't have much time or space to shoot the portrait, so I chose to bring my small strobe light setup. To achieve the look I wanted, I used four flashes—one with a softbox.

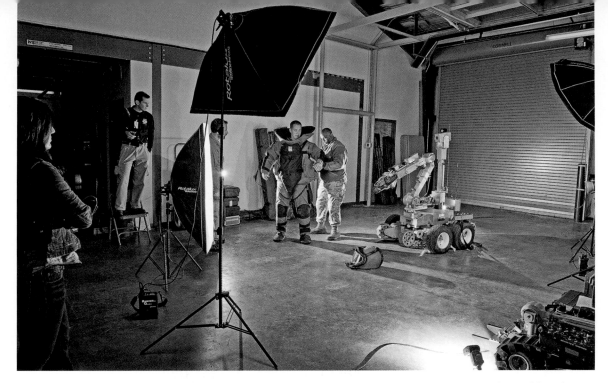

FIGURE 3.6 To make an environmental portrait of this explosive ordinance disposal (EOD) Airman in his working space, I had to bring lots of light. The space was cavernous, and the only available illumination was fluorescent lighting that hung directly overhead—not pleasing at all. I used six Nikon strobes and two Elinchrom Ranger Quadra kits to light both my subject and his robot. You can see them situated strategically throughout the photo.

Bringing the Big Guns

I have been given assignments that require using big, powerful strobes, like the lights you see in **Figure 3.6**, so I can create detailed and stylized environmental portraits (**Figure 3.7**). I keep a Kata Pro-Light FlyBy-74 Rolling Case packed with my Elinchrom Ranger Quadra Pro Set ready to go for in-the-field shoots that don't necessarily have power outlets readily available. The Quadra's portable power pack weighs only about 3 pounds and can fire two strobes, as you can see in **Figure 3.8**. A simple two-light setup can yield great results (**Figure 3.9**). Another perk with this kit is I have the option of using different Elinchrom modifiers on the Quadra heads from a standard square softbox to a 53-inch octa light bank.

However, if I need to overpower the sun, I also have the more robust Elinchrom Ranger RX system. It puts out some 1,100 watt seconds of light, whereas the Quadra produces about 400 watt seconds. The downside to the Ranger RX power pack is that it weighs a hefty 17.6 pounds. No matter what, it's important to know what you're trying to achieve and to bring the appropriate lights to accomplish the assignment.

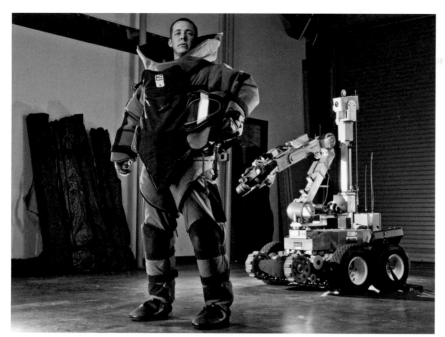

FIGURE 3.7 This portrait of an EOD Airman was taken as part of a portrait series that showed the many jobs Reserve Airmen perform.

Lens (mm): 50, ISO: 200, Aperture: 11, Shutter: 1/200, Program: Manual

FIGURE 3.8 As part of a local color story, I was assigned to photograph the Commander of an American Legion Post. I only had a few minutes to set up and take the portrait before he started the evening's meeting. With time management in mind, I used a two-light setup with an Elinchrom Ranger Quadra pack. I modified the main light using a square softbox and my accent light with a simple reflector dish. The entire shoot from setup to breakdown lasted no more than 20 minutes.

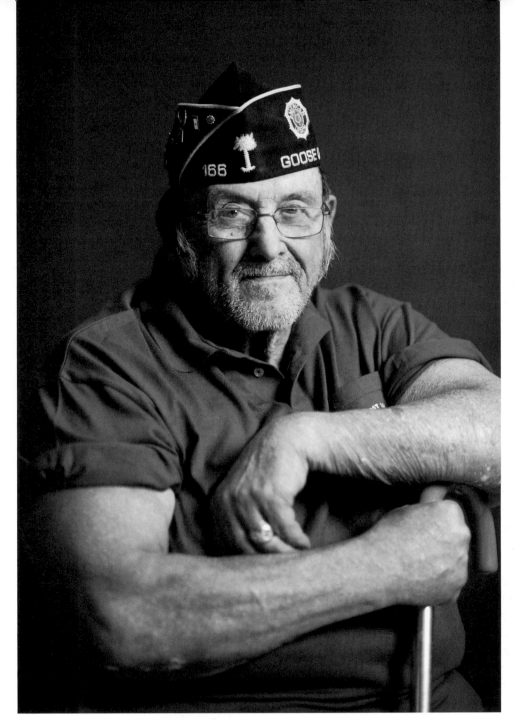

FIGURE 3.9 I chose to convert the portrait of the American Legion Post Commander to black and white for two reasons. The first was the clashing colors of his hat and shirt, but artistically I felt that black and white conveyed the timelessness of his service to his country.

Lens (mm): 85, ISO: 100, Aperture: 1.8, Shutter: 1/200, Program: Manual

Remembering Your Memory

A memory card is a critical component in the photojournalist's camera kit. After all, it's the gadget that holds the images. Lexar, Sandisk, and Hoodman all make decent compact flash cards with various size capacities and write speeds. Some brands offer warranties and technical support, which may or may not be important to you. All I can say is you can't have too many cards, especially if you're in the field shooting for days at a time. If you're shooting a spot news story, you don't want to miss important moments because you ran out of memory. Plus, you don't want to delete or format your cards before you've had a chance to back them up on your computer or external hard drive.

In our career field, speed is important. Just remember no matter how fast your camera is at capturing pictures, the data can only be transferred as fast as the memory card will allow. This is why faster speed flash cards are at a premium price. Be sure to keep them protected when they're not in the camera, too. Cardholders available from Pelican, Sandisk, and Vanguard have rigid outer cases and inner foam padding to keep your flash cards from being damaged. If you're in a wet environment, stick your card case in a watertight bag such as aLOKSAK.

Don't forget to pack your card reader either, or you likely won't have any way to get your pictures from your camera to your computer. Again, the speed of transfer is dictated by the speed of the card and the card reader combination. Therefore, if you've invested good money in fast write speed cards, make sure you don't slow yourself down with an antiquated card reader. Card readers that use USB 3.0 and Thunderbolt technology are currently the fastest readers on the market. However, technology develops and advances every day, so be sure to stay up to date on the latest and greatest card and reader combinations.

Big Job, Small Tool

If one of your two camera bodies goes down, make sure you have a trusty alternate in the wings. I suggest a camera like the Nikon 1 (**Figure 3.10**). It's a compact, silent, mirrorless camera that allows you to affix FX lenses using a Nikon FT1 Mount Adapter, as you can see in **Figure 3.11**. It takes up little room, produces decent images, can be used with a big lens, and makes no noise. If you're documenting a situation where silence is a must, this camera will get you through just fine. You can also get the Nikon WP-N1 Water Housing for the Nikon 1 J2, which gives you the freedom to cover stories around or in the water without the threat of ruining your high-dollar camera systems.

FIGURE 3.10 The Nikon 1 is small and takes up little room in your kit, and it has the capability of shooting 60 frames per second without a sound.

Bits and Pieces

All kinds of accessories are available that can make a photojournalist's job easier. You don't have to go overboard or accessorize to the extreme and spend lots of money doing it. That's why I've compiled some of my favorite gear accessory odds and ends.

Use your night vision

A specialty item called the AstroScope night vision adapter sits between the camera body and the lens, allowing you to shoot in extremely low-light situations. Basically it transforms moonlit or starlit scenes into bright, high-resolution full-frame images that are more easily photographed. Unlike its predecessors, it doesn't have any vignette and it retains full autofocus and vibration reduction capabilities. Although night vision adaptors can help you make pictures in the dark, they are limited to producing green-toned images. But it's better to capture the moment in green than not get it at all.

FIGURE 3.11 The Nikon 1 kit comes with a 10-30mm and 30-110mm lens. However, you can use the Nikon FT1 Mount Adapter to employ any of the FX lenses you have in your kit.

Invest in rain gear

Mother Nature waits for no photographer, which is why it's best to anticipate inclement weather. A number of inexpensive rain jackets for your camera are available on the market, and I highly recommend the investment. After all, it's cheaper to get a cover than replace an entire camera system. I use the Pro-Light Rain Cover made by Kata because it's lightweight and waterproof, and I can easily hold, operate, and shoot my camera when it's covered (**Figure 3.12**). I can also get attachable extensions to cover my longer lenses.

FIGURE 3.12 My rain cover has been through hell and back, which is clear from all the scuffs and smudges on the transparent viewing area, but it serves its purpose fine. Between uses, I dry the cover and compress it down into a small, breathable sack, then store it in my camera bag.

Bring your batteries

Invest in extra camera batteries. I usually have at least four fully charged—one in each camera and the others in my bag. I know it sounds excessive, but I'm a worry-wart. Because I shoot with two cameras, I can burn through batteries twice as fast. On longer days of shooting, I don't want to risk missing the action because I ran out of juice. If I'm in the field shooting for several days straight, I'll pack even more.

> QUICK TIP
>
> I've tried my share of aftermarket brand batteries in an attempt to conserve money. I ended up spending more money because I bought the aftermarket batteries, they failed, and I had to go back and buy the more reliable brand-specific batteries. Learn from my mistakes and buy the proper battery that's custom to your DSLR.

Stay strapped

One of the most important accessories a photographer has in their bag is the lowly camera strap. Over several years of carrying around cameras, I've concluded that something as simple as the camera strap can leave lasting impressions on your body—literally. When I was younger, I could wear a camera around my neck without pain. That's no longer the case. Instead, I wear them on my shoulders, which is why I prefer thinner straps with nonslip rubber technology such as the 1.5-inch Domke Gripper Camera Strap. It has swivel clips that keep the straps lying flat and untangled. Plus, I can remove the strap by unclipping the swivel clips without taking the buckles off the camera body.

Insights: Day-Glo

I keep a small store of fluorescent orange Gaffer's tape so I can identify my bags more easily at airports or spot my gear effortlessly during large, crowded functions. When I travel with multiple bags, I'll wrap a long strip of orange Gaffer's tape around my cases and write my last name on it in black marker. I'll even stick a thin strip on my accessory items such as tripods and monopods. That way, they aren't confused with someone else's from the press pool.

Don't guffaw, gaffer

MacGyver used duct tape on just about everything from making handcuffs to homemade explosives. As photographers, we don't use duct tape—we use Gaffer's tape so we don't leave a trail of residue behind us. I stow a small roll in my bag and use it to secure my lens hoods in place, keep my LCD protector from popping off, tape cords to floors, and secure gels to small strobes. I've even used it to temporarily patch a hole in my pants, tape a flashlight to my Kevlar helmet at night, and secure a split in the sole of my boot. Gaffer's tape comes in a number of widths and colors and is made of a fabric material, so it's flexible and durable. I use matte black and fluorescent orange.

Tidy up

I hate to admit this, but there was a point in time when I used canned air to clean my camera mirror and sensor. I didn't know the extent of damage I could have caused. The velocity of compressed air, coupled with small abrasive particles and debris, had the potential of permanently marring my sensor. I was shown the error of my ways by one of our military camera repairmen. He suggested I turn to a less aggressive method of cleaning, such as the rubber bulb blower you see in **Figure 3.13**, and leave the heavy cleaning to the experts. That's when I discovered the Giottos Rocket Air Blower. The Rocket has an air valve that prevents it from sucking in dust and emits a powerful stream of air to blow dust away. I use it to clean my lenses, cameras, filters, computer, and other electronics.

FIGURE 3.13 The Rocket weighs next to nothing, which is a plus. However, it's about 7.5 inches tall, so I only take it if I'm shooting with a backpack or rolling case.

In my cleaning kit, I also have a Lenspen, shown in **Figure 3.14**. It's a small, lightweight, pen-shaped cleaning tool, designed for camera lenses and filters, but you can also use it on your LCD and eyepiece. Unlike cleaning sprays, it uses a nonliquid cleaning compound that won't spill or dry out, plus it has a retractable, built-in dust-removal brush. I keep this little tool in the pocket of my shooter's vest while on assignment.

FIGURE 3.14 You can get a Lenspen for under 10 bucks, and it's great for when you're in the field.

Stabilization Devices

Stabilization devices can make a big difference in the sharpness and overall quality of photos. They enable photos to be taken with less light or a greater depth of field, in addition to enabling several specialty techniques.

Tripod

For hundreds of years, before photography was even invented, military folks have been using tripods for various purposes—to mount telescopes and stabilize weapons, to name two examples. It makes sense that photographers would employ the tripod for the same benefits—albeit nonmilitant functions. Tripods have come a long way since their wood and brass relatives; they are lighter and more versatile. A tripod may not be ideal for all types of photography, but there's no doubt that it's one of the most useful and most underrated accessories—and that it can do more to improve your photography than just about any other tool in your kit. My Gitzo tripod with ballhead is made of carbon fiber and weighs in at about 4 pounds (**Figure 3.15**).

FIGURE 3.15 When I'm shooting video for a multimedia piece or lighting an environmental portrait, I almost always use a tripod.

Insights: Three-Legged Monopod

I have a few monopods in my storage closet, but one of my favorites is the Manfrotto Self-Standing Monopod. It has three retractable legs that can be stored within the frame of the monopod and pulled up for optimal stabilization. I use it in conjunction with a swivel-and-tilt ballhead so I can tilt the head instead of the monopod.

The benefits of toting a tripod

- **Sharper images:** With 35mm-equivalent focal lengths, the slowest handheld shutter speed is a fraction based on the focal length of the lens. For instance, a 200mm lens would require at least a 1/200th of a second shutter speed or faster. Vibration reduction systems built into modern lenses produce sharper handheld images at slower shutter speeds, but when you're shooting long glass, a tripod can be helpful.

- **Improved quality:** My cameras are capable of reaching astronomically high ISOs while maintaining decent image quality, but some cameras lack that capability. A tripod allows you to set a lower ISO when taking pictures under low-light situations, because you can shoot sharp pictures at slower shutter speeds.

- **Remote photography:** With some assignments, you can't be in the same location as your camera. Therefore, you must have a tripod to turn on and operate your camera remotely.

- **Deliberate movement:** I have a number of stick-and-head combinations that allow me to accomplish different photographic techniques. For instance, I use a Manfrotto Fluid Head to maximize slow shutter speed panning.

- **One-guy wonder:** As I've said before, photojournalists often work alone. Having a tripod allows you to free your hands from your camera to work on other aspects of your shoot. For example, if I have to light a portrait I can set my camera on the tripod and go adjust lights without losing my photographic train of thought or shooting position.

I will be the first to admit that tripods are cumbersome and clunky, and often get in the way. For photojournalists, tripods make it hard to keep a low profile. Nevertheless, they're irreplaceable tools. I don't go to an assignment without one in my car—just in case.

Monopod

An alternative to a tripod is the monopod. Though not as sturdy, a monopod is smaller and more portable, and it may offer just enough stability to get the shot. Other perks are that you can take the monopod into areas where tripods are restricted, and you can strap it to the back of most shooter's vests or the outside of your camera bag.

Minipod

To achieve extremely low-angle shots, you can either eat dirt or use a mini tripod. I've done both. Manfrotto makes a couple of different platforms, such as the Pocket Support, shown in **Figure 3.16**, and the Table Top Tripod. Along with making low-angle shots easier, minipods can be used to set up your camera remotely or to provide stability on flat surfaces such as tables, car hoods, fence posts—you name it.

Super Clamp

When the situation calls for it, whip out a Manfrotto Super Clamp with Standard Stud. It's a tool that can hold just about anything, from cameras to lights. It weighs less than a pound and can hold up to 33 pounds of gear. It's affixed to the camera the same way as a tripod or monopod, and it can be outfitted with a ballhead to get better angles. A Super Clamp can open up to 3 inches and clamp to anything such as a post, beam, or tabletop (**Figure 3.17**).

FIGURE 3.16 I like the Pocket Support so much I give it as a gift to my students and photo friends. It comes in two sizes, but I prefer the bigger version. It can be folded up underneath the camera body so it lies flat, which gives you the option of leaving it attached without it getting in your way.

FIGURE 3.17 The Super Clamp gives you the ability to shoot your camera from unique vantages such as places where you can't fit, or perhaps can't go. This is not a tool I use on every shoot, but I like having the option of securing my camera in hard-to-reach places.

QUICK TIP

To use the Super Clamp, open it fully and place it around the object that you want to attach it to. You can use the wedge insert for flat surfaces such as shelves, tables, and plank fences. Turn the hand lever until the Super Clamp is snug but not too tight.

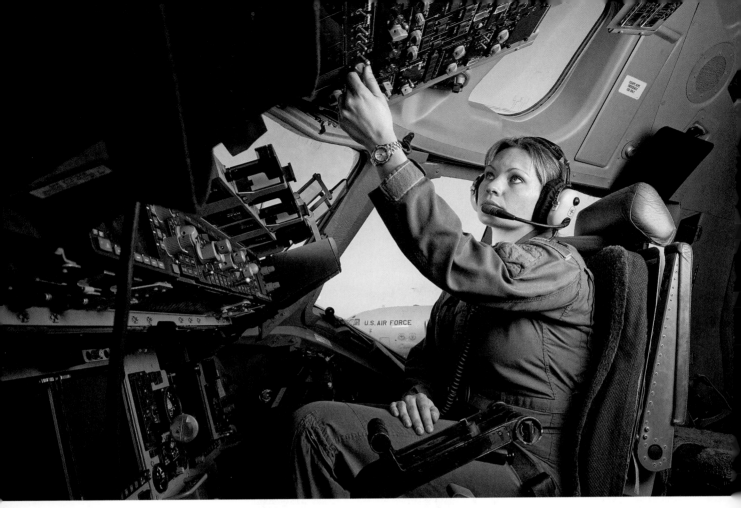

FIGURE 3.18 I used a Super Clamp to secure my camera near the flight controls of a C-17 Globemaster III so I could shoot pictures of the pilot as she flew a routine mission.

Lens (mm): 24, ISO: 200, Aperture: 13, Shutter: 1/200, Program: Manual

I used the Super Clamp a lot in the military because of its ability to fit in small spaces. I've used them inside aircraft cockpits (aka flight decks) like the one featured in **Figure 3.18**, tank driver hatches, and Stryker troop carrier gunner's positions. The trick is to use a wider lens, set your camera on Aperture Priority Mode, prefocus your lens in Manual Focus Mode, and trigger the camera using a PocketWizard remote camera control system. If your available light isn't changing drastically, I suggest manually setting your exposure for the shoot.

Workflow and Transmission

In terms of breaking news, it's important to download your pictures and edit, caption, and transmit your files expeditiously or another photographer may publish the story before you—unless you have the advantage of being the only photographer on scene. In today's world of iReporters and pedestrian photographers, that's unlikely.

Connect and back up your work

Be sure to have a reliable laptop and external hard drive to download and store your work. Also consider using an online archive system such as PhotoShelter or Dropbox where you can back up your edited and captioned images and share them with people around the world.

Laptop

As I've stated before, I'm an Apple user; therefore, I have a Mac laptop. I didn't come by the decision to use Mac computers simply because they're cool looking or they're all the rage. I've used my share of PC laptops while in the military and haven't been pleased. I was once issued a 17-inch Alienware laptop with five cooling fans that weighed over 10 pounds, plus the 2-pound power adapter and cord. I had to lug the behemoth all around the world on my back, in addition to my camera gear and personal items. What made matters worse was that the computer suffered overheating and critical failures nearly every day, which caused immense stress. My previous computer was a Mac, and I hadn't faced those types of issues before. So as soon as I had the chance, I made the transition back to Mac.

My Mac laptops have sustained hard knocks and filthy working environments, and they keep on ticking. You can order your Mac with a solid-state drive, which I highly recommend. They are less susceptible to damage because there are no moving parts, ideal for photojournalists who travel everywhere with their computers. If you're in the market for a computer, just remember that you want to maximize your RAM, processing speed, and hard drive space. Another consideration is screen size. Of course, a smaller screen such as a 15-inch will be lighter and easier to travel with, yet sufficient for uploading and captioning imagery. But if you're using your laptop as your primary computer, you may consider a larger screen, such as a 17 inch.

FIGURE 3.19 I keep a compact plug adapter in my camera kit when I travel abroad so I don't run into issues of battery power shortages.

FIGURE 3.20 My adapter comes apart and provides me with several conversion options.

FIGURE 3.21 Every so often, I'll drive a long distance to get to an assignment, and occasionally I have to charge my gear in transit. That's why I keep a Black & Decker power inverter in my car at all times. It has two AC outlets and a USB port that converts my car's 12-volt DC power to 115-volt AC standard power.

Change of power

Each country has something different—two-prong, three-prong, 120V, 240V. I keep a little Conair converter in my camera bag called the Travel Smart. The converter has plugs that can be used in most countries and a 2000W capacity. In addition, the built-in surge protector keeps electronics safe from foreign power spikes. I also have a sack of plug adapters that fit standard two- or three-prong USA plugs, so I can adapt to whatever standard plug my host country uses (**Figures 3.19** and **3.20**). Depending on where I'm headed on assignment, I use a power strip specifically for that country. If I don't already have one in my storage room, I'll pick one up when I land on foreign soil (**Figure 3.21**).

Connecting with wireless

Most mobile phone providers offer their version of personal, portable Wi-Fi devices; I chose to go with Verizon's MiFi Mobile Hotspot. I use it on the road to send emails to my editor, stay in touch with story subjects, and transmit images.

Devices that connect using portable Wi-Fi devices

- **iPad:** To stream breaking news reports.
- **iPhone:** To correspond via text with clients, subjects, editors, and significant other.
- **Laptop:** To send/receive emails, search the Web, and transmit photos.
- **Camera and Eye-Fi Memory Card:** To help streamline workflow. Eye-Fi gives me the capability of RAW file photo uploads to my computer. With Eye-Fi's Direct Mode, I can take a photo and it will immediately transfer wirelessly from my camera to my iPhone, iPad, or laptop, where it can be stored, backed up, and shared with clients.

Storage devices

Ingest it, save it, store it, and back it up—then back it up again. Just like with the internal drives, external drives offer a few options for methods of backing up your photography. I recommend a portable, solid-state drive that draws power off your laptop versus requiring its own power source. Make sure you have an external hard drive that's large enough to store the images from your assignment as well as a copy of your photo-editing software in case of system failure—at the same time it should be small enough to carry with you on trips. I use an Other World Computing (OWC) Elite Pro Mini storage device and take it with me everywhere (**Figure 3.22**).

FIGURE 3.22 I'm pretty accident prone, and I've crashed or crushed my share of hard drives. In turn, I've paid handsomely for file recovery services. The aluminum case of the OWC unit gives me some reassurance that I won't suffer another downed drive because of my negligence.

I download my compact flash cards straight to the computer desktop and external hard drive simultaneously using photo-editing software by Camera Bits called Photo Mechanic. You can also download your images straight to your desktop and then plug in your external hard drive and back up after you've completed ingestion.

When I'm back at my office, I archive the images from my portable hard drive to my LaCie RAID. I have 10 terabytes of space, so I can file thousands and thousands of pictures in my library of assignment folders.

Software

The digital darkroom is just as important to DSLR shooters as the wet lab was to film photographers. The computer software available on the market today is designed to simulate the wet lab darkroom techniques with digital file photos. Therefore, the software you choose will directly impact your workflow process and speed. You have several to choose from, but I primarily use three for my photojournalism assignments:

◆ **Photo Mechanic**: Photo Mechanic is a picture browser and workflow software that gives photojournalists the ability to ingest, edit, caption, and export photos. It has IPTC (International Press Telecommunications Council) and Exif (Exchangeable Image File) metadata-editing windows with color-coding, sorting, and rating options. You can batch-send your pictures to your editor or online archive using Photo Mechanic's FTP system (**Figure 3.23**).

FIGURE 3.23 I was introduced to Photo Mechanic during my time in service, and I have been a loyal user ever since. The ingest options are amazing because I can write a blanket caption for my images and rename my files as they transfer to my drive.

- **Adobe Photoshop Lightroom**: RAW image capture is by far the best. It produces the highest image quality and has more latitude to adjust white balance and exposure. However, processing RAW files to JPEGs can take ages if you attempt to edit them one at a time. That's why I suggest using software such as Lightroom. Lightroom uses the same RAW processing routines as Adobe Camera RAW, which basically means it's compatible with most digital cameras, and it's nondestructive regardless of file type. You can also edit one image, and then copy and paste those changes to pictures shot under the same exposure conditions, saving gobs of time. Once you've completed your editing, you can batch-export your files to whatever format your editor prefers, including JPEG, TIFF, and PSD (**Figure 3.24**).

- **Adobe Photoshop**: In most cases, I don't need Photoshop because I can accomplish the photojournalistic standards of editing with Lightroom. But there are times when I have a pesky dust spot that requires more precise editing. That's when I turn to Photoshop. I also make any color to black-and-white conversions in Photoshop (**Figure 3.25**).

FIGURE 3.24 Adobe Lightroom is my main editing software. As a photojournalist, I don't edit or tone my pictures outside of the normal exposure adjustment or crop. With this software, I can breeze through a whole take in a matter of minutes and get my assignment off to the editor quickly.

FIGURE 3.25 There are many ways to convert color images to black and white in Adobe Photoshop; some are destructive and others are not. I primarily use the Channel Mixer method, because I believe it's the closest to traditional black-and-white darkroom techniques. You can adjust the various color channels in Channel Mixer the same way you'd use color filters in a darkroom enlarger.

Develop a file management system

Image management is critical, especially when you shoot thousands of photographs on assignment. Without proper management, your images could be lost or destroyed, and tracking existing images becomes cumbersome and time consuming. With a solid image management system in place, you can easily rename, caption, keyword, archive, and recall pictures.

My file-naming scheme

As military photographers, we had a special code we used to rename all of our images. Called VIRIN, or visual information record identification number, it consisted of the year, month, day, branch of service initial, the last four digits of our social security number, and the first initial of our last name. For example, mine looked like this: 130115-F-1234P. There were many benefits to having such a strict naming regime, but mainly it helped narrow image searches in archives of thousands of pictures.

I no longer use a VIRIN, but I've adapted my own version of file naming to improve my personal archive of images. I still use the year/month/day scheme, followed by my three-letter initials and the assignment name or location reference. So let's say my assignment was to document a veteran's motorcycle rally in Charleston, South Carolina, on March 19, 2012. Here's an example of how I'd rename my files: 130319-SLP-VetMotorRally. They'd all be in sequential order using a three-digit sequence number such as 001, 002, 003, and so on. So, I might have filenames such as 130319-SLP-VetMotorRally-001, 130319-SLP-VetMotorRally-569, and 130319-SLP-VetMotorRally-788. Using a three- or four-digit sequence number such as 001 or 0001 helps keep your files organized in their original capture succession. If you start with a single number, you may end up with files out of order, such as 1, 10, 100, and so on.

Folder-naming scheme

I'm also strict about my folder systems. Before ingesting any digital files, I create a main folder on my desktop using the same naming method. For this purpose, I'll stick with the previous example: 130319-SLP-VetMotorRally. Within that main folder, I'll have three subfolders labeled RAW, Selects, and Edits (see **Figures 3.26**, **3.27**, and **3.28**). As I ingest the files from my Flash Card to the RAW folder, I'll rename the files automatically. At the same time, I'll apply a blanket caption and keywords to each image's IPTC Stationery Pad using the Photo Mechanic software.

Once the download is complete, I use Photo Mechanic to search through the RAW folder, narrow down my image selects, and identify my choices with color codes. From there, I copy my chosen images into the Selects folder. I do not transfer the originals; I copy them.

Image-editing regimen

Since I shoot RAW digital files, I process my selects folder through Adobe Lightroom. I make basic exposure and color adjustments, perform simple dust spot removals, and crop images if absolutely necessary. Then, I export the RAW files as JPEGs to the Edits folder. With the Edits folder, I can then move forward with more detailed captioning and keywording without having to weed through any extraneous pictures that I didn't plan to send over the wire anyway.

Phew, I know. It seems like a lot, but I've established a routine and it flies by quickly for me. When I'm working in a war zone, shooting sports, or documenting an extremely time-sensitive assignment, there are times when I'll capture RAW plus JPEG files simultaneously to eliminate the RAW file processing portion. By capturing both RAW and JPEG, I can caption quickly and send the JPEGs over to the editor without unnecessary delay

FIGURE 3.26 On my hard drive, I list master folders by year. I even color-code them to keep each one distinctive.

FIGURE 3.27 Within each master folder listed by year is a subfolder that contains my assignments. Each of these assignment folders is labeled by year, month, and day. They also include my initials and the assignment's name or description.

FIGURE 3.28 Each assignment folder contains a RAW, Selects, and Edits folder. I also have a Word document that contains the assignment and caption information, along with caption IPTC.

and still have the RAW files for my archive. Either way, my archive system isn't impacted.

I can go back years and years to search for images by date or topic and retrieve pictures quickly from my hard drive. If my method seems arduous for you, just be sure to develop a solid workflow and archive system to help manage files.

Transmit your images

Depending on the timeframe of your assignment, you may be required to transmit your images as soon as possible. The obvious first choice to do so is through a hard-line Internet connection. A second option is WiFi; however, if you're somewhere remote and can't access an Internet café, you may want to look into a Broadband Global Area Network (BGAN) system. This is a satellite Internet network provided by Inmarsat that doesn't require heavy, cumbersome satellite dishes. Instead, it uses a BGAN terminal about the size of a laptop and can be carried easily in a backpack. BGAN is currently the fastest global data link available via a portable terminal, but it will cost you a pretty penny to buy one and to transmit your pictures.

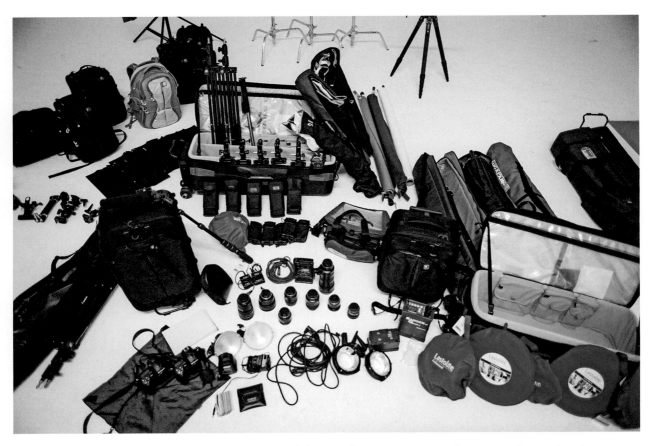

FIGURE 3.29 I have everything from audio capture devices, lighting tools, computer gear, and camera equipment. I can't remember my own name most days, let alone what's in my gear closet, so it's important I have a current list of stuff for reference. Every year, I lay out all my equipment, re-inventory my stock, check for wear and tear, and order replacement parts if needed. I then submit my new accruals to my insurance company for coverage.

Prepping, Packing, and Shipping

Your camera gear costs thousands of dollars, so packing and shipping it properly can save you costly damages and lost shooting time. I've traveled to more than 41 countries on assignment, and with each trip I've gained better insight into packing my equipment. I've lost or destroyed plenty of valuables along the way, too. By learning from my mistakes and following my recommendations, you can help ensure that your gear will arrive at its destination safe and sound.

Make a list and check it twice

To start, take a full inventory of your gear, including nomenclatures, makes, models, and serial numbers (**Figure 3.29**). Most insurance companies require an inventory list anyway, so you'll be killing two birds with one stone. With your inventory information, create a master line-item list from which you can generate smaller assignment-packing lists. If certain items don't have serial numbers, just be sure to take down all their details. Save a copy of your master list on your external hard drive, your personal digital assistant (PDA), or Dropbox account online, and then print a hard copy to keep in your desk. Once you receive an assignment, generate a smaller checklist that catalogs your gear necessities and print a hard copy. Doing so will help you ensure you've packed all the gear you need and help you keep track of it on the road.

> QUICK TIP
>
> I recommend getting a bottle of nail polish and putting one drop on the item's product label. I use orange because that's my signature distinctive color. This helps prevent any gear mix-ups with other photographers because you may be traveling with other photojournalists, or perhaps live with one, like I do.

The checklist also squelches the impulse to overpack. If you've reviewed the assignment, thought through your shot list, and addressed assignment-specific challenges, you should have a comprehensive list of gear that will assist you in achieving success and averting potential disasters on location. The thought and energy you put into the front end of your assignment will payout dividends in the end, plus you won't be strapped carrying tons of gear you don't need.

Let's say I received an assignment to cover my local mayor's big speech at an outdoor assembly. A crowd of 500 is expected to attend and I'll be limited to the press pool platform. However, I've been told I'll have a couple minutes behind the stage to take a portrait of the mayor after the speech. When generating my assignment checklist, I'd consider time constraints, space limitations, lens-to-subject distance issues, and specialty assignment needs. If the situation allows, I'd even contemplate scouting the location before the event takes place.

Because time and space would likely be limited, I'd refrain from using any big lights, modifiers, or stands. Instead, I'd take two small strobes and a collapsible softbox. Also, I'd address the challenge of press access limitations by bringing my remote camera setup and securing a better angle nearer to the podium. It may be a simple, small project, but I treat every task, big or small, with the same care and thought. The checklist is a big part of the process.

Example mayor speech and portrait assignment checklist

- Nikon D4 Camera Body #1 (Serial Number: XXXXXX)
- Nikon D800 Camera Body #2 (Serial Number: XXXXXX)
- Nikkor 14-24mm Lens (Serial Number: XXXXXX)
- Nikkor 24-70mm Lens (Serial Number: XXXXXX)
- Nikkor 70-200mm Lens (Serial Number: XXXXXX)
- Nikon 1.7 Teleconverter
- 6 SanDisk Extreme Pro 64 GB Compact Flash Cards
- 6 Hoodman RAW 32 GB Compact Flash Cards
- 6 Nikon EN-EL 18 Rechargeable Lithium-Ion Batteries
- MH-26 Battery Charger
- 2 Nikon SB-910 AF Speedlight i-TTL Shoe Mount Flashes
- 16 PowerEx AA Rechargeable Batteries
- PowerEx MH-C801D 8-Cell 1-Hour Charger
- Roscolux Colored Gel Swatchbook
- Lastolite Ezybox Hot Shoe Softbox Kit 24x24 inch
- Manfrotto Alu Master 3 Riser 12-foot AC Stand
- Avenger GS207 Zippered Cordura Sandbag (*empty*)
- PocketWizard Plus III, Mini TTi, and Flex TT5
- Manfrotto 536 Carbon Fiber Tripod
- Manfrotto 498RC2 Midi Ball Head with 200 PL-14 QR Plate
- Manfrotto 680B Compact Monopod
- Manfrotto 035RL Super Clamp with Standard Stud
- Manfrotto 244 Variable Friction Magic Arm with Camera Bracket
- Avenger C155 39-inch Safety Cable
- Matte Black 1-inch Gaffer's Tape

In the Trenches: Vested Interest

When I was documenting battles, I wore my shooter's vest exclusively (**Figure 3.30**). I'd comfortably stow my camera gear, a combat load of ammunition, snacks, and water. I wore it over my body armor and adjusted the straps tightly so it didn't shift when I ran. It worked perfectly—or nearly so. I recall being assigned to cover a tank unit that was launching a major offensive in conjunction with an Iraqi Army company about 45 minutes away. There was no room available in the Bradley Fighting Vehicles, so I had to ride along in the tight confines of the tank. The only place available was the loader's seat, and because I was military personnel, they gave me a briefing on how to move the tank's rounds from the storage area and load them into the cannon.

Lugging the wide berth of my body armor and shooter's vest made wedging into the narrow loader's seat nearly impossible, but I managed to cram in. I had just enough space to rotate from the storage area on my right to the cannon on my left. Before entering the tank's haul, I switched my 70-20mm lens on my secondary Nikon D2X camera to a 17-55mm lens for a wider angle of view, and placed the unneeded 70-200mm lens in the front left pocket of my shooter's vest. As we began our journey, the tank gunner moved the cannon from its rest location into firing position. The loading end of the cannon that was nearest me slid down and pinched the pocket of my shooter's vest. At the time I didn't think much of it.

As we made our way to the rally location, I took pictures of the tank commander and gunner while they navigated the booby-trapped roads of Baqubah. Once upon the objective, I continued to shoot the operation without my 70-200mm lens as we were in close quarters during the mission. Everything went as planned, and I was back at my workstation a few hours later. A fellow photographer asked to borrow my 70-200mm lens for a quick shoot, and I was eager to oblige him. However, when I pulled the lens from the shooter's vest pocket, it was bent into a perfect rainbow arch. Apparently the padding of the vest prevented the force of the cannon actuation from shattering the glass elements inside, but it couldn't keep the immense pressure of the cannon from crimping the lens's metal exterior.

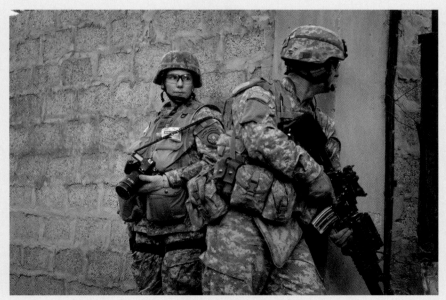

FIGURE 3.30 This is a photo of me during a combat patrol in Diyala Province, Iraq. You can see I'm wearing a shooter's vest that's stuffed to the gills with gear. Peeking through my top pocket is my trusty report-age notepad—another must-have item for any photojournalist. (Photo by Andy Dunaway)

Just in "case"

Packing your gear tightly with sufficient, proper cushion is important because you don't want your gear to rattle and knock about for the length of your trip. The impact of air and ground travel can cause glass to crack and electronics to malfunction, so be sure you don't enclose your fragile gear with a T-shirt or towel because they will not absorb the shock properly. Instead, enfold your cameras and lenses with a non-scratch protective wrap like those made by Domke, Tenba, or Op/Tech (**Figure 3.31**).

FIGURE 3.31 I have enough wraps to cover all my lenses and cameras at the same time. They cost anywhere from $15 to $20, but I think they're worth the investment. Besides, I'd rather not have to buy another 70-200mm lens for the bargain price of $2,400.

QUICK TIP

I use specially designed square protective wraps that are constructed of padded, Velcro-compatible knit with a nonscratch nylon backing. They wrap around lenses, cameras, flashes, or anything else that will fit inside. The Velcro tabs on all four corners allow you to wrap and stick them in any shape.

If my assignments are within driving distance, I'll usually pack my gear in the case, bag, or vest I'll be shooting with on location. As geeky as they look, I prefer to tote my gear around the field with a shooter's vest if the assignment requires a lot of moving about. I have two Xtrahand Vests, one black and the other tan, made by Vested Interest. It has enough water-resistant pouches to hold my Mirrorless camera, small strobes, batteries, flash cards, notepad, pens, monopod, minipod, multitool, tape, and more. Plus, I can access my gear quickly on the fly, which is important when documenting fast-paced assignments (**Figure 3.32**).

When photo stories are slower paced, I'll take my Kata 3-in-1 Sling Backpack or Kata Pro-Light Bumblebee Backpack. They give me extra room to pack my laptop, specialty lenses, and other superfluous doodads I need, whereas with the shooter's vest, I don't have that luxury (**Figure 3.32**).

For long journeys that require air travel, I either use a lightweight Kata Pro-Light FlyBy Case with a trolley system that I carry onboard, or I have a larger, wheeled, watertight Pelican case I can send through as checked luggage (**Figure 3.33**). I strive to secure my gear properly before entrusting it to a perfect stranger, which is why I'm not overly concerned about a disgruntled bag handler's negligent treatment of my valuables. My only real concern with checking my gear is lost cases or theft.

How to pack your Pelican:

◆ Use a small bit of Gaffer's tape to secure your lens caps and hoods with their respective lenses. Enfold each lens in a protective wrap or bubble wrap packaging. For added protection against moisture and other elements, place your wrapped lens in an impermeable carrier such as aLOKSAK.

◆ If possible, unclip your camera strap from the camera body, roll it up, and wrap it with a rubber band. Tape the body cap to the camera body and place it onto a square protective wrap or piece of bubble wrap packaging. Lay the coiled neck strap at the bottom of the camera and enclose all contents in the same wrap. You can also put your camera in a watertight storage bag.

◆ A number of small solid cases built to safeguard your external hard drives are available, including those made by Case Logic, Lowepro, and Kata. If you're not interested in hard drive-specific cases, you can secure your storage devices with a sheath of bubble wrap and a

FIGURE 3.32 My mom used to say, "There's a place for everything, and everything in its place." I try my best to find cases and backpacks that fit the gear to maximize space and utility. Depending on what type of assignment I get, and where I have to travel to get there, I choose my luggage wisely.

FIGURE 3.33 I don't know how many times I've been at the airport conveyer belt and overheard someone saying, "Mine's the black one." Ha! Everyone's bag is black. To make my cases more identifiable, I wrap them with bright orange Gaffer's tape or duct tape. I'm also cognizant of the case's weight as I pack. Pelican cases can be heavy from the get-go, so it's important to watch how much you stuff in there.

plastic zippered bag. The added benefit of a case is you can pull it straight from your Pelican and drop it into your backpack or shooter's vest. I wouldn't do that without supplementary protection, though.

- For loose bits and pieces such as my flash card wallet, camera-cleaning kit, power adapter plugs, spare filters, and other extraneous items, I use small and large plastic zippered bags to keep them together and organized. If I have several items in the same bag, I use a black marker to list the bag's contents. I push out any surplus air, seal the bag, fold over any excess bag at the top, and secure it with a rubber band.

- I disconnect, coil, and rubber-band any cables of objects that have removable power cords, such as my camera battery chargers. I then stow them with the chargers in the same sack. This prevents any kinks, fraying, or breakage during travel.

- Most hard cases often come with prefabricated dividers, but sometimes they just don't fit the gear tight enough. I use antistatic Pick N Pluck foam-cushioning inserts, which I customize and arrange for my specific gear. I can order the foam in sheets based on the internal measurements of my hard cases, and the foam sheets consist of vertically pre-scored blocks that can be easily "plucked" to provide a snug fit for camera equipment and accessories.

- The top and bottom of your case should be lined with antistatic egg-crate foam. If it isn't, you can add some yourself with a can of 3M Foam Fast spray adhesive.

- Secure each item in your Pelican with the heaver pieces closer to the wheels. If you don't, the case may become top-heavy and hard to control. Strategically situate your camera bodies and lenses in the centermost portion of the Pelican. The farther from the hard shell

of the case's exterior, the less likely shock and impact will damage your gear.

- Be sure to leave an empty space, void of foam at the top handle end of your Pelican, so you can pack your empty camera bag or shooter's vest. There's no need to carry an empty camera bag on the plane.

- Place a hard copy of your packing list next to your camera so you can check your inventory upon arrival of your destination.

- Close and secure your case with a Transportation Security Administration (TSA)-approved lock. Both Pelican and HPRC make a three-digit combo lock with a flexible, bendable metal cable fastener that works best with hard resin-style cases such as the Pelican. Traditionally, hard cases come with two separate holes for external locks, so I say get two locks and use both. Avoid locks with keys, because keys can be easily lost.

- Lastly, be sure to properly label your case with your full name and contact information. Samsonite makes a hardwearing aluminum luggage tag with viewing window that's perfect for lots of travel. I suggest listing your home address, so in the event your gear is lost, it will be delivered back to your starting point. Then a trusted neighbor or colleague can retrieve your bag and ship it via Federal Express or UPS to your final destination.

QUICK TIP

I have both FedEx and UPS account numbers so I can ship my gear around the world with greater ease, or have someone from home ship me additional or replacement gear without paying out of their pockets. Accounts don't cost anything to initiate, and you receive billing statements via email after you've shipped your items. You can also arrange for equipment pick-up and drop-off over the Web.

FIGURE 3.34 In addition to the various packing restrictions you may encounter, your mode of transportation may be cumbersome, too. In this case, mine had four legs and a rickety saddle. Knowing I'd have to balance myself and the weight of my equipment on a camel's back while scaling Moroccan sand dunes, I thought twice about overpacking. I ultimately settled on bringing my shooter's vest and the minimum shooting essentials to get the shot.

On the Move

When you're deciding what gear essentials you'll need to photograph an assignment, it's important to factor in how you'll be getting all your equipment from point A to point B. You may be limited by airline luggage weight and size restrictions, vehicle space capacity shortages, or the amount you can carry on foot. In the end, you may have to compromise by rerouting your trip for better modes of transportation, or reducing the amount of gear to the minimum you need to fulfill the assignment successfully. So be sure to do your research, prepare for the worst-case scenario, prep your gear list to bring only what you need to fulfill the assignment, and travel as lightly as possible (**Figure 3.34**).

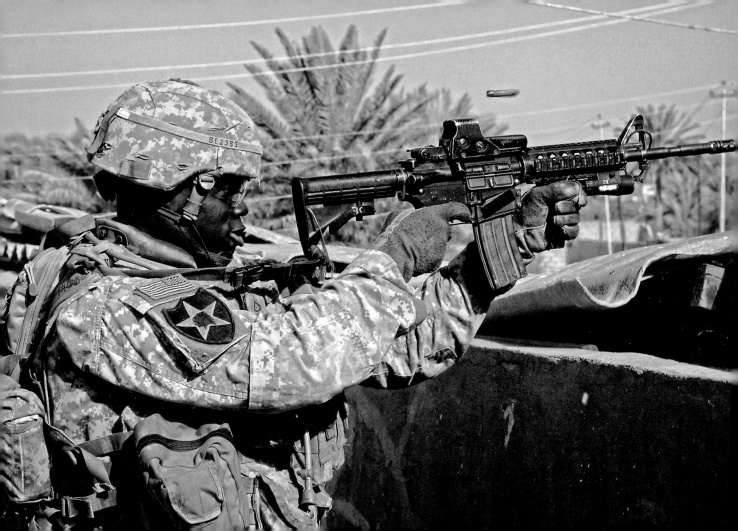

CHAPTER 4

MY SHOOTING METHODOLOGY

There's an old cliché that practice makes perfect, and as much as I despise adages, it's especially true in photojournalism. Perhaps practice doesn't always lead to perfection, but if you practice enough it becomes routine. For instance, as you prepare to take a picture, you have many decisions to make before releasing the shutter—such as lens selection, ISO, f-stop, shutter speed, and white balance. Each photographic scenario is different, which means you must adjust your settings to accommodate for the bright sun or perhaps a lightless room. As you practice more and more, this repetition helps permanently store the data so that when you need the information to be recalled on the fly, it's nearly instantaneous. Eventually you'll be able to walk into a situation and know—or at least be close to knowing—what your exposure needs to be. Approximations are not dead on, which is why I'm reluctant to shout the aforementioned cliché from the rooftops. But I'll take a close estimate over an uneducated guess any day.

A U.S. soldier returns fire on the enemy from a rooftop in Buhriz, Iraq.

Lens (mm): 55, ISO: 200, Aperture: 8, Shutter: 1/350, Program: Aperture Priority

FIGURE 4.1 U.S. Army Private 1st Class Daniel Williams sits inside an M2A2 Bradley Fighting Vehicle while convoying to Buhriz, Iraq, at approximately 4:45 in the morning.

Lens (mm): 55, ISO: 3200, Aperture: 2.8, Shutter: 1/13, Program: Manual

What IFS

Over the course of my career, I developed a shooting method I refer to as my "What IFS," which stands for ISO, f-stop, and shutter speed. When making an exposure, I start with my ISO, and then I choose my depth of field, and finally, my shutter speed. There's no rule that says you must approach exposures any particular way, and I'm not suggesting my way is the only line of attack, but it's what works best for me. Whether or not you choose to adopt my process, you'll find that having a routine exposure method is helpful.

Consistent exposures make assignments go so much easier and far less stressful. As a photojournalist, you'll be required to operate under strenuous, often harsh, conditions. Reducing unnecessary stressors such as exposure will help free up energy better spent elsewhere (**Figure 4.1**).

Step 1

Each scenario will pose a new challenge. It's up to you to determine what your ISO setting should be, based on the available light. The darker the scene, the higher number ISO is required, and the brighter the scene, the lower the ISO. You should check ISO first because you want to set the foundation for the rest of your exposure by getting the most from your camera. If you're in a very low-light situation and shoot on ISO 200, you're not doing yourself any favors. You'll be forced to slow down your shutter speed and risk getting blurry shots. You don't want that. However, the trade-off is that a higher ISO may cause pixilation in your image. I'd rather have a pixilated, sharp image than a soft, unusable one (**Figures 4.2** and **4.3**).

Step 2

The reason I consider f-stop, or aperture, the second item on my list is due to its impact on my ability to take in more light, but also the crucial influence it has on depth of field. If you want less depth of field, then shoot for a smaller f-stop number like f/1.4 or f/2.8. If you want more depth, increase your f-stop accordingly. As you increase f-stop, however, you'll simultaneously be decreasing your shutter speed. When your shutter speed slows, you open yourself to capturing motion in your frame, whether it's your subject moving or you. In extreme cases, the motion blur can render your subject out of focus and therefore become an unpleasant, if not altogether useless, picture. So just keep that in mind that it's a trade-off. Also, shooting with wider lenses can increase your depth of field without forfeiting shutter speed. Last, and perhaps the most important consideration, a higher f-stop will show things like dust spots, sand, hair, and dirt on your images.

FIGURE 4.2 Air Force Technical Sergeant John Mizelle walks to the rescue helicopter an hour outside of Pyongtaek City, Korea, during a pararescuemen exercise.

Lens (mm): 17, ISO: 800, Aperture: 16, Shutter: 1/500, Program: Manual

FIGURE 4.3 Example of dust spots at maximum depth of field.

Step 3

After you determine ISO and f-stop, you can set your shutter speed to make a proper exposure. I recommend that you meter for the highlights using Center or Spot Metering to figure out the most accurate setting. This approach will also ensure you have detail in your highlights. When you shoot with longer lenses, you may also want

FIGURE 4.4 A U.S. Army soldier rests after conducting a foot patrol in Buhriz, Iraq.

Lens (mm): 45, ISO: 800, Aperture: 2.8, Shutter: 1/80, Program: Manual

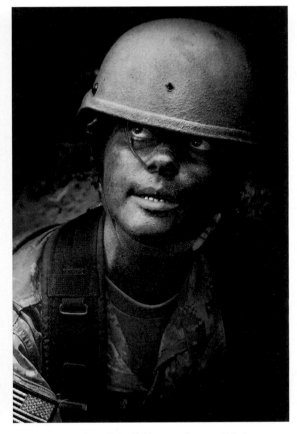

FIGURE 4.5 During night field operations, a U.S. Army soldier stays low in her foxhole at Fort Jackson, South Carolina.

Lens (mm): 255, ISO: 200, Aperture: 2.8, Shutter: 1/500, Program: Aperture Priority

to be sure you have your shutter speed faster than the length of your lens. Nowadays, longer lenses have built-in Vibration Reduction (VR), which allows you to shoot a bit slower. But if you don't have that technology, don't chance it (**Figures 4.4** and **4.5**).

There are exceptions to the precedence of order. When shooting action, panning, or even showing the motion of the rotor blades on a helicopter, you'll want to set your shutter speed first and equate your exposure with your f-stop. Whether

f-stop or shutter speed comes before the other, ISO always comes first in my routine.

Multiframe burst

When you slow down your shutter speed, you increase the risk of picking up any motion. Try to eliminate motion within the camera by using these techniques. Set your camera to take multiframe bursts, slow your breaths, and when possible, anchor your body against something firm such

Insights: Lenses Exposed

Greater depth of field is an inherent trait of shorter focal length and wide-angle lenses. These lenses provide better depth of field than telephoto lenses because wide-angle lenses have a greater rear depth of field and can more easily attain critical sharpness at infinity. Because I was mainly photographing close quarters combat inside houses and aerial combat operations inside helicopters, I often used shorter focal length lenses. When I shot DX format cameras, I primarily used the 17-55mm lens on assignments. DX cameras have a sensor that's about 1.6 times smaller than the standard 35mm full frame (FX) sensor cameras. Now I shoot FX cameras, so I've switched to the 24-70mm lens. These wider lenses allow me to photograph my subjects in the tight spaces; I achieved decent depth of field at wide-open apertures such as f/2.8 and had faster shutter speeds at lower ISO settings. However, there were situations and assignments that called for longer glass.

To save time, I would have one camera body with a normal or wide-angle lens and another camera with a longer lens. By having two dedicated setups, I could switch back and forth without having to stop and change lenses, and I also reduced the amount of sand and debris that got on my cameras' sensors and on my lens's glass.

When I used longer telephoto lenses in close proximity with my subjects, I would run into focus problems because of lens-to-subject distance. The threat of motion blur was ever present. The telephoto lenses often needed more light while inside dark aircraft and house interiors, which meant I had to slow my shutter speed down to compensate, thus resulting in movement from my lens being transferred to my pictures.

Think of your telephoto lens as a boat cruising over small waves. The tip of your lens is the bow of the boat moving up and down as you breathe. You may not notice the movement, but it's happening. Here's a tip when using telephoto lenses in any situation: the shutter speed should be the reciprocal of the lens's focal length rounded off to the next higher shutter speed. Here's an example: a 50mm lens needs a shutter speed of 1/50 of a second or faster: rounded up, it would be 1/60 of a second.

as a wall or a tree. Be sure to tuck in your elbows, too. By having arm-to-body contact, you increase your stabilization. Your lens stabilization and focus hand should be under your lens, not over the top. This gives your lens and camera a more stable platform, decreases camera shake, and reduces the risk of dropping your camera because of sweaty or greasy hands.

Transference

If you happen to be shooting from an aircraft such as a helicopter or fixed-wing plane, the vibration may cause blur. Try not to let your body touch the aircraft's frame. This will reduce the amount of shutter speed of vibration that passes through your body and transfers to your camera.

In motion

When you're photographing helicopters or aircraft with propellers, it's imperative that you show movement in the blades. If not, it will appear as though they'll drop from the sky at any minute.

Shutter speed is the primary control for motion. A faster shutter speed is selected when attempting to freeze or stop a moving object. Let's say a moving car requires a shutter speed of 1/1000 of a second to stop action; well, a person running on foot may only need a shutter speed of 1/500 to stop

FIGURE 4.6 A Marine Corps CH-53 helicopter flies a routine patrol off the coast of Djibouti, Africa.

Lens (mm): 80, ISO: 200, Aperture: 25, Shutter: 1/200, Program: Manual

FIGURE 4.7 A soldier of the Iraqi Army clears a civilian's house during combat operations in Tahrir, Iraq.

Lens (mm): 20, ISO: 800, Aperture: 2.8, Shutter: 1/8, Program: Aperture Priority

the movement. How fast you set your shutter speed will depend on how fast the subject is moving. Shutter speed can also be used to show an object's motion by causing it to be blurry (sometimes referred to as motion blur). Select your shutter speed based on how fast your subject is moving and how you want to render it (**Figure 4.6**).

If the subject is stationary, nearly any speed is fine. If the subject is moving, you have creative options. You may choose to freeze motion so that your subject is stopped and appears clear and sharp. A fast shutter speed will do this: 1/250, 1/500, and higher. You may choose to blur the subject so it appears as a soft, undefined streak across the frame. A slow shutter speed will do this: 1/20, 1/15, or lower.

In the case of **Figure 4.7**, I wanted to demonstrate how quickly Iraqi soldiers moved through houses looking for enemy fighters. I knew that if I simply stopped the action, it would not convey the same movement than if I panned. By slowing down my shutter speed and moving with my subject, I gave him the appearance of forward momentum. The panning also gave me the bonus of blurring the distracting background. Now all of the attention is right where I want the viewer to look—at the soldier.

On assignments, you have to contend with camera motion and subject motion all the time. By virtue of our own heartbeats and breathing, hand-holding a camera will cause movement and could result in a blurry picture. You must then be mindful to use a shutter speed fast enough to prevent camera shake from ruining your picture. The general rule we're taught in basic photography school is to shoot at 1/60 or faster. In my opinion, that's not nearly fast enough.

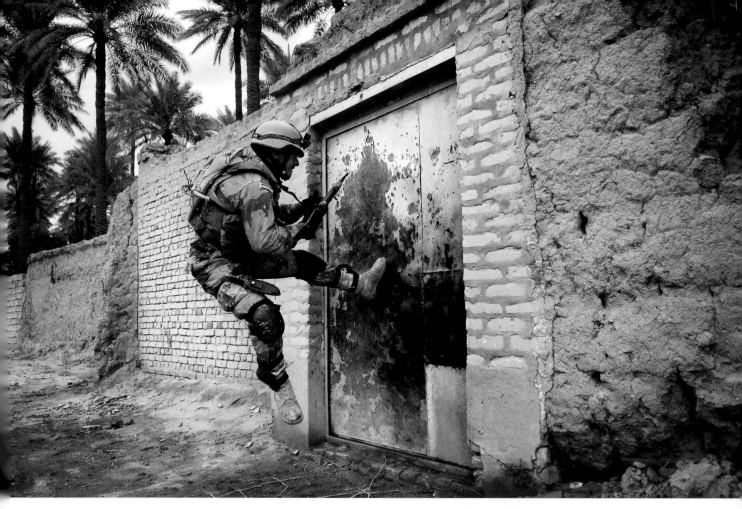

FIGURE 4.8 An Iraqi soldier makes a flying leap at a secured door while searching for enemy fighters during a cordon and search for insurgence and weapons caches in Chubinait, Iraq.

Lens (mm): 17, ISO: 400, Aperture: 2.8, Shutter: 1/1000, Program: Aperture Priority

In **Figure 4.8**, you can see that I've caught the soldier in midair as he attempted to breech the door. Unfortunately, his efforts did not yield any results, and he fell on his butt. After conducting my fair share of cordon and searches running from house to house, I learned that I needed to have my shutter speed as fast as the available light would allow. Like the soldier, I had many failed attempts at catching shots like this because my shutter speed wasn't fast enough. I was running, breathing hard, and my subject was moving, so my results were consistently soft. I began to increase my ISO slightly, so I could obtain a faster shutter speed. I didn't sacrifice the quality of the image with too high an ISO—just enough to give me an edge.

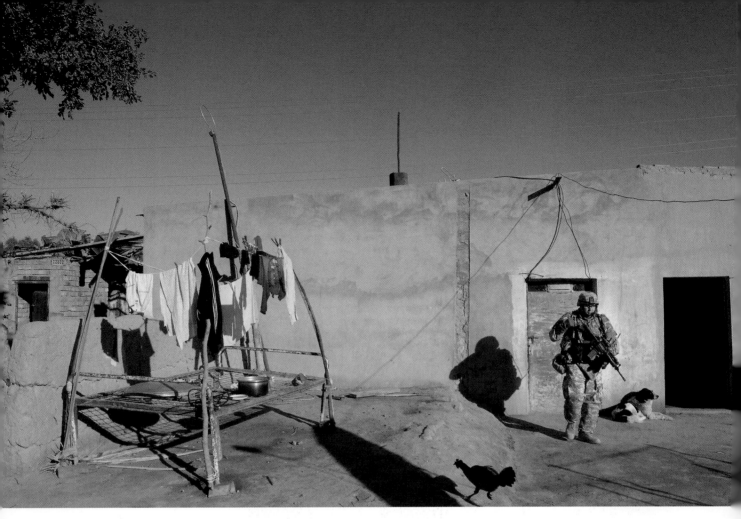

FIGURE 4.9 A soldier from the Multi-Iraqi Transitional Team runs through the yard of a civilian's house during a battle with al-Qaeda and Ansar al-Sunna forces during Operation Orange Justice in Buhriz, Iraq, in February 2007.

Lens (mm): 17, ISO: 400, Aperture: 5.6, Shutter: 1/2500, Program: Aperture Priority

Shutter speed is one of three major exposure components of IFS, and when it is adjusted to capture stop action or show motion blur, it can directly affect the exposure balance. In **Figure 4.9**, the glare of the desert sun bounced off the tan facades and sandy ground, making the entire scene extremely bright. I had the choice of compensating for the sun by increasing my shutter speed or f-stop number, and I'm not a big fan of shooting with smaller apertures. In this situation, I chose to increase my shutter speed and stop the action. If I wanted to achieve motion blur without adding more depth of field in this scenario, I could have used a neutral density filter; however, that was not the look I wanted to accomplish. Instead, I chose to stick with a higher shutter speed and let my aperture stay open.

FIGURE 4.10 A U.S. soldier smokes a cigarette as he prepares for a four-day operation in New Baqubah, Iraq.

Lens (mm): 55, ISO: 100, Aperture: 2.8, Shutter: 1/1000, Program: Manual

Finding Your Mode

Most professional cameras offer several exposure modes, often leading to confusion as to what mode to use and when to use it. I'm going to limit this section to my favorite three modes.

(M) or Manual

The Manual mode allows the photographer to select his or her own ISO, aperture, and shutter speed settings with the assistance of the camera's meter. If you follow the camera's recommended settings, this will render an average exposure; however, this mode allows you to vary from the metered settings to change the exposure and thus the tonality (lightness or darkness) of a subject.

I choose to shoot on Manual mode when I'm in a tricky light situation. Take **Figure 4.10**, for instance. The light is falling on the short side of my subject's face, which makes targeting it with my camera's meter more of a challenge. By switching to Spot Meter on Manual mode, I can achieve a more precise highlight exposure right from the start. I won't have to fuss with Exposure Compensation and miss the moment. (See the sidebar "Insights: Overriding Your Technology" for an explanation of this feature.)

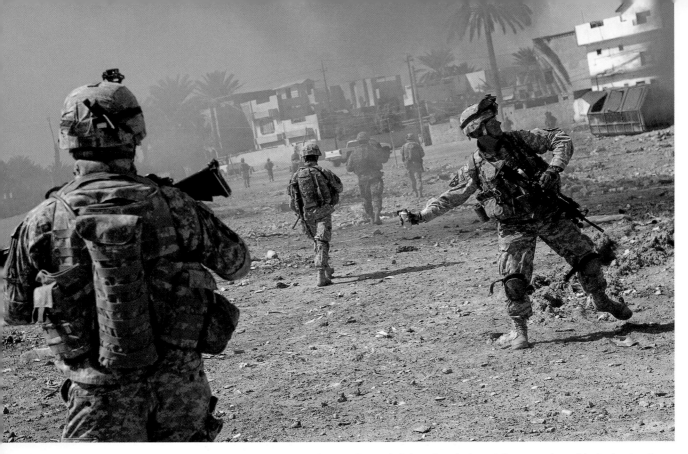

FIGURE 4.11 Soldiers from the U.S. Army pop green smoke to indicate their location during a joint operation with the Iraqi police in Baqubah, Iraq.

Lens (mm): 55, ISO: 160, Aperture: 5.6, Shutter: 1/750, Exp. Comp.: -0.3, Program: Aperture Priority

(A or AV) or Aperture Priority

Aperture Priority is a semiautomatic mode that allows the photographer to set a desired aperture. The camera will select an appropriate shutter speed to render an average exposure. Aperture is expressed in "f" numbers, such as f/11, f/2.8, or f/4.

Aperture Priority is one of my go-to shooting modes, especially for fast-paced assignments that go from indoors to outdoors. All I have to concern myself with is my ISO, because I prefer to shoot on f/2.8 and the camera determines the shutter speed. This mode gives me the freedom to concentrate on the action versus manual exposure. Plus, I can use the Exposure Compensation to make the exposure exactly as I want it if I don't quite agree with the camera's decision (**Figure 4.11**).

(S or TV) or Shutter Priority

Shutter Priority is also a semiautomatic mode in which the photographer selects a desired shutter speed and the camera sets the proper aperture, again rendering an average exposure.

As a former aerial combat photographer, a great deal of my time was spent in the air. I've photographed all types of aircraft in the U.S. Air Force, Navy, Army, and Marine Corps arsenal. Shutter Priority was definitely a handy tool for assignments involving propellers. For those who aren't familiar with planes and helicopters, propellers (or props) are the blades that spin and give aircraft momentum and helicopters lift. You want to see the motion of the props to give the sensation that the helicopter or plane is in flight. To do this, set your camera to Shutter Priority mode and use a slower shutter speed to catch the rotation. Let the camera determine the necessary f-stop to make a decent exposure without missing the moment (**Figure 4.12**).

FIGURE 4.12 A Marine CH-53E helicopter blows sand and rocks as it takes off in Harar, Ethiopia.

Lens (mm): 35, ISO: 125, Aperture: 14, Shutter: 1/125, Program: Shutter Priority

Insights: Spot Metering

Spot metering is very accurate and is not influenced by other areas in the frame. It is commonly used to shoot very high contrast scenes. For example, if the subject's back is being hit by the rising sun and the face is a lot darker than the bright halo around the subject's back and hairline (the subject is "backlit"), spot metering allows the photographer to measure the light bouncing off the subject's face and expose properly for that, instead of the much brighter light around the hairline. The area around the back and hairline will then become overexposed (**Figure 4.13**).

Figure 4.13 A U.S. Army trainee listens to a brief during the Buddy Movement Course at Fort Jackson, South Carolina.

Lens (mm): 170, ISO: 200, Aperture: 2.8, Shutter: 1/1600, Program: Manual

Metering Matters

Metering matters. I prefer to use Center Weighed Metering, a mode in which the meter concentrates between 60 to 80 percent of the sensitivity toward the central part of the viewfinder. The balance is then "feathered" out toward the edges. One advantage of this method is that it is less influenced by small areas that vary greatly in brightness at the edges of the viewfinder. In this mode, you can achieve more consistent results, as opposed to more blanket coverage metering that often results in flat exposures.

I also like to use the Spot Metering mode. With this mode, the camera will only measure a small area of the scene (between 1 and 5 percent of the viewfinder area). This will typically be the very center of the scene, but some cameras allow the user to select an off-center spot or to recompose by moving the camera after metering.

As a rule of thumb, you should aim to expose for the highlights and print for the shadows. Once the details in the whites are gone, you can't put that information back. If you attempt to burn down your highlights in post-processing, the results often turn out gray and muddy. However, if there is detail in the blacks, you can recover information using image-editing software such as Adobe Lightroom or Photoshop. It is important to remember that your camera's meter is only capable of recommending an aperture and shutter speed it thinks is appropriate. It is usually pretty accurate, but it is sometimes very wrong. Any scene that has a predominance of very bright or white subjects fools the meter into underexposure. You can correct this by increasing the exposure from the meter's recommendation—that is, open the aperture, or slow down the shutter, or some combination of the two.

FIGURE 4.14 A Humvee drives through a sandstorm in Iraq. (Photo by Andy Dunaway)

Lens (mm): 70, ISO: 100, Aperture: 2.8, Shutter: 1/3200, Program: Aperture Priority

Figure 4.14 was taken during a sandstorm in the desert, which can be a tricky metering situation. There's no apparent white highlight to speak of and no true black. In cases like this, meter for the brightest part and expose for it. You still want to maintain detail, even in the lightest parts. Without the detail, you lose the color and texture of the sand overall. In situations like these, you have to know what look you're going for and what mood you want to convey to the viewer, strategize, and then expose.

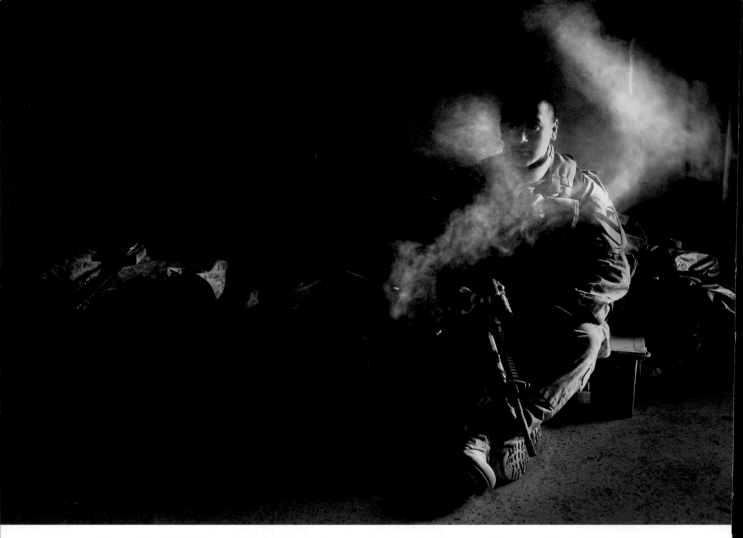

Figure 4.15 A U.S. Army soldier smokes a cigarette after engaging the enemy in a street battle during a foot patrol in Buhriz, Iraq.

Lens (mm): 20, ISO: 800, Aperture: 2.8, Shutter: 1/20, Program: Aperture Priority

Had I let the camera have its way with the exposure of **Figure 4.15**, it would have resulted in a flat mess with the highlights blown out—not to mention you wouldn't see the smoke. Instead, I exposed for the narrow sliver of light coming through a nearby door and falling on the subject. This guaranteed the room would remain black, as I saw it, and he'd be rimmed with light. Considering the fact that the soldier just survived an intense gun battle with the enemy, I thought the mood of the light fitting.

Insights: Avoiding Overexposure

Any scene containing a lot of very dark colors or blacks will fool the meter into overexposure. To fix this, you must decrease exposure from that recommended by the camera. Again, if you meter a black room, the camera will try to make it medium—hence a gray, flat image. If you want that object to look black, you must "close down," or decrease, your exposure.

Light Matters

Simply taking a properly exposed picture is only part of the equation. That's not to say you can't go around taking pictures all day long. However, you must be able to translate the story through that exposure as well. You have to be able to convey emotion by use of light, body language, angle of view, and so on (**Figure 4.16**).

My manual from the Department of Defense's Basic Still Photography Course suggested I take pictures with the sun to my back and, when in doubt, just set my camera to f/8 and shoot. Many of the guys called it the "f/8 and be there" setting. Sure, they were good go-to settings, but I wasn't creating meaningful pictures—I was just letting these rules dictate the look of my photography, not to mention the quality. One day I said to hell with all of the rules. My new mantra was, "Know the rules to break the rules."

FIGURE 4.16
A soldier's face is covered with sand after a 6-hour ride to the Syrian boarder. (Photo by Andy Dunaway)

Lens (mm): 70, ISO: 400, Aperture: 5.6, Shutter: 1/80, Program: Aperture Priority

Insights: Overriding Your Technology

Exposure Compensation: If you are working in Aperture or Shutter Priority, you can accomplish this change by using your camera's exposure compensation feature. Varying aperture or shutter speed in any automatic mode without using exposure compensation does nothing to change the exposure on the sensor. Exposure compensation is a camera setting that biases the meter reading toward a lighter or darker result. It is accessed by a button usually labeled with a +/− mark and is set in stops or fractions of a stop lighter (+) or darker (−) than the metered exposure (0).

Full Manual Mode: You can accomplish the same result using manual exposure control. In manual mode, fill the frame, or spot if using spot metering, with a mid-tone object that is in the same light as your subject. Adjust aperture or shutter speed, or both, to zero out your meter reading.

By experimentation, I came to my own conclusions. If you want to put the sun to your back, go ahead. Just remember, it takes light make an exposure, but the shadows create the dimension. Approach each scene by reading the light source first; explore the space, shift, and watch (**Figure 4.17**).

If you slow down enough to move through these motions, you'll begin to see light in a whole new way. Shoot toward or into the light to create breadth and mood. When possible, use color to convey the emotion of the scene or to push your subject forward or backward; cool colors fall back and warm colors jump forward. To distinguish the importance of your subject in their environment, avoid drastic crops into their body, while perhaps cropping others. Even your lens selection should play a part in how you want to relay the story.

Light is as fundamental to photography as an understanding of aperture and shutter speed. Great lighting is a big factor in creating a great photograph. A photograph of any subject can be improved or worsened by a change in the light in which it is photographed. To best understand how this happens, you must understand the four fundamental qualities of light: intensity, color, direction, and contrast.

Light has intensity

Intensity, the first of the four qualities, is perhaps the easiest to understand. Light can be bright or it can be dim. However, the intensity can change based on your relationship to the light source. Imagine yourself in the desert on a cloudless, sunny day. The light here is, no doubt, very bright. Now imagine yourself walking into a palm grove on that same day. The deeper in you go, the less intense the light becomes. The intensity of the sun has not changed. However, by placing palms between you and the light source, you have effectively filtered or reduced the intensity (**Figure 4.18**).

Light has color

What we consider to be white light is actually made up of equal parts of light of all colors. Again, warmer colors have a forward-moving effect, whereas the cooler colors tend to fall back. You can use this to isolate or draw attention to your subject. **Figure 4.19** demonstrates how a small amount of red can pull the viewer's eye.

FIGURE 4.17 Marine Lance Corporal Taylor K. Truen rides aboard a Marine Corps CH-53E helicopter near Camp Lemonier, Djibouti.

Lens (mm): 70, ISO: 200, Aperture: 11, Shutter: 1/80, Program: Manual

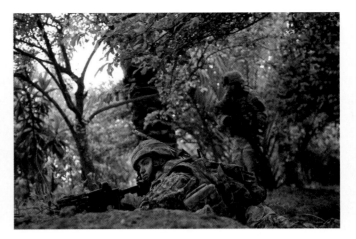

FIGURE 4.18 A U.S. Army soldier hunts down enemy forces in the palm groves in Buhriz, Iraq. This image demonstrates the theory of filtered or reduced light intensity. The sunlight has not changed overhead. However, the palms of trees over the subject's head successfully diffuses the intensity of the existing light.

Lens (mm): 38, ISO: 400, Aperture: 2.8, Shutter: 1/500, Program: Aperture Priority

FIGURE 4.19 Soldiers use a corkboard to post American and European currency with their names signed on them and messages to other military units. (Photo by Andy Dunaway)

Lens (mm): 18, ISO: 100, Aperture: 4, Shutter: 1/100, Program: Manual

In the Trenches: Dark Times

It was well after midnight when I arrived at a small combat outpost located outside a highly volatile village in Diyala Province, Iraq. I'd never met, nor documented, this particular Army unit, and it was my first time at this specific location. I was assigned to photograph these lone soldiers holding ground against the enemy. From my research, I learned the village of Buhriz was the epicenter of all enemy activity, and they were the first line of defense against the trafficking of weapons and bombs into the city. Beyond that, it was up to me to find and capture the story.

I was met by a group of somber, almost morose, soldiers covered with coal soot from head to toe. They seemed happy to see a new face, but not as excited to see my camera. After we became acquainted, they were more at ease with my presence and began to give me the rundown on their daily operations. In quick summation, the soldiers lived and operated out of a private residence, whose occupants fled when the enemy fighters began their killing spree of innocent men, women, and children. The soldiers did their best to preserve the remnants of homeowner's personal belongings and stored them on the first floor, which filled the ground-level rooms from floor to ceiling with chairs, tables, couches, cribs, and other basic household furnishings. Further illustrating the family's hasty, courageous escape were the family portraits left behind, gathering dust on the table, and the bullet holes that riddled the wall nearby. It was obvious the soldiers were impacted by their surroundings, but my intuition said there was more to the story than a group of soldiers cooped up in a creepy house.

It was too dark to shoot pictures that night, and blackout conditions made using any white light impossible. Instead, I pulled up to an upside-down apple box the soldiers used as a card table and played a round of spades. The bitter cold night air forced me to wear every item of clothing I'd brought, and I wrapped my sleeping bag around my torso for good measure. The only source of heat was a small potbelly stove they rigged using an ammo can and some old piping. Needless to say, it leaked like a sieve, and within an hour I looked like a coal miner.

As we played cards and smoked cigarettes, the soldiers revealed to me that one of their teammates had been killed by a sniper only hours before my arrival. I was shocked, but not entirely. My intuition was correct. In essence, they were stuck in their own lightless hell with only their thoughts to pass the time. In that moment, I knew that was the story. My challenge then was to illustrate that story in one picture.

As the sun began to rise, rays of light began to peak through the sandbags that surrounded the stove's pipe. With daylight safely upon them, the soldiers switched on a dim overhead bulb that managed to illuminate some of the caveman art they'd created with the soot on the walls. I stepped back to observe the light as the soldiers gathered around the stove to warm themselves. They began to talk about their friend they'd lost and exchanged fond memories. I picked up my camera, metered the small pool of light emitted from the outside, and waited. One soldier's face caught the sunlight and stood out among the sea of darkness. They continued to laugh at funny anecdotes and shared what they would miss about their fallen comrade; then the room went silent. All seemingly lost in thought, they bowed their heads in remembrance. That was the critical moment (**Figure 4.20**).

Their body language speaks volumes, but it's the light that makes the picture so evocative and telling. Photography is subjective, but I feel the dark shadows represent their loss and the struggle they were enduring in that moment, while the small pool of light on the soldier's face illustrated the ray of hope they had inside for the future.

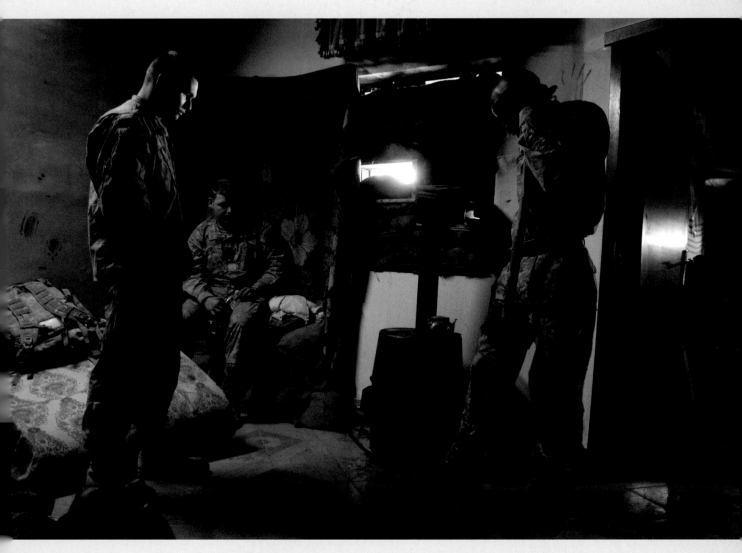

FIGURE 4.20 A short time after a member of their team was killed in action not too far from where they stand, soldiers continue to stand guard in the watch tour of an Iraqi police station in Buhriz, Iraq.

Lens (mm): 17, ISO: 800, Aperture: 2.8, Shutter: 1/13, Program: Manual

Insights: Full Frontals and More

Frontal lighting is the most elemental form of lighting. Although it can be great go-to lighting for some, it can also be flat, shadowless, and featureless. I'll only use this type of lighting if I'm stuck in press pool and have no other choice or it lends itself to the feel of the photograph. **Figure 4.21** is an example of frontal lighting.

Side lighting can be used by the photographer to show shape, texture, and form. Side-lit subjects create their own shadows and therefore a highlight side and a shadow side. This self-induced shadow allows the subject's true shape and form to show (**Figure 4.22**).

Back lighting can reveal shape and form differently, and in some cases will make your subjects appear to glow. One interesting side effect of backlighting is what we call "rim light." Rim light occurs when the source for the backlight is slightly above the subject and is the thin strip of highlight along the upper edge (the rim) of the subject. Rim lighting adds definition to the edges of the subject and can help to separate the subject from the background (**Figure 4.23**).

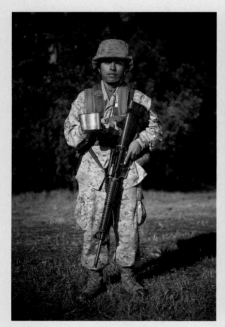

FIGURE 4.21 Marine Corps recruit José Delgado stands near the obstacle course at Parris Island, South Carolina.

Lens (mm): 70, ISO: 400, Aperture: 2.8, Shutter: 1/6000, Exp. Comp.: -0.5, Program: Aperture Priority

FIGURE 4.22 U.S. Army Sgt. Vashon Bolton waits for his squad relief at the Iraqi police station in Buhriz, Iraq.

Lens (mm): 24, ISO: 400, Aperture: 2.8, Shutter: 1/80, Program: Manual

FIGURE 4.23 U.S. Army Spec. Quinton Green looks for weapons and bomb-making materials during a cordon and house-to-house search in Sadiyah, Iraq.

Lens (mm): 30, ISO: 200, Aperture: 2.8, Shutter: 1/800, Program: Manual

FIGURE 4.24 After being relieved from guard duty, U.S. Army Spec. Orlando Garcia takes a smoke break at the Iraqi police station in Buhriz, Iraq.

Lens (mm): 55, ISO: 400, Aperture: 2.8, Shutter: 1/60, Program: Manual

Light has direction

When we express the direction of light, we always do so from the perspective of the subject. Front light is that light which strikes the front (or camera side) of the subject. Sidelight is light that strikes the subject from either the left or right sides. Back light is light that illuminates the back (opposite camera) side of the subject.

Simply because you're shooting uncontrolled action in natural light does not mean you relinquish the power to move yourself into a better light direction. If a window lights your subject straight on with flat light, move yourself until the light is short or rimming your subject's face. It's that simple (**Figure 4.24**).

Light has contrast

Observing the shadows is the easiest way to identify contrast. Distinct, deep, hard-edged shadows are evidence of harsh light. The harsh light of bright, cloudless sunshine is difficult to photograph in, especially if that harsh light is also sidelight. It can

be difficult to come up with an exposure that will show detail in the shadows and not overexpose the highlights. Likewise, it can be difficult to expose for the highlights without completely losing the shadows. It's up to you as the photographer to choose the most pleasing, and sometimes least adverse, alternative. When faced with no other choice than to shoot in high-contrast light, I try to find unique ways to work around the unattractive lighting.

For instance, **Figure 4.25** was taken around one o'clock in the afternoon and not a cloud in sight. I had no choice but to shoot under terrible lighting conditions. So I opted to disguise the nasty light with the environment around my subject—in this case, bars on a window.

Soft light—the light of an overcast day for instance—is the quality of light most photographers prefer (**Figure 4.26**). Soft light seems to wrap around and envelop subjects. It's great for color because there are no hot spots or overexposed areas to detract from a subject's true color. Light, whether bright or dim, always has direction and color. Although I can appreciate soft light situations, they aren't my favorite. I prefer more direct, contrast-laden light. Shadows are what I build my pictures around to create mood and dimension. If I choose to use a softly lit image, it's because the moment outweighs the light.

FIGURE 4.25 A U.S. Army soldier rummages through the rubble of a bombed-out building during a cordon and search for weapons caches and anti-Iraqi forces in Old Baqubah, Iraq.

Lens (mm): 23, ISO: 200, Aperture: 2.8, Shutter: 1/2500, Exp. Comp: -0.3, Program: Aperture Priority

FIGURE 4.26 Marine Corps recruit David Briones stands in formation during physical training at Parris Island, South Carolina.

Lens (mm): 66, ISO: 400, Aperture: 2.8, Shutter: 1/1500, Exp. Comp.: +1.0, Program: Aperture Priority

Coloring Your Characters

Photographers can bring any color forward or push it back, depending on what other spatial tricks they use. An object with a complicated contour is more interesting and appears to be heavier than one with a simple contour. A small complex object can balance a large, simple object. Hues that are lighter at maximum saturation such as yellows, oranges, and reds appear larger than those that are darker at maximum saturation like blues and purples. When a color expands visually, it may also seem closer to the viewer than those that seem to contract, leading to the common statement that warm colors appear closer and cool colors fall back.

FIGURE 4.27 A U.S. Air Force B-2 Bomber flies with two F-117 fighter aircraft. (Photo by Andy Dunaway)

Lens (mm): 55, ISO: 3200, Aperture: 2.8, Shutter: 1/13, Program: Manual

Value

A color's value is the lightness and darkness of a color. For example, imagine a red apple on your kitchen counter with one light falling on it from overhead. The part of the apple nearest the light will be lightest in value because it reflects the most light. The part of the apple opposite the light will be the deepest in the shadow and thus darkest in value.

So now let's apply that theory from the red apple to an airplane. The same concept applies. You can use the available light to change your subject's value. The plane pictured in **Figure 4.27** looks rather menacing because the part of the plane closest to the sun happens to be the back, which makes the identifiable "face" of the aircraft elusive.

Monochromatic

Monochromatic refers to one color in varied tones such as varied reds or varied blues. A monochromatic color scheme uses only one hue (color) and all values (shades or tints) of it for a unifying and harmonious effect.

When someone references the word "pictorial," I immediately think about graphic lines, repetition, and dramatic use of color. This includes the use of monochromatic color choices, as **Figure 4.28** demonstrates. Throughout the image are varied shades of yellowish-orange tones. Though the brightness is varied, the color is not, which contributes to the image's dramatic mood.

FIGURE 4.28 As the sky turns ominous, U.S. Army Sgt. Kyle Ellison searches the roof of a local's house for weapons during an assault against anti-Iraqi forces in Buhriz, Iraq.

Lens (mm): 40, ISO: 640, Aperture: 2.8, Shutter: 1/1250, Program: Aperture Priority

Insights: I Feel in Color

Warm Color Spectrum: Warm colors such as red, orange, yellow, and even white suggest warmth and seem to move toward the viewer and appear closer. I use warm colors to draw more attention to my subjects and, when possible, situate them in front of dark, cool colored backgrounds to further pull them forward. In the case of **Figure 4.29**, I used the reds, oranges, and yellows to further illustrate the soldier's youth, inexperience, and energy.

◆ Red: This color is often associated with apprehension or wariness. It also evokes powerful ideas and emotions such as passion, energy, blood, and war. Red is a good color to use for accents that need to draw the eye's attention.

◆ Orange: This color is considered aggressive and conveys energy. To the human eye, orange is a hot color, so it gives the impression of heat.

Cool Color Spectrum: Colors such as blue, purple, and green suggest coolness and seem to recede from a viewer and fall back. Cool colors are usually calming and soothing but can also express sadness. I use cool colors to help evoke the mood of the situation I'm in. For example, in **Figure 4.30**, the sergeant is alone and solely responsible for the rest of the soldiers under his command. The green helps further identify him as a solitary military man with steadfastness and reliability.

◆ Blue: This is a color of reliability, strength, knowledge, and conviction. Blue works well as both a background and accent color in your photographs.

◆ Green: Dark green is commonly associated with the military and money. Green suggests stability, endurance and, as opposed to red, connotes safety.

FIGURE 4.29 An Iraqi army soldier searches a local's bedroom during a foot patrol in Buhriz, Iraq.

Lens (mm): 17, ISO: 800, Aperture: 2.8, Shutter: 1/15, Program: Aperture Priority

FIGURE 4.30 From his command tank commander's position, U.S. Army Sgt. 1st Class Michael Gibson directs a convoy of M1A2 Abrams tanks down a road in Kahn Bani Sahd, Iraq.

Lens (mm): 17, ISO: 800, Aperture: 2.8, Shutter 1/30, Program: Aperture Priority

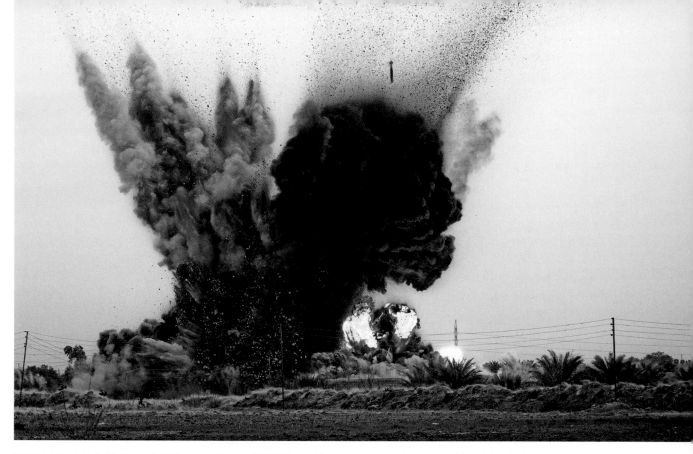

FIGURE 4.31 A U.S. Air Force B-1B Lancer drops a GBU-38 munitions on a torture house used by al-Qaeda forces in northern Zambraniyah, Iraq. (Photo by Andy Dunaway)

Lens (mm): 116, ISO: 100, Aperture: 4, Shutter: 1/500, Exp. Comp.: -1.0, Program: Aperture Priority

Color movement

Color can create a sense of movement. When the values in a work jump quickly from low key to high key, a feeling of excitement and movement is created. When all of the values are close together, the work seems much calmer. When you want to create movement with color, remember to use values of pure hues as well as those of tints and shades. Movement creates the illusion of action or physical change in position (**Figure 4.31**).

FIGURE 4.32 A barrel full of human waste burns on the outer perimeter of a forward operating base in Afghanistan. (Photo by Andy Dunaway)

Lens (mm): 28, ISO: 100, Aperture: 2.8, Shutter: 1/125, Program: Manual

Color coordination

Complementary colors are two colors opposite one another on the color wheel— for example, blue and orange, yellow and purple, or red and green. When a pair of high-intensity complementary colors are placed side by side, they seem to vibrate and draw attention to the element. Not all color schemes based on complementary colors are loud and demanding. When complementary colors are used in photojournalism like in **Figure 4.32**, you can take a drab topic and illustrate the subject uniquely.

The 10-Frame Methodology

I used to be a spastic shooter who'd shoot a picture, and move, shoot another picture, and move again. It wasn't until one of my mentors suggested I slow down, stay in the moment, and follow through that I self-implemented the 10-Frame Methodology. It is my guideline for solving nearly all photographic problems while on assignment. The concept is simple. Slow down and become more deliberate in your photography. Don't jump on the first item or scene that you see. Spend some time looking for the best subject or greatest vantage point. Spend more time looking and less time shooting. Once you've found the ideal composition, sit and wait for the right moment. Let the action come to you. Make 10 frames without moving your composition. If you commit to making a picture, then really commit (**Figure 4.33**).

FIGURE 4.33 A U.S. Army soldier stands guard near a window while his buddy takes a break in front of the television, which is playing Iraqi cartoons, during a raid in Baqubah, Iraq.

Lens (mm): 17, ISO: 800, Aperture: 2.8, Shutter: 1/100, Program: Manual

I'll walk into a situation and assess what's happening—not only with the subjects but with the light, too. I'll move around the room until I find the best possible vantage point and advantageous light. Once I'm satisfied, I'll hunker down. I can look back at a day's take and see sequences of various scenarios where I haven't moved a millimeter (**Figure 4.34**).

In high-stress situations, it's easy to let the pace of actions happening around you dictate how quickly you shoot. You go from being selective and thoughtful to the "spray and pray" method: shooting randomly without any idea of what you're actually doing. You slam the shutter release button at anything that moves and pray it turns out. That's when it's important to remind yourself that there's always something going on. There are always moments you'll miss. All you can do is be ready to make a successful picture when the time is right and the action unfolds in front of you.

FIGURE 4.34 This is one of my contact sheets, which shows how I use the 10-Frame Methodology while shooting. The variances of the action happening in each frame are small, but those little differences pay huge dividends in the end. After all, it is the simple change of gesture, posture, or expression that transforms the entire mood of the picture.

My final thought for this chapter is to be patient and allow time for all of the factors we discussed to fall into place. Be an observer of light and color—use it to convey a message or emotion. Your technical routine must become second nature so your mind can be free to focus on the story.

Once you settle into a scene, think about how to make a picture that best tells your subject's narrative without bias, as creatively as possible. Focus on the action as it comes into your frame; let the action come to you—don't chase the action. When it feels right, release your shutter.

When you're in an out-of-control situation, you're still in control of your camera. Be present enough in the situation to know the dangers around you, yet block out the unnecessary distractions that may detract your focus. Set yourself up for success. The world will continue to spin even if you're not shooting. So take the time to put yourself in the best possible place to capture the story and it will come to you.

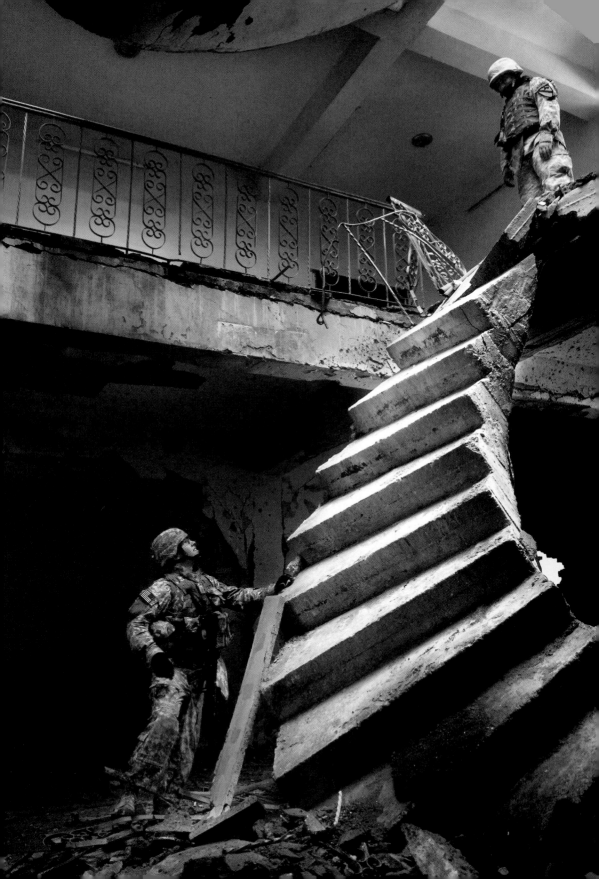

CHAPTER 5

COVERING ALL THE ANGLES

"You must look at your photography career as if it were a ladder. Have high aspirations, but start small. You can't leap from the ground and expect to hit the top rung. It's a process that requires you take each step up the ladder, and as you climb upward you'll gain more experience both visually and professionally."

—Jimmy Colton, veteran photo editor of the Associated Press, *Newsweek,* Sipa Press, and *Sports Illustrated*

With 40 years of experience working with photojournalists, Jimmy Colton knows what he's talking about. For me, he's been an incredibly inspirational mentor and trusted friend. I met Jimmy at the apex of my military photography career and the start of my freelance endeavors. My transition from life in the military to the civilian side of photojournalism was quite a learning experience. Though my formal training as a photographer was equivalent to my civilian counterparts, life as a photojournalist on the "outside" was a new world. Before, my pictures had a definitive purpose, function, and end point, whether that was print publication, web content, documentary support, or simply archival purposes. However, on the civilian side of the fence, I was left with no assurances—even if I was on assignment for *USA Today,* Associated Press, or Aurora Photos. To further complicate matters, the newspaper industry was dwindling, staff jobs were slashed, I was competing with unemployed Pulitzer Prize–winning photographers, freelance assignments were sporadic, and there wasn't exactly a flood of work in my home state of South Carolina.

A soldier unsuccessfully attempts to access the upper levels of a building by using a bombed-out staircase in Baqubah, Iraq.

Lens (mm): 18, ISO: 400, Aperture: 2.8, Shutter: 1/80, Program: Aperture Priority

Taking on the "Real" World

Even as a battle-hardened and tested photojournalist, nothing could have prepared me for the shock of the "real" world. From the time I exited the military, I learned to absorb all I could from wise folks like Jimmy and my fellow photographers, whose guidance helped me gain my footing as a freelance photojournalist. Along with what I've learned in my experience as a combat photographer, and as a freelance photojournalist, I'd like to share a few things that will come in handy as you develop your own career.

Hustle

That's one descriptive word used by many photographers to describe the life of a photojournalist. There was a time in my life when I didn't concern myself with money issues or health benefits; I was taken care of. As a military combat photographer, I made a steady paycheck, had a roof over my head, and even had a good dental plan. Now as a freelance photographer, there's so much more at stake. If I fail, it's not anyone else's doing. I have to push forward, work hard, and not waste any minute of the day. Working 12- and 14-hour days is normal, and perhaps only 5 or 6 of those hours are actually spent shooting. The rest of the time is consumed with researching stories, calling subjects, traveling, captioning, editing, invoicing, and coordinating other shoots. And this is just for your average domestic assignments.

Supplement your income

One may question the sanity of staying in this grueling profession, but I don't do photojournalism for the money. I stay because the benefits of this career outweigh the long hours and small paychecks. The rewards come in the form of relationships I build with my story subjects, knowing I've made an impact on important issues, and seeing my pictures move viewers emotionally. I don't do photojournalism to draw attention to myself but rather to those I photograph. I fund my career as a photojournalist, which I lovingly refer to as my "crack habit," through other means of work such as commercial photography, private tutoring, and teaching. These additional jobs are also gratifying in their own right. I've known other photojournalists who shoot weddings, portraits, and products for catalogs. This doesn't diminish their stature as professional photojournalists but offers a means to finance personal projects.

Another way to approach funding is through grants such as the Open Society Foundation, Alexia Foundation, Getty Images Grant, The Pulitzer Center, The Eugene Smith Grant, Magnum Foundation Emergency Fund, and The Fledgling Fund. Grants are diminishing too and can be competitive, so be aware that the likelihood of earning extra income through grants is slim.

Continue your education

Technology and our industry continue to change, so we must stay ahead of the curve. As a photography educator, I see the advancement of our business from both an operator's and an educator's perspective. I've witnessed those who are reluctant to embrace change left in the dust by those who more willingly accept the future. As web-based content continues to evolve and consumers' needs and demands change, we're required to learn how to best present our imagery for online viewing, whether that's capturing accompanying audio clips, editing with Adobe Premiere or Final Cut Pro, or even shooting video. I regularly attend

workshops, webinars, and expos to expand my knowledge and to stay competitive. On a daily basis, I read industry-related blogs and forums to stay current on new technology, software, and media trends.

Build relationships

I've found the greatest benefits come from friendships I've developed with other photojournalism professionals, whether they're photographers, editors, art directors, writers, or videographers. I have friends who are equipment vendors and camera salespeople. They've taught me new perspectives, unique story approaches, innovative shooting techniques, and inventive ways to use equipment. I don't care whether they exclusively shoot sports, write political columns, or document with video; their insights have compelled me to think differently on assignment. That firsthand knowledge from their experiences is the best education I could acquire. It then becomes my responsibility to translate that information into my daily routine in my own distinctive way.

Maintain friendships

Making friends is one matter—keeping them is another. That's why I pride myself on fostering the relationships I have worked so hard to build. As the Golden Rule suggests, I'm respectful and courteous, and I do not burn bridges. I'm ever mindful of how my personal and professional actions may impact others, and I strive to give back to those who have given me so much. In return for their support and expertise, I try to offer the knowledge and resources I have and pass on what I've learned as freely as I received it. I demonstrate my support for their projects with verbal affirmation and encouragement as often as possible and promote their work through the channels and connections I have without any expectation of reciprocation. Some

would argue that I'm promoting my competition, but I don't see it that way. I'm simply helping a friend and highlighting my profession I love dearly by doing so.

Collaborate

Be willing to recognize your weaknesses, and find others who will work to help you. I'm lucky because I'm married to another photojournalist, Andy Dunaway, so we talk shop and collaborate all the time. Hell, even our pillow talk is about photography. Between the two of us, I'm the artistic, philosophical type and he's the cynical, techy-geek kind. And I can say that because we're married! Each trait has its merits and pitfalls, but together can be harmonious. I'm a solid lighter, and he's excellent at remote camera triggers; I'm decent with Final Cut Pro, and he's good at setting up microphones for audio. By reaching out to others for collaboration, you're not only benefiting yourself and your colleague, but also maximizing the full potential of your photo project.

Don't be a hater

There's nothing I despise more than hearing photographers in our business "hate" on other photographers for their successes. It accomplishes nothing but the erosion of camaraderie and the demoralization of our industry. A photographer's injudicious comments only demonstrate that photographer's personal insecurity—and it's probably just misplaced envy. Don't begrudge others for their success; use it to inspire better work from your own hands. Moreover, don't let vile words discourage you from your efforts. I'm not going to start singing "Kumbaya," but now more than ever is a time for us to muster support for one another, and if you have nothing nice to say, don't say anything at all.

Be your own advocate

You must be an advocate for your work by showing your portfolio to editors of publications and agencies you're interested in working with, and be sure your portfolio is tailored to that publication's genre. (If you're interested in sports, don't shop your book to *Southern Living*.) It's imperative you have someone other than yourself edit your portfolio. I'd like to think I do a good job of editing my own work, but it's not true. I'm too connected to the stories and experiences that surround each photograph, and I unknowingly let that influence my edit. In turn, I include lesser-quality photographs in my book based on emotions and not visual impact. Jimmy Colton's best advice is to show your work to others in your industry—and those who are not, such as your mom, dad, plumber, or car salesman—because they too can recognize a good photo versus a bad one. He also says you're only as good as your weakest photo and that if the consensus is that people don't like the image, then it's probably not a good image. So true. Once you've got a solid book in hand, make appointments to see the editors of the publications you'd like to shoot for, and remember that first impressions are the lasting ones. Dress the part, remember your customs and courtesies, and follow up each interview with a handwritten note of thanks—regardless of the outcome.

If you're going to meet an editor and ask for assignments, it's best to familiarize yourself with who they are first. There's a wealth of information on the Internet, so find out what important projects they have been involved with and why their work inspires you. I'm not suggesting you stroke their ego, but just be sure you don't insult them with your cluelessness. For instance, Maura Foley is a picture editor at *The New York Times*, and she previously edited for *People Magazine*, *Sports Illustrated*, and Duomo Photography. She was also an editor on the *A Day in the Life of the United States Armed Forces* project, a collaboration by civilian and military photographers who photographed the military for one 24-hour period and created a tabletop book. That project would be something I could relate to in terms of my work. So, if I were to meet with Maura, I might mention that project, which in turn might spark a conversation about my time in service, military history, and combat photography, and segue into a discussion of my portfolio. My investment of time getting to know Maura before meeting her would help put my thoughts in order, generate talking points, and put me at ease during our conversation, putting Maura at ease as well.

Get inspired

One might argue that we've reached an impasse in photography where no idea is original. On the flip side, an argument could be made that an individual's vision precludes duplication from happening. Either way, I'm a big proponent of studying other photographers' work—not with the intention of replicating them, but to spark inspiration. In this chapter, I'll share work by other photographers I admire who specialize in all types of genres. It's important you find photographers who arouse your creative muse, too.

Where to Begin or Start Again

I often receive correspondence from photojournalists who are interested in war documentation or overseas assignment work. Some are recent photography graduates; others are established photographers who are in a rut and looking for a new challenge. My initial reaction is to ask about their motivations, intentions, and goals. The majority believe that shifting to this type of work is the best way to launch or further their careers, whereas others see it as an opportunity to take dramatic, iconic photos. However, in my opinion, you can't create an iconic photo simply by placing yourself in photo-rich environments. Granted, you can take compelling images, but whether a photo becomes iconic is up to the viewing public to determine. Furthermore, photographing conflict-related assignments is a hell of a way to jumpstart a fledgling career—trust me, I know.

I don't discourage photographers from their aspirations, but I do try to instill reasonable goals. If your goal is to cover conflict, or periphery stories, I always suggest a gradual escalation toward that goal, regardless of field experience. After all, each step toward one's goals is as important as achieving the end goal itself. For example, someone who watches a YouTube video on performing a root canal isn't automatically a dentist, nor is someone who purchases a violin suddenly a musician. I suggest that photographers who are headed down the path of high-risk assignment work start by building portfolios and preparing visually, technically, and mentally—and doing so close to home.

I'd been a photographer in the military for 5 years before receiving my first combat-related photo assignment. Until that point, I focused on preparing myself for that first venture through various routine and self-generated photography projects. I did travel abroad to cover various non-combat-related stories, which further primed me to connect the two challenges of working overseas alone and covering high-risk assignments. That said, I don't believe you have to get your passport stamped to be in a position to make good pictures and gain field experience. Actually, you can find many stories right in your own backyard to help you develop your photographic prowess.

There are limitless stories right at your fingertips that will help push you creatively while increasing your skills. I suggest working on personal projects nearby that are of interest to you. As Jimmy Colton says, "Get your feet wet before your entire body." These close-to-home projects will help you transition more smoothly into international assignment and high-risk environments where the stakes are much higher and the pressure is on.

Expand your knowledge

Even though I'm an established photographer, I take every opportunity to grow and expand my skills while at home. As often as possible, I'll hang out with another professional photographer for a day or two, Skype with a college professor, or chat on the phone with an editor. I even volunteer my time to various photography organizations such as the Eddie Adams Workshop, because I can learn just as much from the students as they can from me.

In the Trenches: Birth Control Glasses

I wanted to do a personal project close to home, and there was an Army basic training base about an hour's drive from my house that I chose to cultivate for a photo story. The challenge was developing a picture story that no one had covered yet. I'd seen many pictures of young Americans climbing wood walls, crawling through mud, and getting their asses reamed out by drill instructors. I didn't want to re-create these images. So I began to think about my own experiences during boot camp and what the average nonmilitary person might find interesting.

The idea came to me during a site survey when I saw soldiers being issued military glasses, which we refer to as birth control glasses, or BCGs. I've got a pair of my own that I keep around for nostalgia's sake. I used the BCGs as a catalyst throughout my story and focused my efforts on telling the trainee's story by way of the glasses. This angle allowed me to share something unique about soldiers' training experiences and add a little humor to the storyline (**Figure 5.1**).

Over the span of a couple months, and between regular assignments, I made three trips to Fort Jackson to shoot. Each time, I covered a different aspect of Army basic training, but not the same soldier. The object that unified the story was the glasses, not the person. Once I felt I'd adequately documented the story, I enlisted the help of a dear friend and incredible photojournalist, Vince Musi, to help me edit down the piece. It was his expertise and exceptional creative visualization that helped make my personal project sing. It was also his encouragement and support that led to my BCG project being featured at the LOOK3 Festival of the Photograph in Charlottesville, Virginia (**Figure 5.2**).

I stood in the back of the crowd as my pictures cycled through and I heard chuckles and laughter from the festival attendees. Mission accomplished.

FIGURE 5.1 U.S. Army soldiers stare at each other's glasses during Basic Combat Training at Fort Jackson in Columbia, South Carolina.

Lens (mm): 150, ISO: 200, Aperture: 2.8, Shutter: 1/1000, Program: Aperture Priority

FIGURE 5.2 A U.S. Army soldier crawls through a covered bunker during Basic Combat Training at Fort Jackson in Columbia, South Carolina.

Lens (mm): 55, ISO: 640, Aperture: 2.8, Shutter: 1/80, Program: Aperture Priority

Insights: EAW

The Eddie Adams Workshop (EAW) is an intense 4-day gathering of the top photography professionals, along with 100 carefully selected students. The photography workshop is tuition-free, and the 100 students are chosen based on the merit of their portfolios. I attended as a student years ago and had Pulitzer Prize–winning photographer Todd Heisler as my leader. He, among so many other great photojournalistic minds, changed my entire perspective, and has provided continuous inspiration in the years since. As long as they'll have me, I'll continue to volunteer my time (**Figure 5.3**).

Bill Eppridge photographed primarily for *Life* and *Sports Illustrated*. He's documented wars, political campaigns, heroin addiction, the arrival of the Beatles in the United States, the summer and winter Olympics, and perhaps the most dramatic moment of his career, the assassination of Senator Robert Kennedy in Los Angeles. The work of Ami Vitale, Todd Heisler, and Deanne Fitzmaurice is equally astounding, and they're considered some of the finest photojournalists in the profession today.

FIGURE 5.3 Photojournalism icon Bill Eppridge (center) talks with Ami Vitale (left), Todd Heisler (center right), and Deanne Fitzmaurice (right) during the 25th anniversary of the Eddie Adams Workshop.

Internships

The knowledge you'll gain during internships is immeasurable, and there are a number of wonderful positions, both part-time and full-time, offered by major print publications and photographic agencies. Each position's requirements are varied, but you may end up cataloging imagery, aiding production, researching stories, and assisting the editorial department. The important part in searching for an internship is aligning yourself with a publication or agency you're interested in working for. Pay close attention to the photographers, their approach to assignments, and the way their pictures are used. Their practices can transform your own shooting techniques.

Apprenticeships

In the military, we refer to the process of gaining experience as "earning your stripes." One of the best ways to do this is by assisting other photographers. Photojournalists are mostly independent workers, and prefer to operate solo. However, some are amenable to having an apprentice or assistant. Don't assume the answer will be no, so be bold and ask if they'd like an assistant. Select a photographer you admire and would like to learn from and just ask if there are any opportunities; perhaps they won't have a position for you but are willing to be your mentor.

Small markets, big rewards

Approach your local papers or regional magazines about contributing or freelancing for their publication. In my hometown of Charleston, South Carolina, we have a small circulation magazine called the *Lowcountry Dog* that focuses on the southern dog lifestyle. I am an animal fanatic, especially dogs and horses. The magazine often calls upon me to photograph stories related to the military working dog or law enforcement K-9 units. The assignments I receive from them are very rewarding, help pay the bills, and are local shoots to boot. Additionally, I make new contacts that lead to other paid or personal projects (**Figures 5.4a** and **5.4b**).

FIGURE 5.4A Staff Sgt. Jonathan Campbell and his working dog, Rony, sit on an obstacle at the agility course located on Charleston Air Force Base in South Carolina.

Lens (mm): 56, ISO: 200, Aperture: 13, Shutter: 1/200, Program: Manual

FIGURE 5.4B This is the *Lowcountry Dog Magazine* cover I did for the Hero Hounds project.

Insights: The Social Network

The web is a really great way to get your name out there, connect with others in your industry, and start a buzz about your personal projects. I've got a Vimeo account and YouTube channel where I share my multimedia pieces. I also have accounts with LinkedIn, Twitter, Facebook, and Google+, where I link up with friends, photographers, editors, and other industry colleagues while also meeting new folks. I wouldn't suggest posting pictures of you doing keg stands at a New Year's party; those may come back to haunt you professionally. To go a step further, I don't recommend using a crazy email address names or Twitter handles such as sexygirlphoto22@gmail or @drunkphotog69. It's just off-putting. Simply using your name averts any misconceptions about your lifestyle, makes you easier to find, and gives a better initial impression.

I take assignments from both large-market and small-market publications, because they're equally fulfilling and important. Jimmy Colton says, "There are two things in life you need to satisfy, your rent and your heart. Meaning, you may have to do those odd jobs and things that you may not like, but that bring income such as weddings and catalogues. This way you have the money you need to pay the bills and perhaps save some for those things that mean something to you." As I've already said, I pad my wallet through other means of work, but I'm emotionally fulfilled through photography. For me, it's irrelevant whether the circulation is one hundred or one hundred thousand.

Get your work out there

Every freelance photographer should have a website with a current online portfolio, as well as a marketing plan. I suggest using an HTML-based website so potential clients can view your work on all platforms, including Apple products. I use PhotoShelter as my website, because it's search engine optimized (SEO), it's Apple compatible, and it allows for uploading and sharing of private or public picture galleries with clients while on assignment anywhere in the world. I can monitor site traffic, create image galleries for social media, sell prints and stock photography, and market directly from my site. I have a blog where I share past and current projects, and a newsletter that viewers can subscribe to as well. But be warned: Simply having a web presence and blog will not bring the editors calling. It all comes down to energetically, creatively, and persistently sharing your work with the right people.

Have business cards at the ready. I've seen cards that only have the photographer's name. Uh, okay? I find that a bit pretentious, as if to say, "Just Google me, I'm famous." Whatever. My card has my website, office email, physical address, phone numbers, Twitter handle, and Facebook username. That way, there's no reason the recipient of my card can't be in touch.

Aside from my website and cards, I generate press releases based on my current personal projects and share them with local media. Often they'll publish my release in print or online and include a selection of images I've provided. Because most of my personal projects are philanthropic in nature, the readers of my press releases are inspired to contribute their time, money, or both to my endeavors. There have also been instances where the national news has picked up the release as well. And more eyes on the project can't hurt.

Find an agent

It used to be that established photographers would approach an agent because there was too much work coming in, and dealing with the contractual, financial, and invoice side of the business was too overwhelming. The current economic climate has changed that. Now photographers are seeking representation to generate new clients and assignments. Getting representation isn't necessarily going to spontaneously produce work, which is why the sole responsibility lies with the photographer to continue to shoot, evolve, and create good photography.

Agencies are typically very competitive; however, they always need diverse photographers of many genres. Some photo agencies such as VII, NOOR, and Magnum are owned by their photographer members and have a small, selective pool of shooters. On the other hand, larger agencies such as the Associated Press (AP Images), Getty Images, Reuters, and Agence France-Press (AFP) have hundreds of freelance photographers worldwide who specialize in everything from politics to sports, covering diverse subject matter. They also have a number of staff positions, but those positions are highly competitive. Just remember that we all start somewhere and there's great reward as a freelance photographer whether it's with an agency or on your own.

Diversifying Your Work

"Take photos of everything. Making pictures is the same as creating music. There will be high notes, mid-tone notes, and the notes that soar, taking you to heights of beauty or to the depths of darkness, depending on your immediate worldview of the moment. In any case, it takes a lot of practice and exposure to ongoing life in order to advance to a point of maturity where you are able to intelligently define what you see with a camera," says Ellis (Eli) Reed, award-winning Magnum photographer and professor of photojournalism at The University of Texas at Austin.

From the beginning of my career, I was taught you can either be a jack-of-all-trades or a master of none. Some suggested I should stick to what I know; others told me to be well versed in all aspects of photography. So who's right? One of my biggest heroes, the late Eddie Adams, always referred to himself as a photographer, not a photojournalist. I believe he meant that he didn't want to be labeled or pigeonholed into one aspect of photography, but rather known as someone who used every photographic tool to best express the story visually. He not only had the ability to capture and convey the

human side of war, but also possessed the skills to create evocative portraits worthy of *PARADE Magazine* covers.

I tend to agree with the philosophy of shooting all types of subjects in all manners of techniques with every tool available. You may see yourself as a natural light photographer, but that's no reason to ignore the positives of supplemental lighting. You may want to focus your efforts on combat coverage, but shooting sports can sharpen your skills and abilities at documenting the fast paced rigors of war; and you may be averse to photographing lifestyle pictures, but they can help hone your awareness to human nature and interaction. No matter what, don't be so focused that you walk around with virtual blinders on—that's counterintuitive. Be open, observe, and explore.

Within photojournalism, there are a number of rewarding fields for photographers who like variety or who are looking to specialize. I've found that I'm drawn to topics related to the military and peripheral subjects. However, that doesn't mean I'm limited strictly to documentary work and war coverage. I've worked on projects ranging from lit portraits of veterans to military lifestyle projects. Each offers a unique angle and approach to the assignment at hand (**Figure 5.5**).

General News

News generally refers to everyday assignments that are planned or organized in advance, such as protests, court hearings, and awareness rallies, and within general news documentation are many subcategories, such as feature, sports, and portraits. These topic areas can be quite diverse, requiring a photographer to be well versed in many subjects, but they can also be rewarding in that one assignment is visually and editorially different from another.

FIGURE 5.5 Former Army infantry medic Duane McGarva poses for a portrait.

Lens (mm): 170, ISO: 200, Aperture: 9, Shutter: 1/200, Program: Manual

FIGURE 5.6 Jumping boys known as "The Lost Boys of Sudan," at the United Nations refugee camp Kakuma in northern Kenya. (Photo by Eli Reed, Magnum Photos)

No matter what type of general news assignment, a photographer's goals should be to arrive promptly; find the best vantage point; obtain caption information and proper spelling of names; and produce original, effective images. Pictures are most powerful when they show the subject's emotional reaction through body posture, facial expression, or hand gesture. Plus, capturing moments of other people reacting to, or interacting with, your subject can be even more compelling and telling. You don't always have to show your subject's face to reveal something about their character.

"I don't necessarily have a favorite genre of photojournalism because it depends on the time, place, and circumstances," says Eli Reed. "No matter the situation, however, I believe there's always a relationship between the photographer and subject. The best I can hope for is that I am in harmony with the subject and the environment together, which ultimately leads to taking compelling photography.

A good photograph is one that you cannot get out of your mind. It could be subtle or it could shout, but when you walk away from it—it stays with you."

If you passed Eli Reed on the street, you'd never suspect he's a photographer, nor a famous one, for that matter. Looking at his towering height and presence, I thought he might be a defense attorney, music mogul, former sports athlete, or Wall Street type. Upon engaging him in conversation, I was prepared to hear a booming, commanding voice, and I was shocked at how reflective, soft spoken, and gentle he was. Eli has been an amazing inspiration and mentor my entire career, and I often wonder how I got so lucky. Whenever I have doubts—which for photographers happens almost daily—he's there to pick me up with words of encouragement and support. Those words mean so much given all of Eli's own accomplishments and accolades (**Figure 5.6**).

Enterprise, aka Feature Pictures

Feature photography captures a "slice of life" from an everyday occurrence of any manner of subject matter, and is meant to evoke an emotional response—especially humor. This sort of photography doesn't have to contain newsworthy content but cannot be staged either. A feature picture captures a special moment, relays something unique and unknown about human nature, or demonstrates an individual's distinctive culture. I consider feature photography as a cool breeze in Hell. It's lighthearted in content and balances the often heavy, distressing, everyday news photograph. Take **Figure 5.7**, for instance. It makes me laugh because the girls have their guns in the bathroom while they use the toilet and brush their teeth; plus there's a toilet paper shortage—something we can all relate to.

FIGURE 5.7 A U.S. Army Private in basic training hands another soldier toilet paper under the stall door in the barracks at Fort Jackson, South Carolina.

Lens (mm): 17, ISO: 500, Aperture: 2.8, Shutter: 1/125, Program: Manual

Pictorials

A pictorial picture is artistic in nature and exploits the graphic or aesthetic qualities of the subject with a heavy emphasis on composition. By use of repetition, color exploitation, symmetry, and unique perspective, pictorials are arguably the closest to fine art in the photojournalism field. When paired with human interest, pictorials can also be a creative way to tell a subject's story (**Figure 5.8**).

Portraits

Photojournalists aren't supposed to pose any shots, with the exception of portraiture. The majority of portraits are environmental and show the subject's surroundings, whether it's their office, home, or place of recreation. They can be up close and personal, medium head and shoulders, full body, or ultra-wide shots. The choice is yours (**Figure 5.9**).

FIGURE 5.8 Members of the Kenyan army run out to reset targets for the next competition of the Kenyan National Rifle Championship.

Lens (mm): 135, ISO: 100, Aperture: 5, Shutter: 1/600, Program: Manual

FIGURE 5.9 A member of the Air Force security forces squadron poses for a portrait at the firing range located on Charleston Air Force Base in South Carolina.

Lens (mm): 38, ISO: 100, Aperture: 8, Shutter: 1/200, Program: Manual

FIGURE 5.10 Soldiers from the Defense Information School pose for a portrait during the Military Photographers Workshop. (Photo by © Joe McNally, All Rights Reserved)

Some people believe photojournalistic-style portraits should have subjects making direct eye contact with the camera so the viewer knows that it is a set-up shot. To go a step further, they also suggest that the subject be stationary so the viewer doesn't think it's a real action shot. Well, I agree to disagree. I don't always want my subject staring straight into the camera, because I feel that doesn't always represent each individual accurately. People who are shy avert their eyes from others, and if my subject has that personality trait, I'm going to express that in their portrait. Furthermore, I don't always want a sedentary portrait and can't be bothered to have my subject "sit" for a portrait. If movement and action is part of their everyday life, then so be it.

I've been lucky to have a number of mind-bogglingly talented mentors over the course of my career, and one of the most influential has been Joe McNally. A genius both in front of and behind the camera, he's been a *National Geographic* contributor for 20 years, worked as a staffer for *Life* magazine, and written a number of books about lighting and photography. Many moons ago, we met in Washington, DC, during the annual Military Photographers Workshop, where he introduced me to the idea of adding supplementary lights to my photojournalistic arsenal. For several days, he taught me the importance of light position, direction, and modification (**Figure 5.10**).

I distinctly remember Joe saying, "I'm not just a photographer, I'm a problem solver." That has really stuck with me in all the years since we've been friends. It's so true. Joe has a unique ability to recognize what's important and what's not, which is probably how he manages to shoot assignments, teach, write, and develop his own line of lighting products.

In the Trenches: Breaking the Ice

We all have shared an awkward silence with perfect strangers on an elevator. We'd just as soon stare at our feet than initiate a conversation. There's some unwritten elevator law that says, "No eye contact or talking is allowed." I'm the nonconformist who breaks that law and says, "Hey there, how you doin'?"

I suppose it's my outgoing, no-holds-barred style that helps break the ice. My husband thinks I'm crazy. I'm sure the people with whom I engage in conversation think the same thing. It's not that I'm crazy. I'm just practicing.

Here's the secret: I'm a bit shy. If you've ever met me, you'd probably think I'm pulling your leg. But it's true. My heart races when I'm in a crowd of people, especially strangers. I'm even more uneasy when it comes to one-on-one contact. Over time, I have learned to control my nervous response to strangers. I decided I had to take control of my social anxiety in order to take control of my photo assignments, especially portraiture.

Before every shoot, I gear up my mind for the encounter. I remind myself that I have to *give* a bit of myself to my subject in order to *get* any return. This exchange is extremely important to create an atmosphere of ease during my assignments.

For me, meeting and interacting with people is similar to running a race or a marathon. To counter my introverted nature, I expend energy, reaching out to touch strangers physically and emotionally. I greet every subject with a firm handshake, direct eye contact, and a sincere smile. I find that my subjects will respond to the emotions I'm projecting. If I'm smiling, they'll smile, and if I'm nervous, they appear nervous. I try not to get overwhelmed during my shoots and attempt to keep my emotions in check. I remind myself to breathe as much as possible, and when all else fails, I stop and take a deep breath.

I've found the best way to break the ice is to let my subjects talk (at-ease subjects equal better portraits), and I ask follow-up questions to keep them engaged. The best results occur when I just listen. I take note of facial expressions in relation to the topic we're discussing. And if the initial introduction is stiff and forced, I will try to dig out a topic he or she may be interested in. From there, the conversational floodgates open. In most shooting scenarios, I have only a few precious minutes to break the ice and get my portrait, so I employ all of my techniques from the moment I receive the assignment to the conclusion of the shoot (**Figure 5.11**).

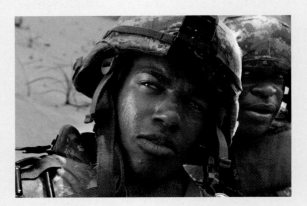

FIGURE 5.11 An Army National Guard soldiers sits on a sand dune at a training facility near Jacksonville, Florida.

Lens (mm): 60, ISO: 250, Aperture: 10, Shutter: 1/500, Program: Manual

Sports action and sports feature

"A good sports photograph defines the action. A great sports photograph is the perfect intersection of action, emotion, and environment," says *Sports Illustrated* Staff Photographer Bill Frakes (**Figure 5.12**).

To prepare for combat, I was assigned many sporting events. I didn't see the correlation between the two initially; however, I found the uncontrolled action of sports helped sharpen my ability to stay ahead of the action and capture images on the fly. Furthermore, like with high-risk environments, there are many limitations in terms of where to shoot from. Just as getting out of the field of play to get a better shot is impossible, so is getting in the middle of crossfire. Ultimately, shooting sports taught me to take the best pictures I could from the vantage point I was limited to.

For most freelance photographers, sports photography is the most common assignment, but that doesn't mean the photographers who shoot sports are average. On the contrary, it's highly competitive and demanding. My first attempt at sports photography was the Department of Defense Women's Soccer Championship, and I really screwed the pooch on that assignment. In my head I thought, "How hard can this be? I'll just bring some long glass and shoot the peak action." Well, it turns out I was very wrong. There were many things I did incorrectly, which led to my epic failure, but my biggest missteps were not studying the sport beforehand, not researching good soccer pictures, and not practicing through coverage of smaller, local soccer matches. The skills I learned while shooting sporting events far surpassed my previous abilities, and although I'm not an exceptional sports shooter, I can get something in the can that's adequate. I still don't hold a candle to my friends who specialize and excel in sports photography, and I usually defer to their expertise for advice.

FIGURE 5.12 Marion Jones of the U.S. Olympic Team wins a gold medal during the 2000 Summer Olympics in Sydney, Australia. (Photo by Bill Frakes)

Bill Frakes lives, breathes, and eats sports, which only makes him better at his craft. He knows the rules of the game and can predict dramatic moments. Hell, he can even rattle off the backgrounds of some of the key players, where they went to college, where they've been traded, their stats, and more. Much like my ability to identify foot patrol formations, military ranks, and tactical movements, Bill's familiarity with various sports and their athletes helps him anticipate and capture their moves during the game.

I'd have to admit there was an intimidation factor upon meeting Bill. His body of work is astounding, which is enough to make any young photographer feel unworthy. He spoke his mind openly, had a clear and concise vision, and knew exactly how he wanted to execute his plan to make his vision a reality. Coming from the military side, I was pleasantly surprised to see how well planned and prepared he was for every eventuality. It's been my experience that photographers are still artists and sometimes have a free-flow attitude that can stump them while on assignment. Bill, however, really showed me that preparation for photography assignments was just like developing a good battle strategy. You must predict the unpredictable and come up with solutions to those problems in advance.

Some tips I learned from Bill:

- Planning and preparation helps you better anticipate and capture the motion and emotion that makes a compelling, informed sports image.

- Know the players and the basic rules of the sport so you can anticipate where the action will happen.

- Situational awareness is important so you don't get run over by players, and so you can see moments when they happen off the playing field.

- Prepare for the worst conditions, both weather and access related. You can't control Mother Nature, so prepare for seasonal downpours and arctic conditions. You will have limited access, and you just have to deal with that, given the nature of the sport you are photographing.

- Use everything you can to your advantage, such as remote camera setups. You may not be able to shoot from a vantage point physically, but you can set up remote cameras and trigger them from your location.

Equipment for shooting sports

As you've already ascertained in Chapter 3, "Gear Essentials," I don't usually carry around heavy, long lenses. In fact, when shooting in high-risk environments, the longest lens I carry is the 70-200mm lens. But here's the clincher regarding sports documentation: In most cases, long lenses are a necessity and they aren't cheap. The Nikon 400mm f/2.8 retails for around $9,000, as much as a used car, and the Nikon 200mm f/2.0 comes in around $6,000. On a photojournalist's budget, obtaining one of these lenses seems nearly impossible. There are other less costly alternatives, such as buying a used lens, renting a lens from a lender house, or perhaps finding someone to share the investment with, like a lens time-share. The pitfalls of sharing a lens with someone is lens availability, wear and tear, and event coordination. I share a number of lenses with my husband, so we've gotten really good about coordinating our schedules and gear. If you've got a trusted photo colleague, it can be a money-saving route.

On top of having decent glassware, you'll want cameras with high frame rates and fast buffers. Your cameras should also have high ISO capabilities, because many sporting events occur at night or indoors under artificial lighting.

Some sports photographers use supplemental lights such as hot shoe flashes or larger strobes and packs when permitted by sports officials. It is more common now to mount remote flashes on the ceilings of pro arenas to light basketball games. A transmitter on the camera uses a system such as those made by Pocket Wizard to trigger the flash remotely. Adding supplemental light opens up many doors to creative peak action, portrait, and feature sports images.

Working with focus

Focus can be daunting when you're trying to lock on a moving target, and if your aperture is wide open there's very little room for error. An out-of-focus picture in the sports world is unacceptable and is equally unforgivable in fast-paced combat photography. To help overcome focus challenges, try using camera models that offer 3D Focus Tracking.

> **QUICK TIP**
>
> 3D focus tracking is a predictive system that automatically shifts the focus point to follow the movement of the athlete. When holding the shutter release button halfway down, you can see in the viewfinder that the lens continuously maintains focus as the athlete makes his or her play.

In situations where the athlete's path is pre-determined, such as a foot race or cycling event, try manually pre-focusing on a fixed spot. And as the athlete crosses your pre-focused threshold, fire away. By practicing this method of focusing while shooting sports, you can apply this technique in other areas of your photography such as high-risk environment documentation.

Sports features

A sports feature is a picture that shows anything other than peak action, such as a screaming coach on the sidelines, a frustrated player in the locker room, or a crazy fan streaking across the field. As implied by the name, the same procedure applies to sports feature documentation as with human-interest features. A photographer tries to capture a climactic, dramatic event not happening on the playing field (**Figure 5.13**).

While I've used sports as a means of practice for conflict photography, there are photographers like Al Bello who've employed their talents to

FIGURE 5.13 Al Bello does a test with his underwater camera rig in preparation for a swim competition. (Photo by Al Bello, Getty Images)

tell the story of sports exclusively through both peak and feature photographs. In observing and learning from Al, I've gained a lot of insight into approaching my own non-sports-related assignments. The lessons he's imparted to me about sports photography are applicable to all types of photojournalism genres, too (**Figure 5.14**).

FIGURE 5.14 Ryan Lochte of the United States (top) and Markus Rogan of Austria compete in the Men's 200m Backstroke Heats during the 13th FINA World Championships at the Stadio del Nuoto on July 30, 2009, in Rome, Italy. (Photo by Al Bello, image 89651919 courtesy of Getty Images)

Al told me I needed to have a passion for anything I do to be truly successful. Let's face it: If you are looking to become a millionaire, you are in the wrong business, he said. To be sure, every aspect of photojournalism is very, very competitive. Photographers must be extremely driven to work in the field of sports photography, plus have the talent, he added. Long, physically draining workdays require a strong will to succeed every day and can be very humbling. Always remember the whole world is looking at your pictures and your byline, and you're being judged every day.

The reason a photographer gets into sports photography is for the love of great sports photos and the game, says Al. You need to separate yourself from other photographers and not be afraid to be different. By doing so, you'll stand out and get noticed by the people who hire you. Don't be a sheep; be different. Anyone can shoot pictures these days, because decent cameras are less expensive and more readily available. But not everyone has a creative brain, so use your head. Think about the photos, and don't spray frames just because it sounds good. I couldn't agree with Al more. I'd much rather be a sniper and grab the decisive shot versus a machine gunner and spray and pray I grab a shot.

Al also taught me there's more to sports photography than capturing a great peak action shot. If it's an impact moment, then it should be, first and foremost, in focus. The overall impression of the picture needs to be peak action with no limbs chopped off, a straight horizon, background as clean as possible—and if it's outdoors on a nice day, then hopefully it is backlit against a jet-black background, or it's shot in full light at 6 in the evening with warm glow light. "That, to me, would be a perfect sports photo," explains Al.

Tips from Al on better sports photography:

- Luck has something to do with being in the right place at the right time, but you make your own luck more often than being lucky. You need to know the sports you're shooting so you can anticipate where and when to move.

- Choosing a decent background to shoot against is critical, because you don't want a pole sticking out of your subject's head, empty seats, random people, or distracting signage detracting from the moment.

- Sports photographers must also know how to contend with various light situations. If it's sunny, you should know where the sun will rise and fall throughout the event and decide whether to shoot front lit or backlit, because lighting impacts the picture immensely.

- Don't be afraid to experiment with your subject. Try a different angle and change your location for a unique viewpoint.

- Composition is everything. Don't take a nice action or feature shot with a head cut off or an arm cut out of the frame because it doesn't look right.

- Changing your perspective by getting up high and shooting down on your subject changes the overall impression of your picture. By changing your angle, you'll also change the background, which may solve your messy background problem from the field.

Adventure sports

Adventure sports photography is not for the faint-hearted; it requires many specialty skills on the part of the photographer and is often very dangerous. These sports involve great heights, speed, and stunts. Similar to sports action and feature sports, it's important for the photographer to have a genuine interest in extreme sports in order to photograph them well (**Figure 5.15**).

I'm not a rock climber, nor have I ever been down fast-moving rapids in a kayak. I did repel down a few walls with some pararescue guys in Baghdad, but even that doesn't come close to what adventure sports photographers Michael Clark and Tom Bol do. The average photographer's fitness level is pretty good, but these guys are in amazing shape, have boundless amounts of energy, and endless endurance. Just holding a conversation about adventure photography with either of them makes me exhausted.

I first met Michael Clark after watching his live presentation in New York where he'd related a story of a near-death experience on assignment. Apparently while shooting a rock climber, his rope began to fray and break apart. He was left clinging for life to what was essentially some dental floss—perhaps I'm exaggerating, but that's what I envisioned as he told the story. I thought, "This guy must be bat-shit crazy to do this." Later over dinner I told him what crossed my mind, and his response was, "Aren't you a war photographer?" Touché.

My other good buddy, Tom Bol, is a man with boundless energy. In 5 minutes of conversation, he'll take you to the moon and back, and make you feel like you can conquer the world, which probably explains why he's a successful teacher, author, and photographer (**Figure 5.16**). Some professionals hold their cards close to their chest, but that's not in Tom's DNA. Like me, he's open and willing to share. After all, and perhaps he shares my view,

FIGURE 5.15 Danny MacAskill does a back flip off a sculpture in downtown San Diego, California. (Photo by Michael Clark)

FIGURE 5.16 Tom Bol hangs off a cliff while on assignment for *Light It Magazine*. (Photo by Steve Glass)

FIGURE 5.17 A rock climber negotiates Sinks Canyon in Lander, Wyoming. (Photo by Tom Bol)

FIGURE 5.18 Bill Mohrwinkel jumps a crevasse on Matanuska Glacier in Alaska. (Photo by Tom Bol)

another photographer can replicate technique, but the creative vision will always be different.

Much like conflict photography, there's more to adventure sports than meets the eye. Before going out on a combat patrol, I'd have to ready my body armor and helmet, attend a battle plan briefing to familiarize myself with the area of operation, and gather mission-essential gear and camera equipment. For shooting adventure sports, there's lots of time spent rigging ropes or getting in position for the right shot, says Tom. If you're documenting an expedition, you might be in the field more than a month working hard for those few shots that define a trip. Also, the key aspect is working with talented athletes who can do the activity for the shot you need; not everyone can paddle off 80-foot waterfalls or climb really hard routes (**Figures 5.17** and **5.18**), explains Tom.

"I scout out locations, work through logistical problems and see if what I have in my mind can really work in the field," Tom says. "I literally will spend an hour at a spot trying to 'see' my subject in the scene, what lighting and angle would work best."

Not unlike conflict photography, environmental conditions easily trash cameras while on adventure sports shoots, so you have to have a solid camera. The ability to shoot many frames a second is helpful capturing the action, says Tom. That said, with the right location, timing, and luck, along with decent available light, a great image can be captured with a basic camera. Artificial lighting is also beneficial and critical for many of my images; without the proper light, the shot wouldn't work.

"Ultimately, stay true to your vision, and just keep shooting. Many times some of my best adventure sports images were created simply because I was out shooting, not home thinking about shooting! For the lucky shot to happen, you have to create your own luck. Get outside and shoot," advises Tom.

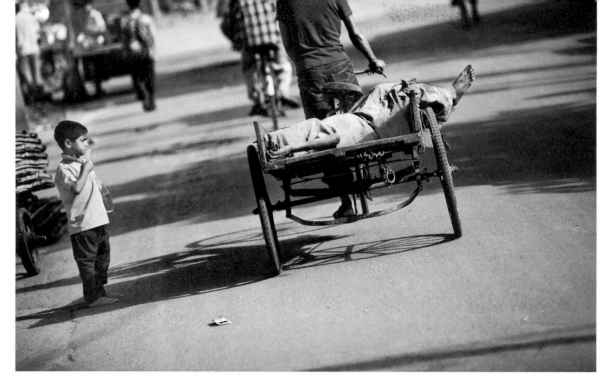

FIGURE 5.19 Darminder is transported to the morgue of the local hospital on a transport cycle as a boy looks on. A few hours earlier, the 17-year-old pharmaceutical-addicted boy from Bihar, India, was brutally beaten and left to die in a dirty alley. (Photo by Enrico Fabian)

Lifestyle

I'm not referring to lifestyle photography in terms of stock or commercial photography. For me, lifestyle photography is the exploration of the human condition. It captures people doing everyday things such as raising children, attending church, or working their jobs. It may also uncover subjects' personal struggles with drugs, health issues, or marital problems. It delves into the manner of living that reflects the subject's values, morals, and attitudes, thus revealing their lifestyle choices. Essentially, it's about capturing a day in the life of someone—the good, the bad, the truth (**Figures 5.19** and **5.20**).

I'd say the majority of my domestic assignments are in the realm of lifestyle photography because I prefer to explore the human condition.

FIGURE 5.20 A boy sits inside a rundown public toilet house in which a group of pharmaceutical addicts live. Widespread poverty leads many of the children and grown-ups into their first contact with hard drugs. (Photo by Enrico Fabian)

As I've said before, most of my work is centralized around armed conflict, military, and veterans issues. By focusing on individuals' experiences, I can put a face to any number of issues, ranging from gays openly serving in the military to combat veterans with children homeless on the streets. Through this genre of photography, I can let the subjects tell their own story.

Lifestyle photography is a great way to enhance a photographer's storytelling capabilities because it's personal, intimate, and revealing. It doesn't require expensive camera equipment or years of photographic experience, but rather, an open, curious mind and the ability to observe and listen. Take Enrico Fabian, for instance. He's a young photojournalist who established himself as a photographer in Delhi only a handful of years ago. He decided to work on a personal project about the misuse of powerful pharmaceutical drugs in South Asia titled "Death for 50 Rupees." Our paths crossed during a photojournalism gathering in New York, and I was instantly blown away by his work and graceful nature. Though he hadn't been shooting long, his exploration into the drug lifestyle earned him a grant from the Chris Hondros Fund in 2011.

Lifestyle photography isn't necessarily an exploration of foreign people and cultures, but perhaps of your next-door neighbor, church pastor, childhood doctor, or third cousin. Everyone has a story and the luxury of lifestyle photography is that you can cultivate as many stories as you desire, whenever you want, as close or as far from home as you like.

Travel

When I travel abroad on assignment, I always try to photograph "local color." For me, *local color* and *travel photography* are synonymous. They refer to the documentation of people, cultures, customs, and landscapes in their natural state, uncovering unique aspects and atmosphere of the time and place (**Figures 5.21** and **5.22**).

Mirjam Evers, a photographer who specializes in world travel, has been to more than 75 countries. She shoots international environmental portraiture, landscape, and adventure images, all of which are considered travel photography (**Figure 5.23**). We've been friends for a long time now and share the mutual interest of teaching photography. Mirjam is one of the founders of Photo Quest Adventures, an international travel company that focuses on photography workshops and cultural experiences. She's also one of the best travel photographers I've met.

"Travel photojournalism is unique because all at once it can celebrate the landscape and the human condition while also exploring larger issues," explains Mirjam. "We live in an era wherein globalization, climate change, and global economies are relevant, temporal topics. The travel photographer can address these political and social issues at the same time he or she shares intimate, profound moments that exemplify humanity."

FIGURE 5.21 Three warriors in the Masai Mara, Kenya. (Photo by Mirjam Evers)

FIGURE 5.22 Mirjam Evers photographs the wildlife during an assignment to Antarctica. (Photo by Tom Bol)

FIGURE 5.23 Gaucho on a horse in Patagonia. (Photo by Mirjam Evers)

"Travel photography is an opportunity to explore new places, expand your horizons and, most importantly, meet new people," adds Mirjam. "The camera grants a special kind of access to the lives and customs of other cultures. Good travel photographs are images that transcend idyllic landscapes or 'exotic' looking people. Instead, truly successful images communicate a shared experience between the place, the photographer, and the viewer. Travel photography is an opportunity to learn that, despite our differences, we are all just human."

Mirjam's travel photography tips:

◆ Leave your self-consciousness at home. You'll get good pictures when you're experiencing new places and cultures firsthand, not when you are watching from the sidelines. Jump in, try new things, be brave, say hello, and stay open to new experiences.

◆ Approaching people with warmth and an open mind and showing respect for their environment and culture can help to establish a certain amount of trust.

◆ Familiarize yourself with the local dress code. In some places, typical American attire such as a revealing shirt may be offensive to local women and an invitation for a come-on from the men.

◆ As a photographer, if you want to connect with the residents, it's important to take the necessary steps to fit in. Buy and wear local clothing if you can. Don't wear clothes that make you stand out, and stay away from bold colors, logos, and definitely anything too sexy.

◆ Leave the jewelry at home as well as clothing that screams "money." As it is, you are traveling with expensive camera equipment. You don't want to be a walking billboard for thieves. Also, rather than carry a purse, wear a fanny pack or backpack.

Spot News

I usually view spot news as the polar opposite of general news; it covers unplanned events such as house fires, plane crashes, car accidents, robberies, and riots. Some general news stories may lead to unforeseen events and inadvertently become spot news. For example, a crazed assailant opens fire on a peaceful political rally, or a NASCAR driver suddenly wrecks and dies. Spot news is unpredictable and spontaneous, which makes it such an elusive target. Occasionally, a photographer inadvertently happens upon the scene of a wreck, but in most cases the vigilant photographer who frequently listens to local police and fire scanners gets the scoop. These types of events are often dramatic, traumatic, and short in duration.

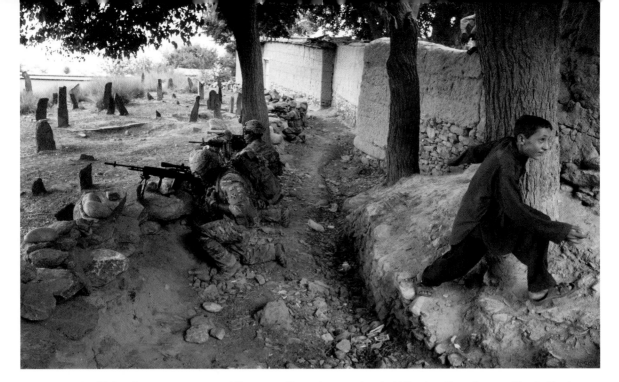

FIGURE 5.24 An Afghan boy runs away as soldiers open fire on insurgents who'd fired on them from a ridge in the town of Manugay in the Pech River Valley of Afghanistan's Kunar Province. (Photo by Lucas Jackson, Reuters)

If you're going to cover spot news, there's more to it than showing up and photographing the scene. It's important to have skills in talking and dealing with law enforcement and emergency response crews. Recognizing and obliging by the boundaries they've set will help keep you on their good side while also protecting you from any harm. Plus, it's important not to impede recovery or rescue operations.

Spot news, long haul

There's another side to spot news that isn't so abbreviated, where the aftermath is prolonged and access is precarious and often photographically and emotionally challenging. In this outside edge of spot news, I usually place events related to natural disasters, manmade disasters, and armed conflict. Spot news events of this magnitude often have a domino effect in which one part of the story's resolution is followed by another unresolved problem. Durations of such events may last days, weeks, months, and even years, requiring expanded coverage.

As long as there are rival tribes, contested territories, religious divergence, and political power struggles, conflict will ensue. As curious human beings, we thirst for knowledge and understanding concerning the human nature of confrontation and mankind's wants and needs to commit violence against each other. By *violence*, I do not mean only an act of physical harm; I am also referring to the psychological wounds inflicted on everyone involved, including innocent bystanders: the mourning mother, whose son was killed by a stray bullet; the farmer whose crops were burned and animals slain by warring armies; and the young girl raped by military guerrillas (**Figure 5.24**).

In the Trenches: Adrenaline

I'm a human being with intelligence and a conscience, or so I'd like to think, but I'm also an animal with subliminal predator and prey instincts. When my life's threatened, my natural response is to react through fight or flight. As a combat photographer, I couldn't do either. I was documenting others defending themselves or running. And in order to do so, I had to place myself in the most unnatural position and fight my own natural instincts versus the direct threats around me.

I've seen some photographers in high-risk environments absolutely shut down when faced with life-threatening situations. Instead of photographing the events, they're struck by fear and their body's natural "fight or flight" response. It's what I call the "ostrich reaction," and what I mean is, "If they can't see me, they can't hurt me." That's just not true, and sometimes the best chance at life is to keep moving forward even if it's toward the threat in question.

Routinely, I operated with an elevated level of adrenaline. After all, it was my body's natural response during fight or flight situations. Operating a camera with adrenaline pumping was a challenge, because my hands would tremble, my breathing became labored, and my physiological functions shifted abnormally. By

that, I mean blood rushed from my head to my limbs in preparation for the "flight" or run. Time seemed to slow to a crawl so I could best calculate my moves strategically. The deafening noise of guns and screaming seemed to go absolutely quiet for less distraction. Plus my vision seemed to be tunneled and focused so I could better identify the predator for the "fight."

Despite my best efforts, I couldn't avoid my body's dispensing of adrenaline. All I could do was learn to work with it. When I felt the telltale side effects of adrenaline, I'd begin to breathe deeply, slowly, and with a four-beat count. In, two, three, four—out, two, three, four. By calculating my breathing, I prevented my body from panting while continuing to provide the necessary oxygen it required in order sustain the exhilaration of natural chemicals coursing through my veins.

To keep my shaking hands from ruining my pictures, I'd keep my elbows tucked tightly into my body and speed up my shutter speed. I'd use the virtual time warp to observe my surroundings, and pre-visualize and anticipate where the action was going to escalate so I could get out in front of the fight rather than chasing it around the warzone.

A friend of mine, Lucas Jackson, knows what it's like to photograph spot news nearly every day. He's a well-versed photographer who covers a wide array of domestic and international assignments as a staff photographer for Reuters. My husband and I often chuckle when we watch breaking news and see Lucas strolling through the frame with camera in hand. I usually turn to my husband and say, "That's one lucky guy! I wish I could be there." However, it's not luck that earned Lucas a coveted position with Reuters; rather, it's his hard work, hustle, and remarkable photographs.

The genesis of photojournalism happened on the battlefield, and photojournalists have been documenting war ever since. Not every photographer is cut out for covering conflict, but those who are up to snuff happen to be a distinctive bunch. As I've said before, I sincerely advise anyone who's considering war photography as an

option to think about his or her reasons and goals. It is not a profession that should be entered into lightly, and the threats are incalculable. Fear can either stop you dead in your tracks or move you forward to safety—the first response may lead to death, and the other just might save your ass.

On the front lines

Now more than ever, there are many exceptional female photojournalists working in my profession, several of whom focus on overseas and conflict photography. When I was being groomed as a combat photographer in the military, there were only a few women photojournalists to emulate. One such remarkable lady was Carolyn Cole. I didn't know her personally, but really admired the photography she produced. Heeding my own advice, I studied her work religiously and followed her career closely. Even over the course of my career when gender boundaries on the battlefield diminished and a rise in the number of women covering conflict began, Carolyn remained one of the primary inspirations in photojournalism. She's among the talented few who've blazed the path for the rest of us, and her work still astounds me today (**Figure 5.25**).

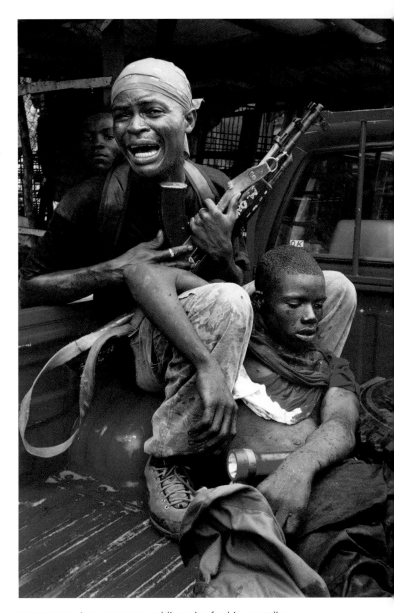

FIGURE 5.25 A government soldier cries for his mortally wounded comrade who died in his arms after a frontline offensive, as government soldiers fought to take back territory lost to rebel fighters in the battle for the country in Monrovia, Liberia. (Photo by Carolyn Cole, *Los Angeles Times*)

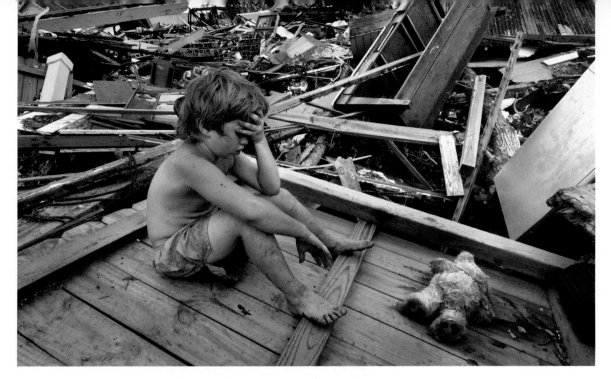

FIGURE 5.26 Seven-year-old Dillan Chancey and his parents clung to trees to survive the deadly storm that demolished their Mississippi home. Hurricane Katrina was one of the worst natural disasters in American history, killing more than 1,800 people. (Photo by Carolyn Cole, *Los Angeles Times*)

Much to my genuine excitement, a mutual friend introduced me to Carolyn during the Eddie Adams Workshop several years ago. I'm not sure she knew how much I anticipated our introduction and I did my best to contain my enthusiasm. After all, at the time I was still serving in the military, and Carolyn had just earned the Pulitzer Prize for her amazing photography covering the civil war in Liberia among other high accolades such as the Robert Capa Gold Medal and the National Press Photographers Association News Photographer of the Year. She was what I aspired to be. She's just a damn good photographer who understands how to capture the human nature of conflict. By studying her work, I became more aware of my own connection to my subjects, or perhaps the lack of it, and began to approach my documentation from another, more intimate, view (**Figure 5.26**).

What further sets Carolyn apart is her ability to move seamlessly between domestic and international documentation with ease and to convey her subject's stories so intimately; to show the impact on the people, culture, and landscape; and to convey the story with such familiarity. She just gets it. The fact that Carolyn's a woman is only one small reason why I adore her. Of course it's nice to see another woman like Carolyn excelling in the field, but her photography is what makes her such an inspiration to me. She sets the bar high for both men and women who also cover high-risk environments (**Figures 5.27** and **5.28**).

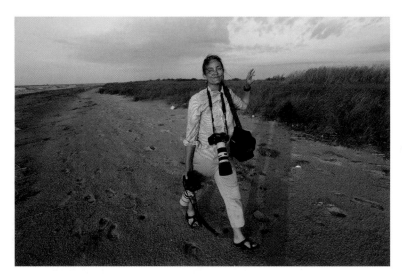

FIGURE 5.28 A heavily oiled pelican flounders on the beach at East Grand Terre Island in Barataria Bay, Louisiana. Oil continues to pour into the area, which is a breeding area for wildlife. (Photo by Carolyn Cole, *Los Angeles Times*)

Along with the ladies I look up to in my field are some really great guys, too. I met Yuri Kozyrev in Baqubah, Iraq, when he came to document the fighting in the area, and I was immediately impressed. By the time ours paths crossed, I'd been a combat photographer for more than 6 years. In war years, that can seem like a long time. However, it paled in comparison to Yuri's decades of field experience. His outstanding photography from other major conflicts such as those in the former Soviet Union and Afghanistan preceded him, but what also impressed me was his personality and demeanor. He's calm, gentle, understanding, and thoughtful, which is why, I suppose, he's so good at interacting with people under duress and operating under stressful conditions. I definitely observed his actions and made note of his uncanny ability to remain calm when utter chaos ensues around him—no panic, just photography.

Since I met Yuri back in 2007, he's been all over the globe covering other conflicts, especially those centered on the Arab unrests in Egypt, Bahrain, Libya, and Yemen. He'll always be an icon to me, and I'll fondly look back at our coffee and cigarette breaks in Iraq and feel thankful I was lucky enough to gain such an amazing mentor and friend (**Figure 5.29**).

If you've decided that documenting high-risk assignments is your path, it's important to remember that it's all right to push the envelope, overcome fear, and capture the decisive moments under fire. After all, to be a truly good photojournalist, you've got to master the ability to be completely aware while limiting your field of view to 50mm; be cool, calm, and collected while sheer chaos unfolds around you; and create thoughtful, emotive, informational, and creative images that viewers will want to see. However, and most importantly, you must never forget you're still human. You can bleed, you can die, and no picture, no matter how significant, is worth dying for. The goal is to live to document another day.

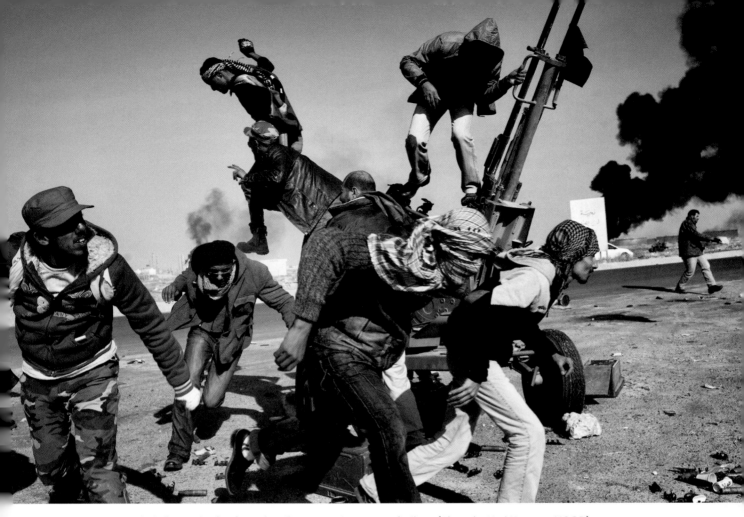

FIGURE 5.29 Rebels flee under fire from the Libyan army in Ras Lanuf, Libya. (Photo by Yuri Kozyrev, NOOR)

CHAPTER 6

PUTTING IT ALL TOGETHER

Thus far, I've discussed preparing yourself physically and mentally, technically and creatively, and inspirationally and occupationally. I've shown you the tools that will help you create unique images, and the methods for processing, archiving, and safeguarding them. Now I'd like to talk about putting all of these elements together so they work in harmony and yield positive results. Whether you're abroad or shooting domestically, the art of developing good photo stories is the same. It requires a solid idea, forethought, research, and refinement. Plus, you'll need a visually compelling subject who can carry the story—and who's willing to open up to you and your camera for the duration of the assignment, whether that's two hours or two years.

Sisters in Sana'a, Yemen, put on their traditional black outer garment, the sharshaf, before heading out for a night on the town.

Lens (mm): 70, ISO: 400, Aperture: 11, Shutter: 1/200, Program: Manual

Telling the Story

A single image has impact, conveys a message, and enlightens the viewer. Place more than one picture of the same subject next to each other, and the meaning becomes more complex. What makes photo stories so powerful is their ability to share a cohesive narrative that overcomes language barriers and illiteracy. As photographers, we are given the privilege to document and share the stories of people's lives, emotions, personal traumas, and successes. The ability to harness the power of storytelling through pictures, and to tell these people's stories, should be every photojournalist's ultimate goal.

Select your story subject

You may receive an assignment from your editor that's a prime candidate for a photo story and noteworthy of further exploration. However, I've found most of my photo stories are self-generated. The stories you choose to develop on your own should have substance, depth, visual appeal, and accessibility. As the creative director, storyteller, and photographer all in one, you must determine how to approach the subject matter photographically to ensure there's visual variety while capturing high-quality, cohesive, storytelling pictures.

The most significant step in a long-term project is choosing the right subject, one that holds your interest. You cannot expect your audience to engage in a topic you don't necessarily care about yourself. For instance, I focus predominantly on subjects related to armed conflict and war because I'm naturally drawn to issues such as warfare, combat disorders, civilian tumult, war protests, veterans issues, and military conflicts. I'm hired specifically for this genre, and I focus most of my personal projects around this subject matter and its periphery.

I've photographed stories about the early onset of Alzheimer's disease in elderly veterans who have been exposed to head trauma in combat, the impact of musical therapy on men and women who suffer from combat-related PTSD, the invisible bonds formed by men and women in war, and the fierce struggle of Iraqi war widows and their efforts to endure. As you can see, each story is tied together by a common interest I have, yet each photographic chronicle is unique.

You may not be motivated by the human conditions surrounding armed conflict, but it's important to locate your passion, whether it's political unrest, volatile economy, medical curiosities, athleticism, or human achievement.

Develop a storyline

To best determine a storyline, I recommend starting with a broad subject. For this exercise, let's use a broad topic I've covered before: unemployment in America. Based on my own interests, I explored the issue from the angle of the military veteran. To further flesh out a story idea, I even looked at the number of unemployed, homeless combat veterans versus noncombat veterans. I studied gender, age, and military occupation as factors, too. I used research analysis, previous case studies, and live interviews with veterans and subject matter experts to further isolate the topic.

As both a woman and a military combat veteran, I was particularly drawn to how unemployment impacted these two groups of people. To satisfy my

curiosity, I decided to spend my time and research focusing on the demographic of unemployed women combat veterans.

Refined ideas

Once I narrowed down my story idea, I needed to clearly define my narrative. To do this, I summarized my narrative in one written sentence based on facts and field research. As I formulated the sentence, I continually asked myself, "What's the story?" The sentence I created was, "Unique challenges, without intervention, put women combat veterans at greater risk of becoming unemployed." From there, I developed my visual narrative.

Creative blinders

Every topic is fluid, so the tagline you create during story development should not create blinders from seeing other, more developed storylines. Through the process of development and subject selection, be sure to keep an open mind and be receptive to change. Don't get bogged down by the tagline you create, because you can always morph your muse sentence to better articulate the new story direction. It should simply be used as a guidepost or navigational compass so you stay on track with the story.

Cool pictures may happen as you photograph your story, and you should capture them. However, these pictures may have little bearing on the storyline. In these cases, it's best to refer back to your tagline and ask, "Does this image enlighten or reveal something new about the narrative of the story?"

The lead role

The tagline I create becomes my muse to find the right story subject. Usually over the course of subject and field research, I'll come across potential story subjects who match the narrative I'm trying to tell. I take great care in fostering relationships with these people early on, so I may refer back to them once I've firmly established my storyline. When choosing a person for a photo story, I try to let the union happen organically. Just like with personal relationships, it's important to have chemistry, or at least a mutual understanding, between the subject and myself, which ultimately leads to acquiescence, open dialogue, and visual candor.

The right story subject

I may find someone who's perfect for my story idea but who may not share my enthusiasm for documenting his or her life. As the photographer, it's my job to build the necessary trust with the potential subject and be honest about my intentions and story goals. I need to be clear about my expectations in terms of access to their daily lives and private space, so they aren't blindsided when I'm there to photograph the most intimate times. If I've spent time building a relationship and my subject is still apprehensive, they may not be the right person of interest for me. If that's that case, I find it's best to find someone who's more open to the idea.

In the Trenches: Mexican in America

To get to my office on base, I used to drive through a depressed area of town where day workers would gather early in the mornings and wait for general contractors to come by and hire them as laborers for a time. The vast majority were migrant workers from Mexico and Central America who lived in the nearby trailer parks that abutted the security fence to Charleston Air Force Base. I had some time between my overseas assignments, and I recognized the potential for a story close to home, but I had to cultivate what that story would be (**Figure 6.1**).

I decided to go for a walk through the trailer park to observe their living conditions and see if that sparked story inspiration. In doing so, I saw an older woman playing in the yard with a toddler as a man around my age watched from the porch. I observed their interaction for a while and finally walked up to the chain-link fence to introduce myself to the woman, only to learn we didn't speak the same language. We played charades and eventually she invited me onto her porch, where we exchanged smiles and watched the toddler run through the wading pool. I had my camera in my lap and occasionally took a picture or two to gauge their reaction. No one seemed to mind (**Figure 6.2**).

I looked about the yard and noticed a small shed that concealed the washing machine, a small engine torn apart under a tarp, clotheslines strewn about the trees, and rusted sheet metal pulled away from the trailer's façade. I recalled my own meager childhood of government cheese, welfare lines, food stamps, and secondhand clothes, and a single mother who struggled, working two jobs just to keep me and my sister fed. Then I looked at the older woman and knew she was my story (**Figure 6.3**).

I mustered the only Spanish I knew at the time to say my goodbyes and headed back to the office. I enlisted the help of a Spanish-speaking colleague to join me for an interview with the woman the next day. I found out her name was Cenobia, the toddler was her grandson, the older man was her mentally handicapped son, and

FIGURE 6.1 Daughter, Franchesca, 24, watches her mother, Cenobia Lomas, pick weeds from her front garden in North Charleston, South Carolina.

Lens (mm): 24, ISO: 400, Aperture: 11, Shutter: 1/320, Program: Aperture Priority

FIGURE 6.2 Cenobia Lomas's handicapped son, Pico Eliseo, stares out toward the trailer park as she tends to her grandchildren inside the house.

Lens (mm): 17, ISO: 400, Aperture: 8, Shutter: 1/30, Program: Aperture Priority

she had emigrated from Mexico many years ago to provide a better life for her family. As she talked, I looked around her house and saw dangerous holes in the floor, roaches crawling on food, and flies stuck to dangling yellow fly strips. I wondered how much of an improvement this was from the life they had before.

Having a translator helped Cenobia better understand what I wanted to achieve photographically. I explained to her that I'd like to come and take pictures during all hours of the day and night and show what it's like to be Mexican in Charleston, South Carolina. I also told her she had a wonderful story to tell her fellow Americans, and with little other explanation, she agreed (**Figure 6.4**).

continues on next page

FIGURE 6.3 Cenobia Lomas puts a load of laundry in the washing machine located in a shed outside her house.

Lens (mm): 17, ISO: 400, Aperture: 2.8, Shutter: 1/250, Program: Aperture Priority

FIGURE 6.4 I wanted to create a portrait of Cenobia that showed her age while also conveying her wisdom and caring. Early one morning, she was babysitting a neighbor's child and soothing the crying infant. The sun crept through the tattered drapes, casting shadows across her lifelines and wrinkles. Though she's slightly out of focus, the baby's hand is tack sharp; this portrayal illustrates Cenobia's reasons for immigrating to the United States and why she continues to fight for her children's future. Her children are always in the forefront of her life.

Lens (mm): 55, ISO: 400, Aperture: 2.8, Shutter: 1/30, Program: Manual

In the Trenches: Mexican in America *continued*

At the time I began working on Cenobia's story, the topic of immigration and illegal workers in South Carolina was a contested issue. American-born citizens argued migrant day workers forced legal workers out of jobs, while directly impacting the healthcare system and overpopulating the grade school classrooms. I began to explore the prejudices against Latino Americans through Cenobia's daily life experiences, from unfriendly reactions from strangers while she shopped at the grocery store, to the cold body language of other non-Latino mothers at the school bus stop. What made the story even more compelling is that Cenobia and her family came to the United States legally, yet were treated as if they had broken the law (**Figure 6.5**).

I spent several weeks documenting Cenobia and her family and through the process learned a lot about people's misconceptions, and even my own. Initially, I suspected Cenobia and her family were living in Charleston illegally. I'm not sure if it was the local media that led me to that presumption, but I eventually discovered I was completely wrong, and I hope through my imagery I revealed another side to the story of immigration. This experience taught me that sometimes the best way to find a story is simply by taking a walk and observing your surroundings (**Figure 6.6**).

FIGURE 6.5 A young man watches from the corner of his eye as Cenobia Lomas talks in Spanish to her youngest son, Alanso, 3, in the checkout line.

Lens (mm): 17, ISO: 400, Aperture: 5, Shutter: 1/40, Program: Aperture Priority

FIGURE 6.6 Before dawn, Eliseo Lomas watches out of the kitchen window for his ride to work while his wife, Cenobia, waits for her day of babysitting to start.

Lens (mm): 38, ISO: 400, Aperture: 2.8, Shutter: 1/10, Program: Aperture Priority

A Thoughtful Approach

Once you've identified a good story subject, I don't suggest walking into their environment with guns blazing. Rather, I suggest taking a slower, methodical approach. As I did with Cenobia, break the ice by having a cup of tea and generating some small talk. Keep your camera nearby so they grow accustomed to seeing it with you, and occasionally snap a picture so they assimilate to the sound. If time allows, make a couple of visits and casually shift your conversation-to-shooting ratio until you're spending more time behind the camera and less time talking. Sometimes talkative subjects need to be made aware that you're ready to shoot, and holding conversation can make working tough. The dialogue can be as simple as "I don't want to intrude, so you go ahead and do your thing. I'm just going to be here quietly observing."

It's best not to expect any great images from your early shoots, because you're still in the "dating" phase. I equate the first one or two days of shooting like that of a first date, because you're still photographing your subject's representation of themselves, not their reality. They'll make sure their hair is done, they're freshly shaved, and their house is clean, but we all know that's not what really happens every day. Once the luster of having someone new (that's you) wears off, they'll go about their lives as usual. Some subjects relax more quickly, which allows the photographer to get started without delay. However, it's best to mark the pace of progress on a case-by-case basis.

Start with an interview

There's a lot to be said for starting your photo stories with an interview. They'll give you better insight into your subject's history, reveal something about them you may not have known previously, and perhaps offer better story direction. Interviews also give your subjects a chance to tell their stories in their own words, which brings additional color and life to the narrative. When feasible, I also encourage recording your subject's interviews with an audio recorder, which can later be used in conjunction with your still images.

Audio capture techniques for interviews:

- Bring a decent recorder, headphones, notepad, and pen. If you can manage it, use a microphone stand to help reduce the transmission of noise caused by hands wrestling with the microphone, and also to free your hands to make notes as you interview. As the interview progresses, be sure to mark key phrases your subject says, and when they say them, so you can reference them quickly during the production process.

- Find a quiet, comfortable place, where ambient sound won't impede the audio recording or distract your subject during the interview. Avoid rooms with lots of electronics or machinery as they emit distracting hums, and steer clear of spaces with high ceilings because voices reverberate. Also stay away from high-traffic areas. Often, an inner room such as a sitting room or bedroom is optimal because it will have cushioned furnishings to absorb sound. If you're in a pinch, the interior of an automobile works too.

- Place the microphone close to your subject's mouth to maximize the audio recording quality. Using a directional microphone such as a shotgun microphone also helps isolate your subject's voice while reducing the capture of ambient sound. Wear headphones so you can hear what's being recorded in real time. I typically cover only one ear with the headphones and leave the other uncovered to hear my subject talk.

- If your subject references something interesting that can be documented with audio, be sure to write that down and record natural "nat" sound that fits the verbal description. For example, if your subject says, "I can't sleep at night because of the constant gunfire," try to capture gunfire noise that will audibly illustrate what they're talking about.

- Wait a few seconds before asking another question. Allowing time between each sound bite gives you more space to cut and splice the audio later.

- Once your interview is finished, make sure you record at least 30 seconds of white noise in the same space the session was conducted. That's the ambient sound in the room without people talking, such as the hum of electricity, birds chirping in the distance, or the far-off rumble of cars on the road. This track of sound is placed underneath the entire length of the interview to help reduce audible dips or harsh transitions.

The interview process

I try to approach my interviews as I would a casual conversation, relaxed and natural. If I'm under time constraints, I'll often begin a conversation with my subject as I set up my audio equipment. In doing so, I can determine how easy or difficult the interview process will be, how to best navigate the conversation, and how to formulate my questions to coax the most coherent answers from my subject.

I'll start off by asking the subject if they've ever been interviewed and recorded before. No matter the response, I'll let them know to include my question in their response. For example, if I ask "What's your name?" they'll answer with "My name is Jane Doe." I do this because my voice will ultimately be cut from the recording during the production phase, and there needs to be a lead-in or context for the answer.

Allow the conversation to progress naturally. If you've formulated questions in advance, that's fine. Having an idea or direction is good. But don't let your list of questions dictate the interview, and don't read the questions verbatim; doing so can make you seem robotic and disconnected. Let the questions and answers flow. Often that leads to better questions and answers that you couldn't have thought up beforehand. Above all, be a good listener, make eye contact, don't interrupt, and avoid rushing the interview.

When you're done, be sure to thank your subject for their time. Leave the recorder going as you wind down the conversation. Sometimes there's a little giggle, a sigh of relief, or a silly comment your subject makes that can be very useful in production.

Q&A

An interview requires patience and interest. You don't want to rush in, get the sound bite, and get out. If you ask a question, be sure to give your subject time to answer; a comfortable silence is all right, too. Start with short basic questions such as "What's your name, where are you from, and what's your job?" If you've done your research well, you should already know the answers to these basic questions, but asking them will give your subject additional time to settle down and feel more at ease with the process.

QUICK TIP

Avoid asking yes or no questions, and if you accidentally throw one out there, don't settle on a one-word response. You can either rephrase the question to get a longer response, or simply offer a prolonged silence. Often, the interviewee will initiate more talk or further explain why they said yes or no.

Insights: Introductions under Pressure

If you're in a high-risk environment, you may not have the luxury of developing the subject-shooter relationship over a period of time. Often, you're there and gone. However, it's best to take your time when approaching a new situation or subject, and above all else remember your customs and courtesies. You may never see them again, but they're still people with real emotions and your actions will directly impact them and your story outcome.

Try not to let the intensity of the situation impact your personality and movements. I suggest you slow down, move calmly, talk softly and articulately, and pace yourself. I try to remind photographers that you'll often get back what you put out. So if you're scattered and bouncing about the room nervously, you'll inadvertently evoke tension and distress from your subjects. That too may not be reality, and we're not there to change or impact what's really happening. By controlling your movements and emotions, you can lessen the impact your presence brings to the shooting environment.

Getting the facts are important, but don't be afraid to ask about feelings. For example, you can ask your subject, "How does it make you feel when *this* happens?" or "How did you feel when *that* happened?" Explore their reasons for feeling that way. Discover the catalyst, the conflict, or the fundamental problem. Find out what motivates them. In some cases, your subject may not be willing to give up that information right away. If you feel the answer is guarded, ask some other off-topic questions, then go back, reword the original question, and ask it again. You can do this a couple times, and each pass will render different results.

Questions to ask during interviews:

- How would you describe yourself?
- What's the most important lesson you've learned in life to date?
- What's your biggest accomplishment?
- What's your greatest fear?
- If you could go back in time and change one thing in your life, what would that be?
- Explain to me *the* events that led you to this moment in time.
- Tell me about how you overcame *the* obstacle.
- Describe to me your motivation for getting through *the* event.
- How do you feel *this* event has changed you?
- What advice would you give to someone in your situation?
- Who's been an inspiration to you?
- Is there anything you'd like to add?

I may not ask all of these questions, nor may they apply to every interview. However, these nonsuperficial questions draw out solid quotes that help carry the narrative. Even if I choose not to use the audio recording later, the Q&A process gives me a better sense of what drives my subject as well as a clearer view of the story's direction.

Use an audio recording kit

Getting high-end audio capture equipment can cost a small fortune, but a simple handheld digital recorder will suffice, such as those made by Zoom, Olympus, Roland, Marantz, and Tascam. Investing in a microphone windscreen can help improve the capture quality, too. I started with a little Sony recorder, and over time I purchased more advanced gear (**Figure 6.7**).

My personal audio kit

- Sennheiser Ultimate Shotgun Microphone
- Windsock for shotgun microphone
- Sennheiser ENG G3 Series Dual Wireless Basic Kit
- Marantz PMD 660 Portable Compact Flash Digital Recorder
- Sony Noise-Canceling Headphones
- Gitzo Microphone Shock Mount
- Gitzo Microphone Boom Pole

Lay down tracks

Once I've captured the audio, I need to cut and splice the interview so it makes sense and relays the story. Often, I'll wait to start the audio editing process until I've completed my photo shoot. Sometimes key moments happen during the story and I capture a great photograph, which inspires me to do another interview or gather additional ambient sound. Just as I let the audio inspire my story and the documentation, I let the images influence the edit of the audio track. Ideally, both come together harmoniously because I've paid particular attention to how one will impact the other.

There are a number of audio editing software applications, but I prefer to use Final Cut Pro (**Figure 6.8**). I don't see the point in investing in additional audio editing software when Final Cut Pro allows me to incorporate and edit audio, still

FIGURE 6.7 I keep all my audio equipment together in a Kata Sundo bag, which is specifically made for audio equipment such as sound mixers, wireless transmitters, and digital recorders. It has a clear plastic zipper top, which, unless it's raining, I keep flipped open for easy access to adjust my recorder.

FIGURE 6.8 For a long time I used Final Cut Pro 7, and then transitioned to Final Cut Pro X. There's quite a difference between the two, and I was initially irate when Apple decided to change the software. But as with every other drastic change in technology, I scoffed for a while and then decided to learn the new interface and press on. I still have Final Cut Pro 7, because there are projects I've built with 7 that I cannot take over to X; however, all my new projects are built with X. Down the road, I'm sure another version will appear and I'll have to transition again. That's just how it is.

photography, video, and text all at once. I've also worked with Adobe Premiere Pro CS6 and Avid, which are also powerful multimedia editing suites. However, those heavy-duty editing platforms come with a hefty price tag. Other, less expensive alternatives include Adobe Premiere Elements, CyberLink PowerDirector 11 Deluxe, Windows Movie Maker, and iMovie. The more robust software offers additional options for creating a polished multimedia product.

Create captions

Interviews are great as source material for captions. You can get your "who, what, when, where, and why" right off the bat. The interview can also help you

acquire a memorable or inspirational quote to accompany your newsprint picture. After all, captions should be a mini-story that not only answers all the questions surrounding an image but perhaps reveals something more about the picture's subject, too.

As I mentioned in Chapter 3, "Gear Essentials," I use Photo Mechanic to write my captions. It has several fields where I can include the caption, city, state, country, date, credit, copyright, keywords, email, and more. When the pictures are from the same event, I can save, or copy, the first completed IPTC Stationary Pad and load, or paste, the information to the rest of the images to save time. From there, I can just tweak the individual caption fields with each image's proper information (**Figure 6.9**).

FIGURE 6.9 International Press Telecommunications Council (IPTC) is a consortium of UK-based news industry folks who developed a standard for storing information that was later applied to digital photography, hence the term IPTC data. This data, or image information, is embedded directly into all JPEG, TIFF, and PSD files once you've used software like Photo Mechanic to apply the details.

Insights: Caption Writing

One of the jobs of a photojournalist is to capture solid, accurate caption information for images. Like with our photography, these should be unbiased and devoid of opinion, insinuation, or assumption. I don't presume to know how my subject is feeling at any given moment in time. But they're more than welcome to share their emotion in a quote.

Here's how I formulate my news captions:

- Write in present tense.
- Identify the subject(s) in the picture from left to right.
- Include the subject's grade, rank, or position using AP Style Guide abbreviations.
- Describe the action happening in the picture.
- Mention the location using AP Style Guide abbreviations.
- End the first sentence with the day, month, and year.
- Include a direct quote from the subject.
- Provide additional information about the event in follow-up sentences with higher-priority information before less essential information. This allows the caption to be trimmed from the bottom up if needed.
- Include a byline with photo credit information.

Here's how my news captions look:

Lt. Col. Morris Goins, commander of 1st Battalion, 12th Cavalry, Multinational Division North, discusses manpower shortages of the Iraqi police force with local sheikhs during a lunch meeting in northern Diyala Province, Iraq, on April 24, 2007. "We do seem to see a little bit more movement of al-Qaeda inside of our battle space," said Lt. Col. Goins. "That's why we're trying to leverage the sheikhs to come to the table and trying to get the local people to step up and join the Iraqi police department." (Photo by Stacy Pearsall)

Important Photo Mechanic IPTC fields

- **Photographer:** Name of the image creator
- **Credit Line:** Acknowledgments of the individual or organization supplying the image (for example, Aurora Selects, Associated Press, or Stacy L. Pearsall)
- **Caption:** The who, what, when, where, and why of the image, along with supportive information such as direct quote and additional event details
- **Caption Writer:** Name of the caption writer
- **City:** Name of the city where the image was created
- **Country:** The full name of the country where the image was created
- **Country Code:** The two- or three-digit country code where the image was created
- **Copyright Owner:** Identifies who owns the copyrights to the image
- **Contact Info:** The image copyright holder's address, phone number, and email
- **Date Created:** The day, month, and year the image was created
- **Headline:** An abbreviated caption with just the immediate, pertinent information
- **Keywords:** A series of words, terms, or phrases (separated by commas) that describe the image content

Several Story Approaches

Although telling the story in a single image has its merits, there are benefits to using multiple pictures together to better illustrate the story. By using several images of a common theme, you can construct a coherent narrative. Just like other photojournalism assignments, photo stories should be unrehearsed, spontaneous, and unscripted. By unscripted I mean the photographer should not influence the subject to act out a situation for the betterment of the story—if it happens, it happens, and if it doesn't, tough. Picture stories should capture images that relay the often-complex human experience and delve deeper into the nature of human society. They should offer a "fly-on-the- wall" perspective.

You can capture a story using one of many different photographic and creative approaches, such as the portrait essay, narrative essay, and how-to essay, or a day in the life. Depending on the story subject, one approach may be better suited than another. It's your job to determine which is best.

Create a nonlinear essay

The nonlinear approach uses images that aren't necessarily chronological but that have a resounding theme that ties them together. They bounce around in time, and there's no clear beginning, middle, or end point. Though not sequential, the narrative still flows smoothly. The nonlinear approach encompasses the "repeated identity" and "day in the life" story methods.

Repeated Identity

One of the most common approaches to photo storytelling is the repeated identity method. The photographer usually pinpoints one person, who is the subject throughout the entire visual narrative, and helps bridge the story from image to image. This story of Donald Rumsfeld by photojournalist Andy Dunaway is a great example of the repeated identity method (**Figures 6.10** through **6.19**).

FIGURE 6.10 Secretary of Defense Donald H. Rumsfeld addresses a group of servicemen who are stationed at Osan Air Base in South Korea.

Lens (mm): 200, ISO: 400, Aperture: 2.8, Shutter: 1/80, Program: Manual

FIGURE 6.11 Secretary of Defense Donald H. Rumsfeld talks with key coalition leaders as they wait in the Kuwaiti International Airport VIP lounge prior to going to Iraq.

Lens (mm): 70, ISO: 400, Aperture: 2.8, Shutter: 1/60, Program: Manual

FIGURE 6.12 Secretary of Defense Donald H. Rumsfeld responds to a reporter's question during an informal press briefing while en route to Washington, D.C.

Lens (mm): 19, ISO: 400, Aperture: 2.8, Shutter: 1/100, Program: Manual

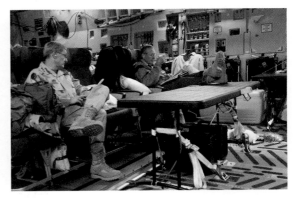

FIGURE 6.13 Secretary of Defense Donald H. Rumsfeld reviews military reports while in transit aboard a C-17 Globemaster III aircraft.

Lens (mm): 26, ISO: 640, Aperture: 2.8, Shutter: 1/60, Program: Manual

FIGURE 6.14 Ministry of Defense General Tevadze talks with Secretary of Defense Donald H. Rumsfeld and Ambassador Dick Miles after arriving at Tbilisi, Georgia.

Lens (mm): 35, ISO: 200, Aperture: 5, Shutter: 1/500, Program: Aperture Priority

FIGURE 6.15 Secretary of Defense Donald H. Rumsfeld answers a question from the audience during a town hall meeting at Osan Air Base, South Korea.

Lens (mm): 35, ISO: 200, Aperture: 2.8, Shutter: 1/260, Program: Manual

FIGURE 6.16 Secretary of Defense Donald H. Rumsfeld responds to his introduction during a town hall meeting at Osan Air Base, South Korea.

Lens (mm): 26, ISO: 200, Aperture: 2.8, Shutter: 1/80, Program: Manual

FIGURE 6.17 Secretary of Defense Donald H. Rumsfeld answers a reporter's question during a news briefing at the Pentagon in Washington, D.C.

Lens (mm): 140, ISO: 200, Aperture: 3.2, Shutter: 1/125, Program: Manual

FIGURE 6.18 Secretary of Defense Donald H. Rumsfeld reviews the local paper prior to a NATO conference in Brussels, Belgium.

Lens (mm): 35, ISO: 400, Aperture: 3.2, Shutter: 1/60, Program: Manual

FIGURE 6.19 Secretary of Defense Donald H. Rumsfeld takes a quiet stroll alone prior to a NATO conference in Brussels, Belgium.

Lens (mm): 35, ISO: 200, Aperture: 5, Shutter: 1/320, Program: Aperture Priority

Day in the Life

Contrary to what its name implies, the Day in the Life photo story isn't necessarily only one day of coverage of your subject. This approach to a story is meant simply to document what happens to the subject throughout their daily lives. Coverage of the story may last one day, multiple days, weeks, months, or even years. Check out this story I photographed over the course of 4 months about a young boy, Zachary Moore. I used the Day in the Life approach so I could best demonstrate the trials and tribulations Zachary faced as he underwent treatment for leukemia (**Figures 6.20** through **6.28**).

FIGURE 6.20 Air Force wife Kim Moore watches her son Zachary get dressed for his doctor's appointment at their house in Charleston, South Carolina.

Lens (mm): 19, ISO: 400, Aperture: 2.8, Shutter: 1/15, Program: Aperture Priority

FIGURE 6.21 While Kim Moore mixes cheese into a bowl of grits, Zachary cries about not getting the chance to do it himself.

Lens (mm): 70, ISO: 400, Aperture: 2.8, Shutter: 1/60, Program: Manual

FIGURE 6.22 After getting into trouble with his mother, Zachary Moore stands by the wall in a "time-out."

Lens (mm): 17, ISO: 400, Aperture: 2.8, Shutter: 1/8, Program: Aperture Priority

FIGURE 6.23 Zachary Moore, 3, grabs his backpack before leaving for his doctor's appointment.

Lens (mm): 38, ISO: 400, Aperture: 3.2, Shutter: 1/15, Program: Aperture Priority

FIGURE 6.24 Zachary Moore leads his mother Kim and Dr. John Whittle down the hallway to exam room 2.

Lens (mm): 17, ISO: 640, Aperture: 2.8, Shutter: 1/180, Program: Aperture Priority

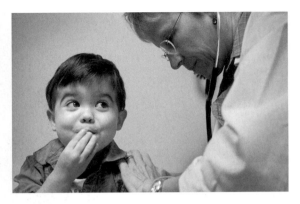

FIGURE 6.25 Diane Dufour, nurse practitioner, checks Zachary Moore's lungs for any sign of infection.

Lens (mm): 30, ISO: 400, Aperture: 2.8, Shutter: 1/160, Program: Aperture Priority

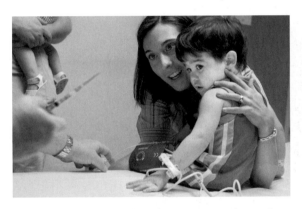

FIGURE 6.26 As the anesthesiologist prepares the medicine, Zachary Moore receives some encouragement from his mother Kim.

Lens (mm): 28, ISO: 640, Aperture: 2.8, Shutter: 1/250, Program: Aperture Priority

FIGURE 6.27 Zachary Moore lies sedated on a gurney while his chemotherapy is injected.

Lens (mm): 28, ISO: 640, Aperture: 2.8, Shutter: 1/350, Program: Aperture Priority

FIGURE 6.28 Kim Moore helps her son Zachary open presents before blowing out his birthday candle.

Lens (mm): 52, ISO: 500, Aperture: 8, Shutter: 1/15, Program: Aperture Priority

Create a portrait essay

A portrait essay is a series of portraits centered on a common idea or theme. These essays capture the emotional complexity of their subjects, humanizing the story, while evoking strong reactions from viewers. They may consist of a variety of stylistic portraits, such as environmental, studio, or candid. Check out this series of portraits portraying men of the Afghan armed forces by Andy Dunaway (**Figures 6.29** through **6.35**).

FIGURE 6.29 An Afghan National Army soldier stands guard outside a building in Kabul, Afghanistan.

Lens (mm): 23, ISO: 100, Aperture: 4, Shutter: 1/500, Program: Aperture Priority

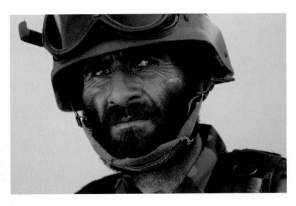

FIGURE 6.30 An Afghan National Army soldier waits for a foot patrol exercise at the Kabul International Airport in Afghanistan.

Lens (mm): 62, ISO: 100, Aperture: 4, Shutter: 1/200, Program: Aperture Priority

FIGURE 6.31 An Afghan National Air Force helicopter pilot waits for his orders at the Kabul International Airport in Afghanistan.

Lens (mm): 24, ISO: 200, Aperture: 4, Shutter: 1/80, Program: Manual

FIGURE 6.32 An aircraft maintainer with the Afghan National Air Force watches planes take off from his hanger at the Kabul International Airport in Afghanistan.

Lens (mm): 28, ISO: 100, Aperture: 4, Shutter: 1/500, Program: Aperture Priority

FIGURE 6.33 An Afghan National Army soldier sits on his bunk at his barracks in Kabul, Afghanistan.

Lens (mm): 32, ISO: 200, Aperture: 4, Shutter: 1/160, Program: Manual

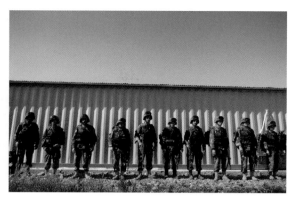

FIGURE 6.34 Afghan National Army soldiers stand in formation before conducting training operations in Kabul, Afghanistan.

Lens (mm): 17, ISO: 100, Aperture: 4, Shutter: 1/800, Program: Aperture Priority

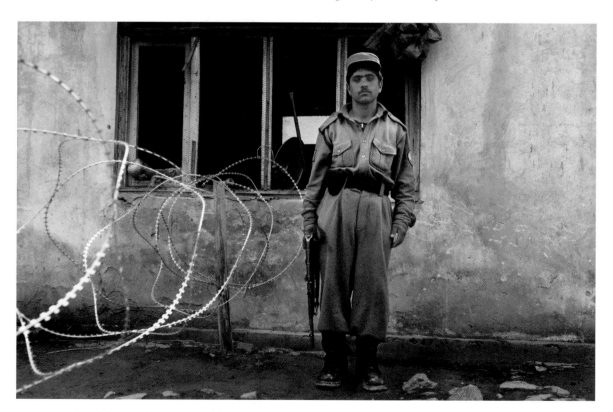

FIGURE 6.35 An Afghan National Army soldier stands outside of the base dining facility in Kabul, Afghanistan.

Lens (mm): 28, ISO: 100, Aperture: 4, Shutter: 1/500, Program: Aperture Priority

Create a how-to process story

In a how-to photo story, the photographer shows how something is done from beginning to end. These types of stories are most commonly used in hobby-type magazines, and we often used them in the military to document training scenarios. In my opinion, they're the easiest type of story to photograph and often take the least amount of forethought and effort. While there are good uses for this type of approach, I don't believe it's the most effective in terms of conveying a human-interest story. Here's a how-to process I used when photographing the U.S. Marine Corps as they trained Djiboutian policeman how to clear buildings during an operational assault (**Figures 6.36** through **6.43**).

FIGURE 6.36 A Djiboutian policeman watches the more experienced squad demonstrate how to properly clear a room in Djibouti City, Djibouti.

Lens (mm): 70, ISO: 400, Aperture: 5.6, Shutter: 1/200, Program: Manual

FIGURE 6.37 Djiboutian policemen watch Marine Steven Jacobs demonstrate how a terrorist may attack the policemen during close quarters combat.

Lens (mm): 42, ISO: 400, Aperture: 14, Shutter: 1/200, Program: Manual

FIGURE 6.38 Djiboutian policemen lean on a wall during a short break in training.

Lens (mm): 24, ISO: 400, Aperture: 5, Shutter: 1/200, Program: Manual

FIGURE 6.39 Marine Steven Jacobs teaches Djiboutian policeman how to move through hallways as a team.

Lens (mm): 12, ISO: 400, Aperture: 4, Shutter: 1/15, Program: Manual

FIGURE 6.40 Policeman Bachir Abdillah Nour watches as his teammates move forward in the hallway.

Lens (mm): 24, ISO: 400, Aperture: 4, Shutter: 1/15, Program: Manual

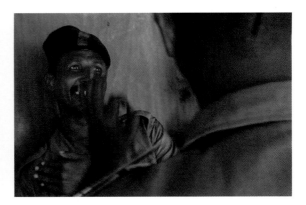

FIGURE 6.41 Djiboutian policemen talk about their experiences after training at the shoot house.

Lens (mm): 24, ISO: 400, Aperture: 5, Shutter: 1/20, Program: Manual

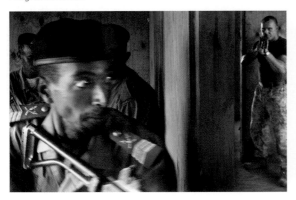

FIGURE 6.42 While acting like an aggressor, Marine Steven Jacobs aims his rifle at a team of policeman who are learning how to sweep and clear rooms.

Lens (mm): 24, ISO: 400, Aperture: 6.3, Shutter: 1/125, Program: Manual

FIGURE 6.43 During their lunch break, Djiboutian policemen pray as a group on the roof of the shoot house.

Lens (mm): 24, ISO: 400, Aperture: 16, Shutter: 1/60, Program: Manual

Create a narrative photo essay

The narrative photo essay uses a finite chronological timeline to tell the story of an event with a distinct beginning, middle, and end. It's not a literal "how to" approach but is similar to a written story with conflict and resolution. Each picture is closely related to the previous and subsequent images that follow, with a visual rise and fall. It's similar to the Day in the Life photo story, but differs in that it lasts only as long as the duration of the event being covered, whereas the Day in the Life photo story can unfold over multiple days, weeks, and years. This sample story of the narrative approach is one I photographed about a soldier suffering post-traumatic stress and combat-related trauma who sought help and healing through musical therapy at an event called Song Writing with Soldiers. The event was two hours long; it took place in one room and had a beginning, middle, and end point (**Figures 6.44** through **6.51**).

FIGURE 6.44 U.S. Army soldier Staff Sergeant Kenneth Sargent sits on a couch next to a worn-out guitar as he relays his story to country songwriters Darden Smith and Radney Foster.

Lens (mm): 44, ISO: 500, Aperture: 2.8, Shutter: 1/2000, Exp. Comp.: -2.0, Program: Aperture Priority

FIGURE 6.45 Musician Radney Foster strums his guitar during a music-writing session with U.S. Army soldier Staff Sergeant Kenneth Sargent.

Lens (mm): 180, ISO: 800, Aperture: 2.8, Shutter: 1/320, Exp. Comp.: -0.7, Program: Aperture Priority

FIGURE 6.46 U.S. Army soldier Staff Sergeant Kenneth Sargent listens to songwriters Darden Smith and Radney Foster as they put his story to music. "I was told almost a year ago that I would never walk again," said Sargent. "I heard my thoughts and heartaches come out of the mouth of a stranger and I listened to it and heard myself through someone else, then sung as if it was the Star Spangled Banner. It was the most amazing experience in my life."

Lens (mm): 70, ISO: 200, Aperture: 2.8, Shutter: 1/2000, Program: Aperture Priority

FIGURE 6.47 U.S. Army soldier Staff Sergeant Kenneth Sargent shows songwriter Darden Smith some pictures during his combat deployment to Iraq.

Lens (mm): 70, ISO: 6400, Aperture: 2.8, Shutter: 1/20, Exp. Comp.: - 0.3, Program: Aperture Priority

FIGURE 6.48 U.S. Army soldier Staff Sergeant Kenneth Sargent shows off the tattoo he got after being wounded in Iraq to songwriter Radney Foster as fellow musician Darden Smith strums his guitar.

Lens (mm): 31, ISO: 200, Aperture: 2.8, Shutter: 1/400, Exp. Comp.: - 2.0, Program: Aperture Priority

FIGURE 6.49 U.S. Army soldier Staff Sergeant Kenneth Sargent recounts the day he was blown up in Iraq as songwriters Darden Smith and Radney Foster listen.

Lens (mm): 200, ISO: 800, Aperture: 2.8, Shutter: 1/500, Program: Aperture Priority

FIGURE 6.50 Songwriter Darden Smith lies back and strums his guitar as he writes a song about U.S. Army soldier Staff Sergeant Kenneth Sargent.

Lens (mm): 29, ISO: 800, Aperture: 2.8, Shutter: 1/160, Program: Aperture Priority

FIGURE 6.51 Crying, U.S. Army soldier Staff Sergeant Kenneth Sargent embraces songwriter Radney Foster after they complete writing a song about Sargent's experience in Iraq.

Lens (mm): 32, ISO: 640, Aperture: 2.8, Shutter: 1/1600, Program: Aperture Priority

Creating Visual Variety

A photo story should be able to stand alone without written words and make logical sense to the viewer. Much the same as a written story, photo stories should have a setting, plot, and characters. Of course, not every story will be as in-depth as the next, and depending of the type of photo story, may not contain a conflict and resolution. But it's important to explore the story to see how deep it can take you. The further you dive down into your subject matter, the more likely you are to bond the subject with the viewers. A good photo story connects the audience and evokes an emotional response—whether that's anger, contentment, exhilaration, or bewilderment.

There's nothing more stagnant then a photo story shot with one focal length from eye level and flat lighting. If all your subjects have the same head size, you're doing something wrong. Be sure to vary your angles of view, change out lenses, get high, get low, and exploit the available light. Try to use foreground, middle ground, and background in your shots to help deliver more information, and visually drive the story forward. And capture light, color, and contrast for visual, emotional conveyance.

I was taught a basic formula for creating photo stories. I don't necessarily adhere to it for every assignment, and for some story approaches this technique doesn't apply, but it keeps me thinking about incorporating visual variety throughout my documentation. This formula stresses five key visuals: overall, portrait, detail, action, and clincher. When my story is ready for edit, I may drop two or three of these formulaic images, but they are available as options. Standard photo stories use eight to twelve images, so I may end up with two, three, or four action shots if they're dynamic and carry the narrative—or perhaps none at all.

The formula for creating visual variety

- Overall: The overall image is a scene setter that establishes the location or setting of the story subject. For example, if the story is about a homebound hoarder, then the overall can be a high, wide-angle view of the claustrophobic, cluttered home environment. Or if the story is about the effects of a hurricane on a small town, the overall can be an aerial photograph of the vast, destroyed landscape.

- Portrait: I don't mean to state the obvious, but it's important to identify the subject of your story, especially in repeated identity stories. It's easy to overlook getting a close-up portrait when they're in nearly all your shots. However, they may be too far off to identify the person. Having a solid portrait gives a face to your story no matter what narrative approach you take.

- Detail: The detail shot is pretty self-explanatory. It's an informative, close-up picture of a relevant object, or subject feature, that should educate the viewer or reveal something unknown about the story's subject.

- Action: The action shot can illustrate your subject's human interaction with others, daily activities, occupation, or athleticism. Getting good action shots requires keen observation on the part of the photographer, to anticipate when and where the action will take place and be prepared to capture it. On the other hand, sometimes it's a matter of being in the right place at the right time.

- Clincher: The clincher, or final image, is a picture that settles or resolves the story's conflict. Perhaps it's a picture of a new mother embracing her baby right after birth or a soldier's farewell salute to fallen comrades.

FIGURE 6.52 In the early years of the multimedia movement, Bruce Strong covered a story about the effects of Alzheimer's on a long-married couple, who happened to be his grandparents. (Photo by Bruce Strong)

Multimedia

"Newspapers are becoming the dinosaur, and the media is now reaching audiences on multiple platforms such as the Internet, tablets, and smart phones. There's an expectation that photographers should know how to capture a story using multiple mediums such as audio, video, and still photography," says Jimmy Colton.

Stories that include any combination of still photographs, audio, text, and video in one production are considered multimedia stories. The approaches to multimedia stories are exactly the same as still photography stories, and the process of compiling story ideas, doing research, and developing the stories is the same. Where multimedia deviates from the standard photo story is its inclusion of other tangential mediums. Plus you're no longer relying on eight to twelve images to tell the story; now there are multiple frames in motion and audio to boot.

Learning good audio capture techniques, video transitions, and video production software, such as Final Cut Pro or Adobe Premier, can be daunting at first. Just like with the art of still photography, becoming proficient in multimedia takes practice and dedication, and there's extra cost involved when introducing additional gear and technology. However, the benefits of learning and investing in multimedia pay dividends in the long run.

I've been inspired by many visual journalists, but one of the guys who's at the top of my list is Bruce Strong. I defer to his expertise whenever I need guidance or inspiration. In addition to being a multimedia-extraordinaire, he's got the amazing knack for teaching it, in a way that makes everything simple enough for me to understand. Currently Bruce is an associate professor and the chair of Multimedia, Photography, and Design at my old stomping grounds, Syracuse University's S.I. Newhouse School of Public Communications, where he instructs on a variety of subjects such as video, audio, photography, and of course multimedia. He's also a Professional in Residence at MediaStorm, and his work has been published in *TIME* Magazine and *National Geographic* (**Figure 6.52**).

Bruce believes multimedia allows us to be a complete journalist and gives us the power to tell a complete, emotionally evocative story with both words and visuals. I couldn't agree more. As for photographers who aren't prone to thinking about the whole story, the new way of working can be a struggle to adapt, says Bruce. It's no longer just six still images of a wide, medium, detail, and portrait. Multimedia requires the photographer to understand what the story is and how to put it together so the information gets past the head and penetrates the heart. The story's visuals and audio should rise to a much higher level, eliciting an emotional response from the viewer.

"I don't think anyone really knows where all this is leading to," said Bruce. "But one thing is for certain: it's not going to revert back to the old way. We need to figure out how we can get out in front of the digital revolution rather than be swept up by the change. Let's steer it in a direction we want it to go, because we can't brush it off as fads anymore. The fun part in all this change is the technology we haven't even seen or thought about yet. Technology is spinning at such a speed that I don't think we can even grasp what's coming. All we can do is embrace the change and enjoy the ride. No matter what, we need to use what's available to tell better and more creative, truthful, powerful stories that are imaginative and fresh."

Stay competitive and innovative

I believe the year was 2002 when I completed my first true multimedia piece under the tutelage of Brian Storm at the Multimedia Bootcamp at the University of North Carolina at Chapel Hill. I have to admit, before attending the workshop I had little interest in becoming a "visual journalist." I walked away a changed professional. That's not to say I altered my beliefs about the power of the still photograph. Instead, I added skills and methods in other areas of documentation to develop a new way of telling a visual story. Still photography has remained my primary method of documenting a story, but now I can touch viewers' other senses by incorporating my story subject's voice and showing key action with video. My ability to see as a still photographer only benefits the video I record, and the method of coverage is not too dissimilar either.

The other important lesson I learned early on is that as my profession evolves, the standards and requirements for professional photojournalists like me are changing. If I don't embrace new ways of documenting news, I'll be left at the proverbial

station. The demand for creating more Hollywood-style pieces that deliver beautifully documented, tightly packaged, well-produced stories of vital information to the masses is insatiable. Even I'm critical of the stories I see online, and if I'm not grabbed by the story within the first 30 seconds, I'm gone. It's not a negative, really; it's just that our expectations for production value in news stories have grown more demanding. With that, we're all challenged to take our storytelling capabilities to another level. It's a matter of staying competitive in the marketplace and being creative photographers at the same time.

"Being versed in more than just photography presents an opportunity of multiple revenue streams versus one or two; now we have eight or nine because we can produce news and write news stories; capture audio, video and photo; and edit sound, video, multimedia," says Bruce Strong. "We've moved away from pigeonholing ourselves into one kind of storyteller."

Manage your time

What makes multimedia even tougher is we're meant to do this all by ourselves. Yup, one guy, one story, one finessed final product ready for web viewing. And for the daily staff photographer or freelancer, it's to be done in short order to boot. I don't care if you're the Superman of Multimedia; it's a big undertaking. But it can be done. I was taught excellent time management skills in the military, and it's a skill I wouldn't trade for anything.

As I said before, the approach to multimedia isn't very different from preparing for a dedicated still photography photo story. I still research my topic, define my narrative, identify a good subject, pre-conceptualize the story and begin with an interview. Since I almost always break the ice with my subjects by conducting a recorded interview, I'm already ahead in my project. Depending on my subject, sometimes I'll document the interview with video too. I'll then go about my photo shoot the same as I would any other assignment. If I see something happening that's better suited for video, I'll put my DSLR on a tripod, switch to video mode, and shoot.

QUICK TIP

If the story is time critical, I'll be more cognizant of how much audio and video I capture. After all, if I get one hour of audio, I have to review one hour of audio in production. The time spent sifting through gobs of video footage may be better spent in Final Cut putting the package together.

Insights: A Team Effort

I've mentioned the importance of collaboration before in Chapter 5, "Covering All the Angles." Creating a multimedia piece is a prime example of why it's so important to establish a solid network of talented friends in the industry. Although you'll usually be expected to create multimedia stories on your own, whenever possible make it a team effort. With a different person dedicated solely to capturing audio, recording video, producing, editing, and so on, you can take advantage of one another's strengths and all work simultaneously to get the work done quickly. Keep in mind that having a three-man (or wo-man) team on location during an assignment can get crowded, and if you're documenting someone in his or her one-bedroom loft it can become a circus quickly. Just be sure to think about these scenarios in the pre-planning stages of your story development.

Shoot video with your DSLR

Along with making great still images, today's professional-grade DSLR cameras can record HD video that looks amazing. With superior optics and glass, many visual journalists have begun using DSLR cameras as their standard equipment while on assignment. I shoot with a Nikon D3s, Nikon D800, and Nikon D4, which all have video capabilities, so I don't see any point in bringing a dedicated video camera. It just takes up more room and weighs my bags down. Plus, I'm already familiar with the feel and function of my DSLR and its lenses (**Figure 6.53**).

FIGURE 6.53 When I'm shooting fast-paced assignments, "guerilla-style" as they say, with video, I'll usually grab my Nikon D800 with a shoulder rig and hot shoe microphone and go where the action takes me.

To avoid getting "monkey cam" when I shoot video, I have a few different tripods, monopods, fluid heads, sliders, and shoulder mounts I use as stabilization platforms. Plus, there are a few other accessories that can help make life easier in the field.

My DSLR video shooting accessories:

* **Zacuto DSLR Z-Finder Pro** allows the camera's LCD screen to be brought up to my eye so I can focus on my subject in Live View while keeping my camera stable. It also blocks out the ambient light, which improves viewing.

* **Manfrotto 529B Hi Hat** gives me better low-angle shots while shooting video because it's only 5.7 inches in height. I can interchange any number of heads on my Hi Hat as well.

* **Manfrotto 546B 2-Stage Aluminum Tripod** has spiked feet, rubber shoes, and a mid-level telescopic spreader that allows me to shoot on multiple surfaces without worry of slippage or movement.

* **Manfrotto 561 BHDV Video Monopod** has a fluid head with pop-out feet at the base for added stability.

* **Manfrotto 516 Pro Video Fluid Head** supports up to 22 pounds and has friction control, pan and tilt axis capabilities, and a counterbalance spring, which combined make following the action while recording video smooth and seamless. When I first began shooting DSLR video, I only had my still photo heads, which made panning impossible due to sticks and stutters as I moved the head. It was an ass pain. Then I got turned on to video fluid heads and it's been much, much easier since.

* **Konova Slider** can be set up independently or attached to my tripod, and then I can place my camera on top of the track. The slide can be set up for smooth lateral pans, vertical movements up and down, and inverted and diagonal shots, too. Although the slider offers a polished cinematic video clip, it can be just another tool you have to haul around on location. If your assignment is fast paced, this may not be the right item to bring. However, if you have the luxury of time, the slider can add something special to your documentation.

* **Manfrotto SYMPLA System with Fig Rig, Mattebox Kit, and Shoulder Support** gives me the ability to take my DSLR off the tripod for handheld shots while reducing camera shake. The ability to handhold my camera while shooting video gives me the freedom to follow the action up close, as it happens, and that's how I normally like to shoot anyway.

* **Litepanels** are LED continuous running lights that are lightweight and cool to the touch, and have adjustable output and color. I have a few mini and micro Litepanels I keep in my bag for standup interviews with my subject or to help fill shadows of a dark room.

* **SmartMyk** hot shoe external, directional microphone is a small external shotgun microphone I can set on top of my camera to record audio right onto my video files. To be clear, there's no substitute for getting the microphone off your camera and nearer your subject. In terms of maximizing sound quality, it's the best. But if you're shooting on the go, this microphone is perfect.

* **Singh-Ray Variable Neutral Density Filter** allows me to knock down the amount of light coming through my lens on the front end so I can open up my aperture for more shallow depth-of-field shooting.

Work with video exposure modes

Just like shooting still photography, you get the most control over your video when you shoot in Manual Mode. The Manual setting gives you full control over the aperture, shutter speed, and ISO. And like shooting Manual Mode in still photography, shooting Manual Mode video takes quite a bit of practice. After you experiment a bit, field-test your video skills, and try new techniques, you'll start to get a good feel for your Manual Mode settings. If you've already been shooting Manual in your still photography, it's going to be a much easier transition. You can also shoot video in Aperture Priority Mode and adjust your exposure using the Exposure Compensation button just like you would when shooting still images.

Aperture

The concept of aperture is the same as in still photography, so if you're shooting f/2.8 then you'll have shallow depth of field and if you're shooting f/22, nearly everything will be sharp. The Nikon cameras are not able to change the aperture while you're in Live View Mode, so it's important to exit out of Live View, set your desired aperture, and then go back to Live View Mode to shoot video.

Shutter speed

When shooting still frames, shutter speed determines how much blur will be captured in the image. For example, if you're shooting a shutter speed of 1/1000 of a second, you'll achieve stop action; conversely, if you're shooting 1/10 of a second, you'll pick up your subject's movement. Video isn't much different. When shooting a faster shutter speed in video mode, your subject will remain sharply defined; however, when you slow down your shutter speed you'll begin to pick up the motion blur as objects move through your frame.

To maintain the film look of shooting videos with your DSLR, you want to make sure your shutter speed is synchronous to your frame rate. Simply put, you'll want a frame rate that's double the number of your shutter speed. If you are shooting 24 frames per second, you'll want to set your shutter speed to 1/50 of a second.

> **QUICK TIP**
>
> Your camera's frame rate should not be confused with shutter speed. No matter whether you're shooting a fast or slow shutter speed, your frame rate will remain the same. For example, if you're shooting 24 frames per second, the number of frames exposed over a one-second interval will not change if you switch from 1/30 of a second to 1/400 of a second shutter speed. What happens is when your shutter stays open longer at, let's say, 1/30 of a second shutter speed for the duration of the frame interval, it captures the object or subject's movement. Here's a simple way of thinking about this: frame rate equals the number of images taken per second and shutter speed equals the length of exposure for each frame.

ISO

ISO's effect on the final outcome of your image is no different from still to video. If you use higher ISOs, you'll be able to shoot in lower light but may also begin to encounter grain. For that reason, it's always best to use as low an ISO as possible based on shooting conditions.

Extra steps, difference between still and video

When shooting video, I always use my still photo abilities to recognize good light, varied angles, and

moments. However, sometimes I need to shoot sequences that help make the video clips more cohesive when spliced together in the final product. As a still shooter, I never really thought about transitions, subject directional movements, or audio and visual continuity. Now when I flip my DSLR from still to video, it's in the forefront of my mind.

Preplanning

When shooting still photo stories, I won't necessarily have a clearly defined storyboard. But if I include video in my multimedia story, I create a visual storyboard in advance of my assignment, which helps me focus on the shots I'll definitely need. During my preplanning phase, I try to determine a video shot list so I don't end up shooting too much video that doesn't have any relation to the visual narrative. In the end, if I capture two hours of video footage, I'll have to wade through all of those clips to flesh out the story, and that's not efficient.

Story structure

Video documentation tends to be very linear with a beginning, middle, and end, so I do my best to shoot opening and closing shots while on location, along with my other formulaic shots such as details, portraits, and overalls. It's also important to shoot transitions that will be used to move from one story segment to another or perhaps transition your subject from one environment to another. I try to capture shots that I can use to transition from one story segment to another. For instance, if my subject is in a hospital bed and is about to be released to go home, I may shoot him or her leaving the hospital, helping transition the shooting environment from the hospital to the home.

Directional continuity

If I'm shooting a subject walking from left to right in a wide shot, I'll be sure they're still walking left to right in other similar shots. If I don't, the transition from one video clip to the next will be a visual jump and challenging to marry together.

Audio and visual continuity

There has to be continuity between the audio and the visual I present to the viewer. That's why I try to capture ambient sound on location as well as sounds that illustrate what my subject's talking about in their interview. Likewise, if in the voice-over the subject is discussing, say, bullet holes in the window, I need to be sure to get video or stills of the bullet holes in the window.

Make your final edit

For me, editing the final product can be the biggest challenge. When I first started down the multimedia path, I'd create these ghastly long pieces because I didn't know how to look at the overall story critically or how to cut audio succinctly. It's not like editing a 10-picture package for a still photo story, because the added layers of information must be taken into consideration when laying out the story on the timeline. Over time, I've gotten better, but I'm still no expert. I highly suggest taking a class or workshop on multimedia production and editing. Several wonderful options are offered by MediaStorm, NPPA, and Platypus, among others.

The most important lesson I've learned when putting my final product together is to keep it from running too long. If the subject is a talking head, that tends to bore the viewer—and me, too. Clips of video or sequential still images in rapid

succession can be good, but when overused, they can be distracting. I try to let the narration moderate the pace of the story, especially with more complex story issues. I want to make sure I give viewers enough time to process what they're reading, hearing, or seeing before introducing more information. In the end, my goal is to share my subject's story through layers of creatively documented and succinctly narrated information (**Figure 6.54**).

FIGURE 6.54 Once you've edited your video, you'll need to consider a few export options, such as codec, resolution, and frame rate. It's best to consult your client regarding where the video will be posted, viewed, and archived so you can perform the best-quality compression for the final multimedia product.

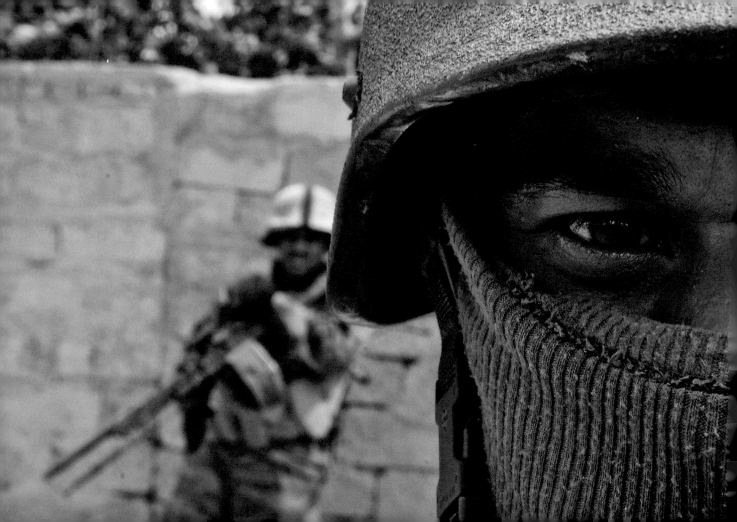

CHAPTER 7

STAYING ABOVE BOARD

As photojournalists, it's our job to be ever-vigilant observers, watching over humankind to ensure that civil liberties are not compromised. We create images that inform others of important events from far-off places and cover an array of issues that influence lives, perceptions, and decisions. Considering we are humans, and not without fault, it's important we stay above board professionally. That's why we operate under written and unwritten rules that guide us through ethically challenging situations. We as individuals must live up to all that is demanded of us by the laws that govern our occupation and the people who trust us.

An Iraqi Army soldier wears a ski mask during a combat patrol to conceal his identity from villagers near Baqubah, Iraq.

Lens (mm): 50, ISO: 100, Aperture: 16, Shutter: 1/30, Program: Manual

A Promise to Protect and Serve

"Ethics has evolved to become a central issue for National Press Photographers Association (NPPA). Insistence on ethical conduct by photojournalists has become a major goal of NPPA, and this means we must promulgate a vibrant code of ethics."

—NPPA Ethics Committee Chairman John Long

I became a member of the NPPA many moons ago at the urging of a mentor. Before becoming a member, I'd studied their ethics policies quite a bit. After joining, I began entering their photography competitions, reading their publications, using their educational tools, and attending their workshops. I'm now an NPPA mentor, and I teach their ethics policies to many of my students at the Charleston Center for Photography, among other educational institutions (**Figure 7.1**).

An Ethical Education

I was 24 when I attended the Military Photojournalism Program at Syracuse University, only marginally older than other undergraduate students I attended classes with. You can see me in **Figure 7.2** on the left posing with the rest of my classmates.

FIGURE 7.1 This picture was taken at my education studio, the Charleston Center for Photography, during a 3-day intensive workshop I was giving for a group of Marine Corps photojournalists. (Photo by Andy Dunaway)

FIGURE 7.2 This is a graduation picture of my Military Photojournalism Program classmates and me in the stairwell of the S.I. Newhouse School of Public Communications at Syracuse University. Our class was made up of a mix of Army, Marines, Navy, and Air Force photojournalists handpicked for advanced training. For 1 year, we exchanged our rucksacks for backpacks and attended school in street clothes with the rest of non-military student body.

Unlike my classmates and me, most of the 'Cuse undergrad student body were 19 or 20 years old, and looked at me as if I were pushing up daisies because I'd already traveled the globe, survived combat, and experienced enough for two lifetimes. One class in particular, Ethics, further distanced me from the rest of the general student population. I engaged in ethical class discussions based on what I'd learned operating in the field as a combat photographer, and compared to my classmates, I had an entirely unique view on the subject. For me, ethics in journalism wasn't as clear-cut as it was when I was a naïve 17-year-old, nor was there a textbook answer for every scenario in which I'd found myself during my tours documenting war.

My class at Syracuse wasn't my first education in ethics; actually, I was taught the NPPA Code of Ethics when I attended the Defense Information School. Plus, these issues were hammered into my very fiber on a daily basis at my combat camera unit. Before I had any firsthand experiences of my own, the ethical guidelines set forth to me seemed straightforward, black and white—no gray areas.

Most of the students who engaged me in debates during class made lofty declarations that they would always act in the right and would never doubt their decisions, as long as they followed the journalism code of ethics. When I was a rookie photographer, I made similarly confident statements. I was taught that as a photojournalist, I was a trustee of the public, whose primary role was to document and visually report any significant events and to tell the story from varied viewpoints without personal bias or opinion. It was my creed, and I swore by it. I was never able to rattle the NPPA Code of Ethics off the top of my head, but the essentials were in the forefront of my mind. If I

ever needed to refresh my memory, all I had to do was visit www.nppa.org. Here's how I recall them.

Key guidelines of the NPPA Code of Ethics:

- Tell the story accurately, thoroughly, and from all sides.

- Be unobtrusive toward your subjects.

- Do not be influenced by a subject's agendas or partisanships.

- Do not let your own prejudices and biases influence the story.

- Never stage or manipulate photographs.

- Do not alter the story's environment, impact the outcome, or influence events.

- Treat subjects from both sides of the story with equal respect and coverage.

- Do not accept bribes, favors, money, or compensation.

- Do not compromise your integrity by associating with people who may be viewed as influential and may have something to gain by manipulating the story for their own agenda.

- When confronted with a situation where the proper course of action isn't clear, consult with another journalist whose ethical standards are of the highest regard.

Easy. Yeah, right—maybe all but the last one, which I seemed to encounter about 20 times a day. It was all the more complicated by the fact that I was on my own overseas and couldn't phone-a-friend for the answer to my dilemmas. I had to search within myself to find the answers, and to this day I wonder whether I made the right calls.

Making Difficult Choices

There is one event in particular that haunts me over and over. I'd been working with a small group of American soldiers who trained the Iraqi Army and shadowed them during combat operations. I'd worked with them before and became friends with one of their team members, Captain Donnie Belser, Jr. (**Figure 7.3**). To be honest, he was the only person receptive to me accompanying them on a mission. The rest of the team was leery about having anyone with a camera near, because they believed that a previous journalist had behaved unprofessionally during a very sensitive situation. One of their soldiers had been severely wounded during a past operation, and this photojournalist took pictures of him as he struggled to stay alive. When the photographer released the photos, they were published before all the members of the soldier's family were notified of his injuries. Needless to say, everyone was upset—rightly so. That photographer's actions now reflected badly on everything I did. Luckily, Captain Belser was able to distinguish between my actions and those of this other photographer.

The mission

On February 10, 2007, I woke up before dawn to rendezvous with Captain Belser and his team. There was small talk among the guys as we loaded our equipment into the vehicles. The commanding officer gathered everyone around in a circle and gave a quick briefing about our mission objective. There was little light available to shoot pictures as the sun hadn't come up yet (**Figure 7.4**).

The mission was a big operation that took weeks to plan and involved other American and Iraqi units. The objective was to flush out a small

FIGURE 7.3 Captain Donnie Belser, Jr. poses for a portrait outside of an Iraqi Army barracks in Buhriz, Iraq.

Lens (mm): 32, ISO: 200, Aperture: 2.8, Shutter: 1/400, Program: Aperture Priority

town called Buhriz, an enemy stronghold that was key to winning the Battle of Baqubah. If successful, it would change the course of the war for the Diyala Province region. It was a massive undertaking, considering the amount of concentrated opposition. Hundreds of improvised explosive devices riddled the roads and walls of houses, not

FIGURE 7.4 U.S. and Iraqi soldiers rally before dawn to conduct a cordon and search for insurgence and weapons caches near Baqubah, Iraq.

Lens (mm): 17, ISO: 800, Aperture: 2.8, Shutter: 1/15, Program: Manual

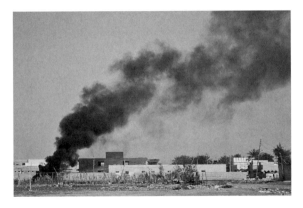

FIGURE 7.5 As small arms fire rings out and explosions go off around me, I photograph all I can from the Humvee seat. The window slightly obscures the billowing smoke where a mortar round has impacted the ground nearby.

Lens (mm): 55, ISO: 100, Aperture: 2.8, Shutter: 1/250, Program: Aperture Priority

to mention the highly trained snipers strategically placed on roofs throughout the village.

After the mission brief concluded, we jumped in the vehicles to rally up with the Iraqi soldiers. From there, we made our way to Buhriz. Because the unit's job was merely to observe and guide the Iraqi soldiers, Captain Belser and the rest of his team brought up the rear of the offensive force. As the first vehicles of the Iraqi Army reached the outskirts of the village, heavy exchanges of gunfire ensued, followed by rocket-propelled grenades, mortars, and improvised explosive devices. This slowed forward progress to a halt, leaving the American soldiers I traveled with out in the open. I did my best to photograph from every vantage point within the vehicle. Mortars plunged all around and impacted with tremendous force nearby. Enemy small arms fire tinged off the sides of our vehicles, and brass shells fell from above as our gunner returned fire on the enemy. Puffs of

smoke, sand, and debris drifted in the air, making it hard to see (**Figure 7.5**).

The impact

Then a voice broke over the vehicle's radio. It was from Captain Belser's Humvee. The soldier said, "Our gunner's been hit. We need the medic!"

I looked to my left, where the medic's case of equipment sat securely strapped, and then up toward the medic sitting behind the steering wheel. We locked eyes but didn't say anything to each other. I looked down at the camera in my lap. I set it aside and began to unfasten the medical kit from where it was secured next to me. The medic swerved our vehicle up to the other Humvee where the soldier lay wounded inside. Our vehicles were now parked parallel to each other, with a small gap to give us some cover from the hail of gunfire raining down. Without hesitation, the medic opened his vehicle door and exposed himself to a barrage of small-arms

FIGURE 7.6 The bullet that almost hit the medic's head, lodged instead in the Humvee armor.

Lens (mm): 55, ISO: 400, Aperture: 2.8, Shutter: 1/640, Program: Aperture Priority

FIGURE 7.7 Captain Gino Davis, a teammate of Captain Belser, takes cover from small arms fire beside a Humvee in Buhriz, Iraq.

Lens (mm): 55, ISO: 400, Aperture: 11, Shutter: 1/60, Program: Aperture Priority

fire. One round narrowly missed his head and lodged into the Humvee's armor (**Figure 7.6**). Instantly, I did the same. The driver of the other vehicle had already opened the back door for the medic. I met the medic there with the kit. I stumbled back on my heels as I identified the wounded soldier—Captain Belser. I glanced back at my camera and felt the whiz of incoming bullets fly past my head as I contemplated what to do next. There was no room in the vehicle for me to help, and the medic had all the assistance he required.

The decision

"I should be taking pictures," said the voice in my head. I was instantly repulsed by the idea. Captain Belser was dying; how could I even think of such as thing? However, it was my job as a photojournalist to document everything, no matter what. I thought about the NPPA Code of Ethics: When in doubt, consult another journalist. Yeah, right. I looked up to see another soldier staring at me. I wondered if he could see the doubt and confusion on my face or worse, hear my thoughts. I wondered whether he

was waiting for me to act just as the other photographer had done before (**Figure 7.7**).

"I don't know what to do," I said to him truthfully, as a battle of ethics raged inside my head. Be a photojournalist and take the picture. Be a friend; leave the camera where it is. I knew that he thought I meant I didn't know what to do in that moment of the fight, or how to help Captain Belser. Of course I knew how to fight, I had little doubts in that regard. My confusion was over whether I could live up to the Codes and all they stood for, but also be respectful of Captain Belser and his family. In that moment, I chose not to take pictures.

I stood and watched as the medic worked diligently to stabilize Captain Belser. The commanding officer made the call to drive back to our forward operating base (FOB) and rendezvous with a medical evacuation helicopter. The drive was long and short at the same time—long because I struggled with my decision the entire way and short because I didn't have enough time to come to

terms with it all. Where was my photojournalism lifeline? What was I supposed to do?

The judgment

My thoughts were immediately redirected as we ripped through the gravel lot toward the FOB aid station and came to a screeching stop. The vehicle carrying Captain Belser was right behind us. We dismounted the vehicles, and soldiers ran to get a stretcher. I looked around to see if there was anything I could do to help, but there was nothing I could do, outside of my job. Without hesitation, I lifted my camera from around my neck and began to shoot.

My heart was broken. I was losing another friend to war. I tried to stifle my emotions, but the pain burned my cheeks red. Yet the camera and my work shielded me somewhat from the realization that I might never speak to Captain Belser again. I still had a job to do, and I set my mind to completing the task at hand.

The gunner fired on the enemy, the medic rendered aid, the drivers drove, and the commander called the shots. My job was to take pictures. I snapped a few frames as soldiers loaded Captain Belser's body on the stretcher and realized, for the first time in my career as a combat photographer, my hands were shaking uncontrollably. As I lowered the camera from my face, soldiers began to yell profanities at me. I felt ashamed.

I watched as they carried Captain Belser past me into the medical aid station. My heart was thumping so loudly I could hear it in my ears. What had I done? What *should* I have done? I ripped the camera off my neck and sat down on a wood pallet next to the Humvees. I shifted my feet through the gravel and tried to hold back the tears that began

welling up in my eyes. All of the training I received and all the classes I took to become a photojournalist had not prepared me for moments like this.

The lecture

My mind returned to a lecture I'd once attended. It was given by Bill Eppridge, who took the picture of Robert F. Kennedy as he lay on a kitchen floor of the Ambassador Hotel, dying from an assassin's bullet. I know it was the right thing to do, Eppridge said of his own decision to take pictures. I, too, believe that this kind of brutal situation, no matter how terrible, has to be documented, it has to be told, and it has to be told to people who do not know the horrors that humans sometimes face.

I thought about the millions of Americans back in the States who have never witnessed the ravages of war—the death, the mayhem, how quickly it starts and how abruptly it ends; the pain soldiers feel after losing one of their own; and the civilian children crying over bodies of dead parents—lives forever changed, including mine. Bill Eppridge was right. I thought about all those people who'd never know how great a soldier Captain Donnie Belser, Jr. was. They needed to know—to see. In that moment, I made a pact with myself. I would adhere to the NPPA Code of Ethics and do what was required of me as a photojournalist. But I'd also act as my conscience dictated. I had to know I could live with my actions later.

The resolution

I snapped back to reality as the medical evacuation helicopter came near. I could hear the blades cutting the air before I could see them. The commanding officer came out with his radio and guided the helicopter down safely. I glimpsed one last time at

Captain Belser, as soldiers from his unit carried him to the waiting helicopter. I bit my lip to stave off the tears. I stood
in the middle of the gravel parking lot, exposed to the spitting rocks and projectiles spewed by the helicopter's rotary wash. I welcomed the pain. It was my penance.

Captain Belser, husband, and father of two, died on February 10, 2007, at the age of 28 (**Figure 7.8**).

FIGURE 7.8 It took a long time to process all that had transpired during my time in the Battle for Baqubah, and that included mourning the loss of friends. Every time my mind turned to those events, I couldn't help but question whether I'd done things right. As a part of healing, I visited my friends' graves to say my final farewells, allowing myself to cry and asking each of them for forgiveness (Photo by Andy Dunaway).

Lens (mm): 24, ISO: 100, Aperture: 2.8, Shutter: 1/750, Program: Aperture Priority

As a photographer, you'll face similarly difficult situations, and there will not always be a clear way to handle them. On paper, ethics is simple enough, but in reality it's more complicated. We are all individuals with various backgrounds, ethnicities, upbringings, social standings, morals, and values.

When faced with the same scenario, every one of us responds differently. My younger, less experienced self would not have behaved the same as the older, wiser version, and neither will you. All we can do is behave professionally, and with integrity.

Protecting Your Rights

It's the right of every photojournalist to freely inform the public through photography and other media, and our right as citizens to be informed, too. According to Article 19 of the Universal Declaration of Human Rights, everyone has a right to freedom of opinion and expression, not to be penalized for those opinions, and to "seek, receive, and impart" information and ideas by whatever means, regardless of national borders. Some extracts from the Universal Declaration of Human Rights have the force of international law, which journalists may quote before the authorities in their own countries.

I've never been in a situation where I've had to invoke these privileges in the court of law, and the likelihood of ever needing to do so is slight. As a member of the NPPA here in the States, I'd more than likely have their support if I were ever in a bind. However, it's good to know I have something in writing to fall back on if I find myself in a pickle overseas.

Because I have had no firsthand experience with the Universal Declaration of Human Rights, my knowledge is limited to what I've read and studied on my own. Here's what I do know: As part of the United Nations, the United States adopted the Universal Declaration of Human Rights when the General Assembly voted in favor of the international law. Article 19 of that document states that everyone has the right to freedom of thought and expression. This right includes freedom to seek, receive, and impart information and ideas of all kinds, regardless of frontiers, either orally, in writing, in print,

in the form of art, or through any other medium of one's choice. Naturally, photojournalism falls under this umbrella. You can find Article 19 in its entirety on the United Nations website un.org. I've done my best to put the rights in layman's terms, and I am including them for you here.

Article 19: Universal Declaration of Human Rights

- The exercise of rights shall not be subject to prior censorship but shall be subject to subsequent imposition of liability, which shall be expressly established by law to the extent necessary in order to ensure the rights and reputations of others and the protection of national security, public order, and public health.

- The right of expression may not be restricted by indirect methods or means, such as the abuse of government or private controls over newsprint, radio broadcasting frequencies, or equipment used to disseminate information, or by any other means tending to impede the communication and circulation of ideas and opinions.

- Any propaganda for war and any advocacy of national, racial, or religious hatred that constitute incitements to lawless violence or to any similar illegal action against any person or group of persons on any grounds including those of race, color, religion, language, or national origin shall be considered as offenses punishable by law.

Censorship Starts with You

Choosing whether or not to shoot a scene could be construed as censorship. There may be a number of reasons not to fire the shutter, such as personal emotions, biases, and employer influence, or perhaps environmental challenges. Just remember that the story starts with you, and you play the most crucial role in gathering the information. Keep in mind also that when faced with a difficult situation, such as my own with Captain Belser's death, your decision may come down to human decency. One guideline in the NPPA Code of Ethics states that photojournalists should treat each subject with respect—and your idea of showing or giving respect may differ from mine.

Well, there will always be caveats, which makes our job that much more challenging. One might argue that photographers should shoot the action no matter what, and with no regard to those around us—after all, we're journalists, and that's our job. It's not up to us to control others' lives; we're there to document life as it unfolds. Just leave it to the editors to decide what gets published and what stays on the storage drive.

There's an angel on one shoulder and the devil on the other; then there's the photojournalist stuck in the middle. No matter what decisions we make, we must be able to live with them after the chaos of the moment is over. Then we leave ourselves at the mercy of the viewing public.

In the Trenches: Living with Your Pictures

I really enjoyed documenting one particular squad of soldiers from Delta Company, who generally referred to themselves as Dealer, and I covered many of their operations. They were set to take down a bomb-building cell located in a house on the outskirts of New Baqubah, so naturally I asked to come along and photograph the occasion. However, on the morning of the mission, I was abruptly reassigned to cover a massive 3-day offensive with the Iraqi Army. Until that morning, the mission was kept secret to prevent any enemy infiltrators of the Iraqi Army from alerting opposition forces. It was to be a pivotal operation in the Battle for Baqubah (**Figure 7.9**).

As I hastily packed my gear, I continued to monitor my classified Secret laptop for updates from the Dealer operation. They'd made it to the house and sent up some of my friends to breach the front door. That's when an improvised explosive device detonated, engulfing the soldiers in smoke and nearly leveling the front of the house. Updates poured in with initial casualty reports and speculations as to the number of dead. The last line I read before running out of my office was "We're transporting the bodies to the FOB Warhorse Aid Station."

continues on next page

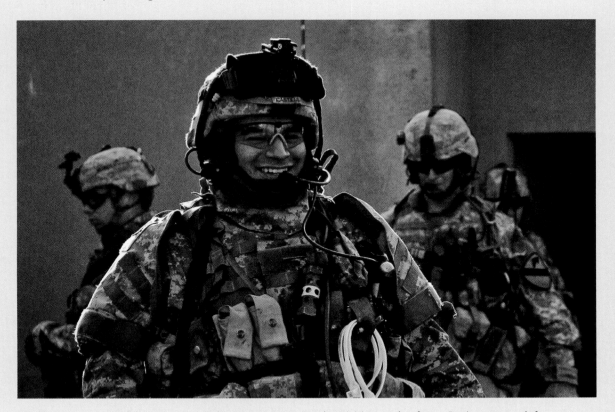

FIGURE 7.9 Members of the U.S. Army, Delta Company, 1st Cavalry Division, 12th Infantry Regiment, search for weapons and improvised explosive device materials during a cordon and house-to-house search in Sadiyah, Iraq.

Lens (mm): 48, ISO: 400, Aperture: 2.8, Shutter: 1/4000, Program: Manual

With my camera in hand, I made a beeline to the Aid Station, where I found medics, doctors, and nurses wearing surgical gloves and gripping stretchers. I felt a sense of uneasiness knowing that my friends were on that operation, but there was no way of knowing whether they were hurt. To keep my mind occupied, I photographed the medical staff as they prepared for the inbound wounded. I could hear the tracks of the Bradley Fighting Vehicles speeding over the concrete perimeter road as they approached, and then nearly careening over as they hit the Aid Station's gravel lot. The vehicles skidded to a stop and immediately dropped their ramps to unload the wounded (**Figures 7.10** through **7.12**).

Soldiers' faces were marred and covered in dust and blood, nearly unidentifiable. I photographed medics as they carried limp, blood-soaked bodies on stretchers, as well as a nearby soldier who hobbled on the one foot he had left. None of the faces I photographed belonged to my friends. For a moment, I exhaled a sigh of relief. If they weren't wounded, they were okay. The body bags were the last to come out, followed by my buddy from Dealer Company. His face was stoic and ashen, and his eyes held a 30-mile stare. It was then I knew for sure—the rest of my friends were dead.

FIGURE 7.11 A Bradley Fighting Vehicle transporting critically wounded soldiers speeds into the gravel lot situated in front of the FOB Warhorse Aid Station.

Lens (mm): 55, ISO: 400, Aperture: 8, Shutter: 1/1250, Program: Aperture Priority

FIGURE 7.10 Medical workers gather near the entrance of the FOB Warhorse aid station awaiting the arrival of wounded soldiers.

Lens (mm): 20, ISO: 400, Aperture: 8, Shutter: 1/1000, Program: Aperture Priority

FIGURE 7.12 Soldiers wounded by a house explosion are carefully moved from a Bradley Fighting Vehicle to the FOB Warhorse Aid Station.

Lens (mm): 55, ISO: 400, Aperture: 8, Shutter: 1/1250, Program: Aperture Priority

That was a terrible day for me—and for many others. Daughters lost dads, wives lost husbands, and mothers grieved their babies. Perhaps impacted the most were the soldiers who survived. Some suffered from debilitating physical wounds, and some suffered the emotional trauma that survivor's guilt often causes. These are the kinds of hurt only time can heal, and even then may be too much to bear (**Figures 7.13** and **7.14**).

Years passed and I stayed in contact with many of the soldiers I served abroad with through social media and email. Many began to request pictures I'd taken during our tours, so they could reminisce or perhaps heal and move on. I responded by creating a public folder where they could view and download their pictures. It spread like wildfire and was passed from soldiers' computers to friends' and families' email inboxes all across the country.

One day I received a distressing email from a mother of a soldier who was wounded the day of the house explosion. She accused me of being emotionally inept, self-centered, and cruel. She went on to say, "I do not care who you are, who you think you are, or what you do. But I do know you have no compassion and kindness in your being and no right to share this [photo]."

The words crushed me. I was confused and upset. My occupation as a photographer was also my eternal damnation of guilt. No matter what I did, I was the adversary, even though I didn't ignite the bomb, nor was I complacent or disrespectful to the wounded soldiers after the tragic event. I fulfilled my duty as a photojournalist by recording the events so no one would forget the soldiers' sacrifices on that dreadful day. In turn, I grievously offended a woman I've never met and will probably never have the chance to.

Sometimes it's hard to be the photographer because you're an easy target and villain, someone to scapegoat when there's no one to blame. All you can do when you receive this kind of reaction is listen, acknowledge the feedback, and move on.

FIGURE 7.13 Medics transfer a critically wounded soldier on a stretcher into the FOB Warhorse Aid Station.

Lens (mm): 200, ISO: 400, Aperture: 8, Shutter: 1/1000, Program: Aperture Priority

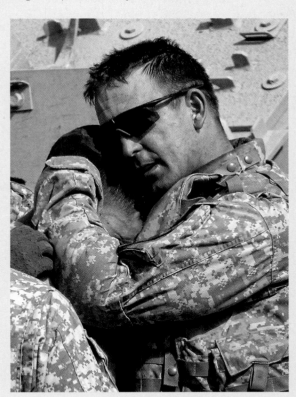

FIGURE 7.14 After being informed of the death of their friends, soldiers embrace outside the FOB Warhorse Aid Station.

Lens (mm): 200, ISO: 400, Aperture: 8, Shutter: 1/800, Program: Aperture Priority

Maintaining Image Integrity

As photography has become accessible to everyone, so have the tools to manipulate it. This goes for photojournalists as well, including myself. Unfortunately, there have been cases where so-called professional journalists have manipulated their photographs to alter the story, but in these rare instances they've been called out, publicly shamed, and blacklisted within the community. Don't be that guy.

When it comes to editing images for photojournalism, you always want to maintain the integrity of the image. Removing a distracting object changes the environment of the picture and also creates doubt as to its authenticity. If you can remove something as simple as a Coke can, who's to say you didn't remove an entire person? Keep your edits to the basics of cropping, dodging, and burning, and don't go overboard. Avoid excessive lightening and darkening that may change the context of the photograph. If you take an image shot in broad daylight and burn it so much it looks like nighttime, you're overstepping. You may be tempted to blur out the background or a distracting object in your frame, but blur tools also alter the image's meaning.

Photojournalistic editing constraints make our lives as photographers easy in the digital darkroom. There's not much we can do, so we shouldn't obsess over every detail. Sure, we can bang our heads and say, "I wish I would've moved a bit so I didn't have that streetlamp coming out of my subject's head." But there's nothing to be done about it in the editing phase. Just be more aware of your backgrounds on your next assignment, and make better compositional decisions while you're shooting; that will save you heartache in the end. If you've got massive exposure problems that would warrant excessive exposure changes in post-production, for example, I suggest you get out and shoot between assignments so you can practice your metering techniques.

There are some shooting situations in which the environment and time of day will result in less than desirable images. I assure you, if the moment is a good one, your subjects and their actions will outshine the technical pitfalls—or a distracting background (**Figure 7.15**).

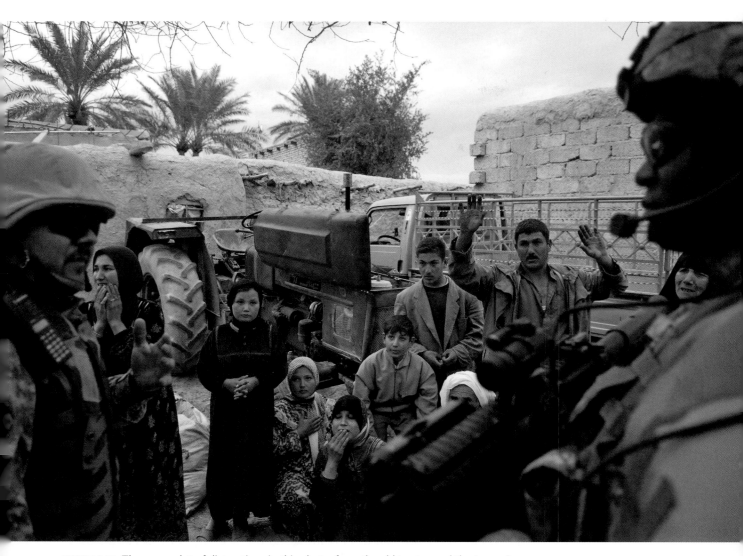

FIGURE 7.15 There are a lot of distractions in this photo, from the old tractor and the turquoise green truck in the background to the jagged branches dropping down from the top. But the moment taking place between the subjects outshines the photo's pitfalls.

Lens (mm): 17, ISO: 400, Aperture: 2.8, Shutter: 1/500, Program: Aperture Priority

CHAPTER 8
STAYING AFLOAT

You may not be aware of this yet, but if you're a freelance photojournalist, you're a small business owner—an entrepreneur, if you will. When I served as a combat photographer, I was clueless when it came to the business end of photography, and I didn't concern myself with learning about it. It wasn't until I struck out on my own that I became painfully aware of my ignorance of the outside world. As a freelance photographer, you have to be equal parts accountant, manager, negotiator, producer, and photographer. Outside of my photographic responsibilities, I had a lot to learn.

As a freelance photojournalist, I'm required to wear many hats—accountant, office manager, marketing director, supply chief, receptionist, photographer, and more. I don't have to be an expert, but I at least have to be knowledgeable enough to run my business. If I fail as a freelancer, it's my own fault. (Photo by Andy Dunaway)

Lens (mm): 70, ISO: 1600, Aperture: 2.8, Shutter: 1/90, Program: Manual

Developing a Plan

I was in over my head. Not only was I operating as a freelance photojournalist, but I also decided to start my own photography studio and photographic education center. You may have no interest in expanding your range outside of freelance work, but whether you're a florist, roofer, or baker working for yourself, the business concepts are the same. Whether you're just starting out as a freelancer, or you're established in the field, you still need to be able to pay Uncle Sam and earn enough to survive on—hopefully more. To do this, you need a working plan. In the business world, this is referred to as a business plan—and developing one is not as daunting a task as you might think. Here's how I approached my plan.

Create a mission statement

Your statement can be one sentence or a paragraph, just as long as it clearly defines your goals. For example, "As a professional photojournalist with 10 years of military photography experience, I will document assignments related to military, government, and law enforcement agencies to include editorial and commercial assignments. I will document audio, stills, and video, thus offering my client several multimedia options for their final product. My unique skills as a trained combat photographer and understanding of military culture and techniques will allow me to take assignments pertaining to military styling, direction, and production during commercial shoots." The more concise your mission statement is, the more you'll be able to focus your efforts to meet your goals in the future. This statement is not set in stone, and you can adjust it as needed.

Research market needs and demands

Based on my example mission statement, I'm not going to pitch my talents to a bridal magazine. Therefore, it's important to understand what portion of the market has a need for my talents. I suggest you develop a list of potential clients and acquire points of contact for each. When possible, create a file with editors' profiles from every publication you think is a match for your photography. Be sure to check and update this information for accuracy as time progresses.

Get to know your competition

As you research the market, take note of the photographers you'll be competing with. It's also important to know how saturated your market is. Tailoring your mission statement toward a market that's less abundant with photographers can really work to your benefit. With less competition, you'll find it easier to secure work, so doing this kind of homework can prove quite lucrative in the long run.

Establish your day rate

During your market research, be sure to study how much other freelance photographers are earning for day rates. If you cannot obtain this information because of privacy issues, you can always refer to the American Society for Media Photographers (ASMP) at www.ASMP.org. They have assignment rate calculators that can be helpful when you're initially establishing a workday rate. Most print publications have a set rate they pay, so it's not too hard to track down. If you're unsure about the day rate, I suggest estimating on the low side. I say this because there's no guarantee you'll receive a higher rate and it's best not to count your chickens before they're hatched.

Discover your price of doing business

More often than not, there's little thought given to the price of doing business. Sit down and estimate what it costs to maintain your camera equipment, insurance, car, fuel, phone service, computer, software, Wi-Fi, and all the other occupational essentials it takes to operate as a photographer. Don't overlook your home office, either. If you're a freelance photographer, you're more than likely mooching from your own household. Therefore, you should factor in electricity, water, and other expenditures. Add all those costs together and divide it down to a cost-per-day analysis.

Determine assignment needs

Once you've calculated a low-ball estimate for an assignment day rate and your daily cost of doing business, you'll begin to see how many assignments you'll need per month in order to stay afloat financially. I like to call this my "break-even" point. Ideally, you'll get enough work to get past the break-even mark. However, as a freelance photographer, you never have a guarantee. It may be feast or famine, so it's important to take any extra cash you earn and safeguard it for dry spells you may encounter throughout the year.

Reserve funds for marketing

You can waste a lot of money trying to connect with editors who have no interest in what you specialize in or the skills you have to offer. That's why researching the market is so essential. By narrowing down your field of potential clients, you can focus your efforts solely to the purpose of gaining their attention. As you develop a market strategy, be sure to include the cost of presenting your work, whether that's a printed portfolio, website, or business cards and printed marketing material. With this projection, you can establish how much of your earnings you're willing to place toward marketing every month.

Set attainable objectives

It's important to set goals for yourself so you have something to strive for. The first 3 years of working for yourself can be tough because your success in self employment rests solely on you and how much effort you're willing to put into assignment generation and completion. Initially, you may opt for a higher quantity of lower-end day-rate assignments, but you can also set a 3- or 5-year goal to get fewer assignments that pay larger day rates. Other objectives may include competing in photography competitions, attending advanced training workshops, completing a personal project, or putting on an exhibition.

Make a distinction

Most freelance photographers operate as a sole proprietorship, a small business usually run and owned by one individual where there is no separation between the person and the company; they're one and the same. If you choose this approach, you will generally be hired as a contractor to fulfill an assignment and be required to fill out a Form W-9 where you list your social security number as your tax identification. Because your name is synonymous with the business, as a sole proprietor you now carry your company's liability. In short, if you were to be sued, you could lose everything, including your house, car, cameras, and liquid assets.

Your other option is to establish a Limited Liability Company (LLC). This is what I chose to do. Through my own experience, I learned one of the distinctions between an LLC and a sole proprietorship is the separation of the individual from the company. There's no comingling of funds, nor am I personally liable for lawsuits filed against my company, thereby reducing the threat of losing everything I have. I maintain a separate checking account with an Employer ID Number (EIN) that I use when filling out my Form W-9. When I receive checks from a client after completing as assignment, the money is deposited into my business account. I draw from that account to pay bills such as insurance, gas, phone, and other business-related incidentals. I also pay myself from my business operating account and deposit the money into a personal account. This helps me keep my personal life separate from my business and helps me immensely when tax time comes around.

It's best to consult with a certified public accountant (CPA) as to which option is better suited for you. With a CPA's guidance, you can set up a bookkeeping system through software like QuickBooks, and figure out how to file taxes, and how often, too. Once you've determined a business distinction and selected a method of bookkeeping, make a section in your business plan that outlines your bookkeeping and tax filing process.

QUICK TIP

There is a negative to forming an LLC. You may be subject to double taxation depending on the state you live in—taxes on the LLC and then taxes on the income and profits you receive from the LLC.

Insights: The Bookie

As an entrepreneur, you must be versed in the lingo of accounting. Whether or not you choose to delegate financial responsibilities, you're still going to have some hand in your business finances. You can learn a lot from resources such as the U.S. Small Business Administration's Small Business Development Center (SBA.gov) and the Association of Chartered Certified Accountants (ACCAglobal.com). Don't allow your finances to get away from you, and be sure to check on them diligently at least once a month. Invest in software like QuickBooks that will help simplify tracking of financial documents, accounts, and the like, while allowing you to share your information with a bookkeeper or CPA as well.

I learned there's a difference between a bookkeeper and an accountant. At first, I kept my own books. Over time, I realized I needed to learn more about invoices, estimates, accounts payable, and accounts receivable, and I learned QuickBooks in order to keep track of all those elements of the business. I found myself spending a lot of time and effort on bookkeeping and less on developing new client relationships and shooting assignments. That's when I weighed the value of my time

versus the cost of a bookkeeper and decided to hire one. She logs all of my trip reports, receipts, and bills; creates estimates, invoices clients, and pays debtors; and assesses, files, and pays my taxes. You can find a freelance bookkeeper who will take you on as client for just two or three hours a week. Of course, the amount of work you rely on them to do may require more time and consequently, more money (**Figure 8.1**).

There were aspects of my finances that my bookkeeper couldn't address, so I began to shop around for a CPA. I found a local guy who gives me to freedom to call or email throughout the year, without charge, and addresses any questions or concerns I may have. Once or twice a year, we sit down face-to-face and he consults with me about profit and loss projections and discusses depreciation values of gear, tax write-offs, charitable contributions, and so forth. We've even come up with a strategy to secure money for equipment upgrades. Each CPA is different, and their consultation fees vary. I've been lucky to secure a CPA who doesn't frivolously charge me for phone conversations or email questions, and that's why it's important to shop around for the right accountant.

FIGURE 8.1 Your accounting system should fit your needs as a photographer and reflect the effort you're willing to put forth to maintain it. A desk drawer or Microsoft Excel spreadsheet is sufficient if you don't provide customers with estimates or invoices. QuickBooks software, on the other hand, is simple to set up and can help you do all of these things quickly and easily.

FIGURE 8.2 I'd already accumulated a large amount of gear prior to becoming a freelance photographer; however, I still had plenty of gear to purchase—a storage room full, in fact. Plus I had to furnish a studio, digital labs, classrooms, and more.

Calculate your start-up capital

It's safe to say that, like the average worker, you've got bills to pay and the costs of living to worry about. On top of that, you may have student loans and other debt. This doesn't leave a lot of meat on the bones to invest in start-up costs. Trust me, one photojournalism assignment's day rate will not cover all start-up expenses. Because of this, you may need to apply for a small business loan to obtain the working capital needed to get through your first year of freelancing and to purchase operational equipment (**Figure 8.2**).

To begin the process of setting up my business, I laid out a start-up capital summary that included computers, hard drives, lenses, cameras, lights, tripods, and all the other equipment I'd need to operate at the level I wished to and to fulfill the objectives of my mission statement. This is separate from the cost of doing business, because it addresses the initial purchase of gear and not daily operational costs. I'm

not saying you should go crazy and spend money you don't have, nor am I encouraging you to purchase gear you don't need right away. However, I am suggesting you acquire the funds needed to get off the ground. For each photographer, that starting number is different. It could be $2,500 or $25,000.

No matter what, you need to look at your cost of doing business, your cost of living, plus the number of potential assignments you can realistically acquire and how much you can reasonably afford to pay back on a start-up capital business loan per month. Do not overreach yourself. Think small and build up.

If the idea of a loan is out of the question, you can always start shooting assignments with the equipment you have or rent the gear as each assignment presents itself. With every day rate you earn, you can squirrel away some funds that can be used to upgrade your gear. Just be sure to have a clear and detailed strategy that's outlined in your business plan.

Working from Home

As I've stated before, most freelancers operate out of their house. I did initially. In doing so, the amount I spent in overhead costs was significantly lower, because I was not paying rent and utilities on two locations. What's more, I wasn't burning up gas driving my car, I ate leftovers for lunch, and when my work was done I was already home.

But there is a downside to the home office: It's still your home. There's the couch, television, and refrigerator beckoning you on a daily basis, trying to distract you from your to-do list. I found myself procrastinating on important tasks by washing the dishes, vacuuming the floor, doing laundry, and sweeping the deck. Aside from the self-generated distractions, my husband was often popping into my office and interrupting me all the time with random questions, spontaneous harebrained ideas, or simply saying hi. Though the home office was cost effective, the number of distractions was not. I had to set firm parameters for myself and my spouse if I were to earn any money from home.

FIGURE 8.3 Here's one of my industrial metal shelving units that I've inverted. You can see that by flipping the shelf, I can use the lip as a protective guard that keeps my gear from falling accidentally.

Insights: Homebound Niceties

At great length, I've discussed the protective gear it takes to survive in high-risk environments, the equipment required to document multimedia stories and even the clothes you might consider wearing on assignment. The gadgets you have in your home office are equally important and beneficial. For instance, I have a fax machine, scanner, printer, and phone combo unit that allows me to sign and scan contracts, fax Form W-9s to clients, print model releases, and take business calls from a landline. I have bookshelves for camera gear storage, a corkboard to tack up important documents, a gigantic calendar riddled with handwritten notes, an external Mac monitor to plug into my laptop when I'm not on the road, and an ergonomic chair for long sessions at the computer while editing and captioning images. I've even got a tabletop I use as a dedicated charging station for my camera batteries, AA battery chargers, and an iPhone dock. I've got a paper shredder, label maker, spool of DVDs, scotch tape, stapler, jar of pens and Sharpie markers, and a file cabinet. My point is to not overlook the importance of stocking your office with the creature comforts you'd find in any traditional workspace (**Figure 8.4**).

FIGURE 8.4 When I'm not on the road, I've got all of my charges laid out on a table and ready for use. This shaves minutes off of my time by allowing me to come in, get my batteries on the charge, and start editing.

Claim your space

I set aside one room in the house dedicated solely as my office and when I shut the door, my husband knew it was time for me to get some work done. I asserted my need for solitude and asked not to be disturbed unless it was an emergency. We arranged a time of day when we'd sit down and discuss story collaborations, client correspondence, business budgets, and other work-related topics. Outside of this designated time, I asked him to send his spontaneous thoughts in an email, so I could look at them during a break. We've now got a workable routine down that suits us both.

Get out of your pjs

I've made it a habit to get up, go to the gym, eat breakfast, shower, and dress for work—even if I'm not leaving my home office. If you lounge in your pajamas, you may be inclined to put those comfy clothes to use. Plus, you never know when you'll receive a short-notice shooting assignment that requires you to leave right away, and if you're not dressed already, you'll be wasting valuable time. You have to dress for success.

Time Is Money

You can't expect to sit back, relax, and wait for the jobs to come to you. As photo-journalists, it's important to give your all every minute of the day—including nights and weekends. After all, time is money and you can't afford to waste either. From my years of military service, I've developed good time management skills that I've applied in my new life as a freelance photographer. If you'd like to maximize your minutes, just follow these few helpful tips:

- Carry a notebook or smartphone with note applications and write down a to-do list for the day, with items in order of precedence. I find that having a list helps keep me on track and focused. Time-sensitive tasks are made a priority and not accidentally passed over because of a brain fart. For example, my list may look something like this: generate packing list for assignment X, create an estimate for client Y, deposit checks at bank, review trip report, edit images for client Z, and write a blog post.

- Mark your smartphone calendar daily with the most important tasks and set alerts to prompt you throughout the day. These little reminders will help spark motivation to get them off your to-do list. Some days you'll face unforeseen interruptions, in which case there won't be enough time in the day to accomplish the tasks you've alerted yourself to do. Simply move those tasks to the following day and make them your priority. Just remember to take one task at a time.

- Set aside time every day when you'll stop to check emails and avoid checking them outside of your set window. I receive somewhere in the neighborhood of a hundred emails a day, and I could certainly spend hours on that task alone. To manage my correspondence and time, I have a folder system that prioritizes time-sensitive and important emails. Those of immediate concern are answered right away; others are archived in appropriate folders and addressed as time allows. For example, I have folders labeled Lectures, Education, Photo Assignments, Student Letters, and Photo Inquiries.

- Screen your calls to reduce interruption. I've set up my iPhone so I can respond to callers with a text message that says, "I'm on assignment right now, but I'll call you when I'm finished." By limiting your telephone time, you'll be reducing the amount of idle chatter and therefore wasted minutes. By allowing your voicemail to pick up, you can screen the important calls for those of a personal nature. When a client does call and leave a message, you gain valuable time to prepare for a follow-up call and perhaps some talking points.

- Stay present in your work by eliminating distractions such as Facebook and Twitter. You can set aside time at night to be social, but it's more important you give your attention to your business and not the Internet. The only caveat I have to social networking is if it involves self-promotion. However, that time too should be factored into your day.

- Reward yourself for accomplishing tasks by giving yourself 10 minutes of free time per task accomplished. You can spend your 10 minutes however you like by watching funny videos on YouTube, calling a pal and catching up, or perhaps taking an extended long lunch. You can't always be a taskmaster, even to yourself. You have to give yourself some incentive to want to push harder.

Keeping Track of Your Records

During my time as a combat photographer, I made countless trips all around the world. Some assignments lasted a few days; others were months at a time. No matter the trip duration, I was required to keep detailed trip logs that included daily activity reports, expenditures, receipts, and other miscellaneous trip-related documents. I got into the habit of using pocket folders like the ones featured in **Figure 8.5** to keep all of these articles together. I've adapted this method of record keeping in my daily assignment work, too.

All of the expenses you incur during a day's work should be filed for tax purposes, and that includes tolls, food, lodging, travel, gratuity, and other various costs. Whether you're keeping your own books or you've opted to outsource your bookkeeping, you'll need to be extremely meticulous in cataloging your trips and expenses. Not only will the Internal Revenue Service (IRS) be interested in seeing these receipts, so will your clients. Along with a standard day rate, some clients may offer to pay for expenses incurred through travel and lodging. However, some of them will not pay unless you can show documentation supporting your expense claims—hence the importance of keeping very good records.

FIGURE 8.5 I started buying pocket folders by the case to stay organized. I found I could get them cheaper during the back-to-school shopping periods. I prefer to use colored folders, so I can use one color per month.

File away

For each trip, I use a pocket folder and label the outside with the assignment name and requester, dates of assignment, and the location. This approach makes it easier for me to archive my folders and retrieve old travel logs. Initially, I'll print any written correspondence I've had with the client that contains information pertaining to the story, points of contact, addresses, and contracts. Once I've generated an equipment inventory list, I'll add that to the folder, too. From the moment I head out the door on assignment, I keep track of all my receipts. I'll even make notes on each receipt annotating the assignment and purpose of the payment. For instance, if I stop to get gas I'll mark the receipt with a note that says, "Gas, Ford Freestyle, AP Assignment, Governor Nikki Haley." If I pass through tollbooths, pay for parking, or tip a doorman, I make note of how much I spent and to what purpose. If possible, I'll try to get a receipt for those items, too.

When I get home, I'll scan the receipts and file them digitally. However, I'll hold onto the physical receipts for a period of two years after my taxes are filed. This is recommended by my bookkeeper, in the unlikely event that the IRS audits me. I can then send the digital copies to my client and archive them for safekeeping.

Give yourself some credit

When I first started out and I was still a sole proprietorship, I used a personal credit card to cover the upfront costs of trip expenses. My justification was that I'd do the assignment, get paid, and in turn pay my credit card. What I didn't know was how long it took to receive payments once I'd filed my invoices with the clients. Some are more prompt than others, but universally it was taking weeks,

if not months. So long as my clients didn't pay their invoices, I didn't pay my credit card, which reflected badly on my credit and my credit card limit. As a result, I obtained a business credit card with a sizably bigger credit limit that allowed me to charge all of my business expenses without threat to my own personal credit score. If I needed to, all I had to do is call the credit card company and ask for a temporary increase on my credit limit that would allow me to conduct more business in the interim until I got paid.

Here's the ironic part. When I was on active duty, my credit report reflected that I had a steady paying job, financial security, and solid credit. However, when I started working as a freelance photographer, that all went away. As a small business owner, on paper I'd no better credit than someone who was unemployed. Therefore, obtaining credit to purchase a house, car, or credit card was very difficult. I'm not frivolous with money, and I've always paid down my debts on time, but the rub was being self-employed. It's often harder to verify your income when you don't have a pay stub to prove your value.

QUICK TIP

Your vehicle is just an extension of your office and can be written off on your taxes as a company vehicle, or at least a portion of it, depending on how much you use it for business compared to pleasure. My CPA requires I keep a detailed mileage log for any driving I do that pertains to business. If I run to the Post Office for stamps, that's business; if I drive my car to a shooting assignment, that's business; if I make a trip to Staples for a ream of paper, that's business, too. I have multiple vehicles, so each one has a mileage log where I write the date, point of destination, and purpose of the trip. At the end of the year, I tally up the miles, along with oil change expenses, tire changes, property taxes, insurance fees, and other maintenance costs, and submit them to my CPA.

I've learned there are ways you can obtain credit without the traditional pay stubs. For example, you can show previous tax returns or business profit-and-loss statements, or provide a credit report that includes your income. The best approach is to start by applying for a credit card with a small limit, and as time passes, apply for credit cards with larger limits. This approach will help establish your credit history while you're self-employed. I also found a local bank where I established a business checking and savings account. Through them, I obtained a small business loan and line of credit. By using this local bank, I was able to build my credit, as well as a trusting relationship with the bank and employees, an important benefit not afforded by national chains.

Safeguard your important documents

Record-keeping expands beyond the obvious trip logs and camera purchase receipts. There are also the equipment warranties that need to be cataloged, supply inventories and purchase orders that need to be filed, and insurance documents that need to be safeguarded. Every minute detail must be given attention, and that's why it's so important to be organized. I've established a system that helps me keep track of all the miscellaneous and extraneous documents that are important to file (**Figures 8.6** and **8.7**).

Suggestions for maintaining files:

◆ Invest in a file cabinet to keep in your office, and get in the habit of organizing and filing all necessary paperwork.

◆ Create a file organization scheme with applicable titles so you store the documents under the appropriate heading. For instance, I have mine segregated as follows: Insurance,

FIGURE 8.6 My filing cabinet is probably older than I am. You can probably pick one up at an office furniture outlet, or you may even try scouring your local thrift shops. If all else fails, you can get one at a retail store near you.

FIGURE 8.7 My filing cabinets are stocked to the gills with manila folders, and each folder is in a designated area according to content.

Warranties, Utility Contracts, Lease Agreements, Agent Contracts, Client Contracts, Office Supplies, Camera Inventory, and so on.

◆ Scan a digital copy of these documents and keep a folder in your Dropbox account. By using a service like Dropbox to back up your file system, you can ensure you'll have copies in case there's a natural disaster or fire. Plus it will enable you the ability to share these documents with your bookkeeper and/or CPA.

◆ Along with your miscellaneous documents, you can store your trip logs in the same filing cabinet. I suggest filing them in sequential order based on the date of assignment.

Track your purchases

Of course it seems logical to keep all receipts pertaining to the purchase of big-ticket items such as computers, software, lenses, and cameras.

However, it's the small stuff that usually gets passed over, and that often adds up quickly. Be sure to stockpile any receipts relating to business-centric items so you can tally those in QuickBooks and apply those purchases toward your taxes at the end of the year. What's more, you can start to track how much you're spending on these supplies and determine where you can make cost cuts to keep overhead down. Just keep in mind that even a paperclip costs money (**Figures 8.8** and **8.9**).

FIGURE 8.8 (left) I keep a large stock of CDs and DVDs, along with other office-critical items that I pay for with my business credit card. All of these can be submitted as work-related expenses at the end of the year.

FIGURE 8.9 (right) Between invoices, estimates, trip plans, receipts, and the like, I print a ton. I buy my paper in bulk because it's more economical in the long run.

Knowing Your Worth

In the world we live in today, where everyone owns a camera, it may be easy to succumb to the idea that there's no value in our occupation. Don't fall prey to this way of thinking. Photographers are every bit as valuable as they've ever been; we as a community simply have to believe that and demand it, too. Just because everyone has access to a camera doesn't mean they know how to use it. I could rent a crane, but that doesn't mean I can operate it. It's our job to be not only consummate professionals, but also educators. We have to be able to articulate to clients why we're a good investment, and we have to believe in what we're selling—our creative talents, technical skills, and professionalism.

Exchange something

I receive frequent phone calls from various organizations and companies around my local area asking if I know of any students who can document one of their events or photograph their products. They figure I'm the best resource to get in touch with budding photographers since I own the Charleston Center for Photography. My first question in response is, "What's your budget?" The majority of them respond with, "I don't have a budget, that's why I thought I'd offer it to a student." In my head I'm calculating the money they spent on an event space, valet service, catering, booze, and the like, which is probably a pretty penny. Then they want to use a young photographer so they can work for free and gyp the working professional photographers in town. I could be crass and throw that in their face, but I prefer to handle these situations diplomatically. As part of educating potential clients, I'll point out that photography is a legitimate business in which services are rendered in order to earn a living. At my education center, we teach our students to understand the value in the services they offer and not to work for free; by doing so, they undermine and devalue our entire profession.

This is usually followed by a long pause, to which I further engage the requester: If you don't have a budget, maybe there's something you can offer the young photographer, perhaps a product your business makes or a service you render, that can be exchanged for photography services provided. By offering an exchange, you're not asking them to work for free; rather there's an exchange of product with a price tag and retail value. I'd have to say nine times out of ten, the requesters either come up with monetary compensation or an exchange of services. Either way, no one is working for free. You should apply this mentality to your own work. You are worth something, so be sure to get what you deserve.

Be a charity case

I'm involved with a number of charitable organizations where I contribute my photography talents. Taking on assignments from charitable organizations can be very rewarding both photographically and monetarily. Simply because they're nonprofits does not mean they don't have money. Be sure to ask up front if they have any budget for media services. If they don't, that's not the end of the road. You can pick and choose where to donate your time, and then ask for a letter stating that you provided a service for X amount of dollars, which can be used as a tax write-off at the end of the year. The benefit is you get to cover some really cool stories, fulfill your community service hours, and get a financial reward to boot.

Master the art of negotiation

Sometimes you'll be required to generate an estimate for a client. My first experience doing this was absolutely terrifying. I'd never had to put a price tag on my photography. I asked a ton of questions about the assignment, photographic expectations, final products, image transfers, travel arrangements, location accessibility, and more. All this data gave me a better idea of where I needed to start.

The little voice in my head said, "You're charging too much, they'll never buy it and they'll walk away." I had to overcome my fears and throw caution to the wind. In the end, they went for it and then I thought perhaps I didn't bid high enough. I didn't pull a number from thin air. I did my research to find out what other photographers were charging, determined what the market could bear, and factored in my operating costs based on my business plan. It took time to come up with a comprehensive estimate, but I came in right on the money, which ultimately secured me the assignment. What I found out later was that I should have let them throw a price out first by asking, "Do you have a budget?" In doing so, I place the pressure on the client to come up with a starting price. Most of the time, they're forthright about what they have to work with. Other times, it requires a little more negotiating to raise the starting number a bit. My first go-round turned out fine in the end, but I've since made asking that one question common practice.

Once an estimate was agreed upon, we moved into the contractual phase of the negotiations. There were words I didn't understand, such as indemnity, intellectual property, usage, rights, and heirs. I had to study up on what these terms meant and how they could impact me in the long run. That's when I turned to other freelancer friends in the business who had experience with contracts to guide me through the process. I also used the ASMP a great deal to navigate the complicated language of contracts. It was an eye-opening experience.

Tips for drawing up contracts:

- Contracts should always be in writing. It's okay to start initial negotiations in person or over the phone, but verbal agreements don't hold up in the court of law as well as those done in writing. A written contract also gives both parties involved the chance to outline their expectations and spell out their exact needs.

- Include a section that addresses copyright ownership. Whether you choose to retain your copyright ownership, or negotiate the copyright as part of the sale, that should also be made very clear.

- Dedicate a section to how the images will be used, a concept referred to as "usage." If the client would like to use them for a print magazine and for online web viewing, both usages must be addressed.

- It should be made clear what the assignment entails and the ultimate goal for the project. For instance, the client may request a multimedia piece that includes still photography, audio, video, and graphics. They may want a 1-minute abbreviated clip and a 10-minute video alternative they can showcase online, plus individual still images to accompany a written article.

- Establish a timeframe in which to accomplish the assignment. If it takes two days to shoot, that should be annotated. Be sure to factor in image editing time, production days, and so on. If the assignment is time sensitive, set a due date for deliverables.

- Of course, you must include a clause that addresses payment. If you've submitted an estimate based on the requester's needs, you should already have a number in mind. Be sure that you have that in writing. Plus there should be a plan in place for the dispensing of money, whether that's half up front and the remainder upon completion, or the total sum due upon receipt.

- If the assignment requires travel, include another section that addresses the reimbursement of expenses to include travel, lodging, per diem, and other incidentals.

- You and the requestor should sign the contract and each should retain a copy.

Being Business Minded

It takes a certain business savvy to identify a need in the market and then develop a product that fulfills that need. As photojournalists, we don't stand to earn a large income based solely on the editorial assignments we bring in, so it's important to seek supplemental income outside of photojournalism. That's not to say you'll need to stray too far. I've mentioned before that I own a photography education facility and commercial studio in South Carolina, the Charleston Center for Photography (CCP) (ccforp.org). Along with editorial shoots, I cover commercial and multimedia assignments. The revenue I earn from those enterprises helps fund the photography projects I'm passionate about, and I get to teach several courses, including photojournalism, which keeps me sharp.

Mirjam Evers, who you saw featured in the Travel photography section of Chapter 5, "Covering All the Angles," found a way of exploiting her specialty as a travel photographer by co-founding an adventure photography tour company called Photo Quest Adventures (PhotoQuestAdventures.com). She leads photography education expeditions all over the world, making fresh new pictures for her portfolio along the way that can be sold to magazines or as stock for additional income. Joe McNally designs his own line of light modification tools through Lastolite, Tom Bol shoots ad campaigns for commercial clients, and Bill Frakes runs a multimedia company. In essence, what we're doing is taking advantage of our unique talents in specialized fields by maximizing the products we produce within those niches. By having more viable irons in the fire, you can generate more streams of revenue.

Specialize and expand at the same time

One fellow freelancer, Deanne Fitzmaurice, is a shining example of narrowly tailoring her talents as a social documentarian while diversifying her products to include audio and video. After leaving the *San Francisco Chronicle* in 2008, and in the midst of a deep recession, she realized she had to expand her documentation skillset to meet

FIGURE 8.10 Photographer Deanne Fitzmaurice walks across the field at the Oakland Coliseum in California. (Photograph by Phil Pacheco)

her client's demands, and that involved adding multimedia to her repertoire. In addition to taking an educational workshop hosted by MediaStorm (MediaStorm.com), she broadened her client base to include various corporate companies and commercial customers (**Figure 8.10**).

"As photojournalists, we need to figure out ways to fund the stories that we want to do," explains Deanne. "We all love doing editorial work, but editorial doesn't pay that well. It's smart to identify the subject matter you're interested in so you can find your forte; then once you hone in on one specialty, go in several directions creatively. Set about getting commercial and corporate clients who appreciate your documentary style because those assignments will really help round out your business."

Get out on your own

As a staff photographer, Deanne was given company camera gear, a staff car, steady salary, health insurance, and other perks. When she switched to freelance work, she faced a significant transition. Like most freelance photographers, she had to

FIGURE 8.11 Hue Jackson (right) is the head coach of the Oakland Raiders. The Raiders are known as one of the toughest teams in the NFL, so he gets a lot of grief from the other coaches and players for getting a manicure and pedicure before every home game. (Photograph by Deanne Fitzmaurice)

come up with a business strategy and purchase camera equipment, audio gear, and video essentials. Then there was insurance, a retirement plan, and marketing to think about.

"Some of things I had to learn to become business-wise," says Deanne. "Good time management, for starters. I also had to buy my own equipment, but first I had to figure out what kind of gear I needed: cameras, lenses, microphones, stabilizers, audio recorders, and tripods. And then the website, branding, social media, marketing, networking—getting myself out there and letting people know I'm freelancing."

Once she established herself as a freelance photojournalist, Deanne began photographing assignments like the one featured in **Figure 8.11** to help cover additional gear purchases, business costs, and regular cost-of-living expenses. With these types of assignments, she was able to home in on the types of subject matter she wanted to focus on, such as behind-the-scenes stories. After all, this style of documentation is what makes her happy, and getting paid for it is just an added bonus.

"My editor at *ESPN The Magazine* called me and asked if I'd photograph the head coach of the Oakland Raiders NFL team," explains Deanne. "I said, 'Sure, what is he going to be doing, a team workout?' He said no, and that he would be getting a mani-pedi. I replied, 'Are you serious? Is he on board with us photographing this?' My editor explained that he was good with it, but if he backed out I'd have to talk him into it, just as I'd done with Barry Bonds. The photo was later recognized in 2012's POYi [Pictures of the Year international] and American Photography."

Schmooze and make friends

I've said this before, but I'll say it again. You've got to network. Get out to the industry expos, workshops, and group functions and make some friends. Often you'll find opportunities through acquaintances you've made a good impression on, so it's imperative to be cordial, likeable, friendly—and perhaps most important, be yourself. The ultimate goal is to learn from others and expand your contacts list.

"People want to hire photographers they'd like to work with," says Deanne. "It's important to go to conferences and workshops and meet the people in the business. I can almost trace every job I've got back to a business relationship that I've created by meeting someone."

Branch out

We all have individual motivations for branching outside of photojournalism; some may be solely monetary and others might be driven by the need for personal achievement. Mine grew out of necessity. I started CCP in 2009 after I was wounded in Iraq and was facing the end of my military career. I was still in physical recovery and CCP afforded me

the time I needed to get slowly and progressively better while also offering an unhurried work pace since most of my time was spent at a desk or in front of a classroom. I had no experience running a company, but just as I'd learned photojournalism on the job, I learned business as well. I found it was easier to take on one new challenge at a time and expand my knowledge at the same time. I gained invaluable information from my photojournalism mentors, so I began to seek out other entrepreneurs to guide me through daily business operations. Simultaneously, my business grew and I physically healed. I began to shoot more and more, and take on more clients. The contacts I made at CCP offered huge opportunities such as teaching worldwide, writing this book, shooting awesome assignments, and mentoring photographers online for photography industry companies.

By contrast, Deanne Fitzmaurice started her business, Think Tank, with her husband out of an industry need. They wanted to create camera bags designed by active photographers. Along with two designers, she and her husband set out to build one of the most successful camera carrying–solution companies. Deanne calls on her experiences in the field to better the bags she makes at Think Tank, thus improving her business and product. She also calls on the many friends she's made over the years for their insights and knowledge.

"I always care about the best quality with my work both in photojournalism and with Think Tank," explains Deanne. "I do have that drive and high standard to do everything as well as I can."

The proof is in the results. Deanne earned a Pulitzer Prize for her amazing photography, and her business produces top-of-the-line gear. Though she admits that balancing both her photography career and Think Tank is a challenge, she's gained personal fulfillment from both, and these two worlds often intersect. I know the feeling entirely.

Learn to balance it all

No matter what you choose to do outside of photojournalism, or the reasons for doing it, don't lose sight of the ultimate goal: to produce good, compelling images. I make it a point to set aside time to work on my personal projects, and I am consciously balancing the time I spend on paid shooting assignments with the time I spend doing administrative work, teaching classes, and living my life. Time management is everything, and you're in control of the clock. Be wise about how you distribute the minutes, so you can accomplish all you'd like to in order to create high-quality stories.

"My husband, Kurt Rogers, is awesome and gives me lots of freedom and independence, so if I have to go out of town for a week to shoot, he's cool with it," says Deanne. "It's a challenge balancing time management. I'm always struggling to get that right. The ultimate scenario is in my free time I'm 100 percent there, and I'm not trying to work at the same time. And having a chunk of time when I'm working on the marketing, doing my workouts and things for myself."

There's a special rhythm that's unique to each individual photographer. Find your beat and you'll do well.

Staying Motivated

I know I've covered a lot of ground in this book, and most of it had nothing to do with operating a camera. However, the skills it takes to get you on assignment are just as important as the assignment itself. No matter what, the most significant part of photojournalism is the pictures. They are the lasting and true testament to who you are as a photographer and storyteller. They stand the test of time and can outlive their makers for hundreds of years.

My final advice is to carry your camera with you wherever you go because there's no telling when and where the story will happen; start a personal project to keep you personally fulfilled; seek and mentor and get critiqued from time to time; join a community of photographers such as the NPPA so you can talk shop with others in your profession; continue your education and expand your knowledge base; challenge yourself by experimenting with new photographic techniques; and most importantly, just get out there—take beautiful pictures, tell compelling stories, and make every moment count (**Figure 8.12**).

FIGURE 8.12 U.S. Air Force Airmen transfer a critically wounded soldier, who had been struck by a roadside bomb, from an ambulance to a C-17 Globemaster III aircraft in Baghdad, Iraq.

Lens (mm): 35, ISO: 400, Aperture: 2.8, Shutter: 1/10000, Program: Manual

INDEX

J

Jackson, Hue, 234
Jackson, Lucas, 158
Jacobs, Steven, 186–187
Jones, Marion, 147
Justin Clamp, using with flash, 70

K

Kata Sundo bag, using with audio
 equipment, 174
Kenyan army photo, 144
Kevlar
 soft armor, 50
 stab-proof vests, 50
kneepads, wearing, 43
knowledge, expanding, 135
Konova Slider, using for DSLR video,
 196
Kozyrev, Yuri, 162

L

Lambert, Jarod, 29
land navigation class, taking, 34
laptop, using, 83
laundry, washing, 62–63
Lebanon, evacuees from, 29
leisure activities, engaging in, 54
lenses
 depth of field, 103
 fixed-aperture, 67
 normal, 68
 packing, 95
 prime, 67
 protecting with UV filters, 70
 telephoto, 68
 with VR (vibration reduction), 68
 wide-angle, 67
 zoom versus telephoto, 67
Lenspen, packing, 79
Libya, 10
lifestyle photography, 153–154
light
 color of, 114–115
 contrast, 119–120
 direction, 119
 importance of, 113–114
 intensity, 114
 soft, 120
light setup, 70, 75
lighting
 back, 118

frontal, 118
 side, 118
Lightroom software, 86–87
lip balm, packing, 59
Litepanels, using for DSLR video, 196
LLC (Limited Liability Company)
 versus sole proprietorship, 220
local color, photographing, 154
Lochte, Ryan, 149
Lomas, Cenobia, 168–170
Long, John, 202
losing weight, 16
lotion, packing, 59
Lowcountry Dog magazine, 138
lunges, doing, 21

M

(M) Manual mode, shooting in, 107
MacAskill, Danny, 151
magazines, approaching for work,
 138
Makasseb Elementary School, 8–9
Manfrotto products
 516 Pro Video Fluid Head, 196
 529B Hi Hat, 196
 546B 2-Stage Aluminum Tripod,
 196
 561 BHDV Video Monopod, 196
 SYMPLA System, 196
manual exposure control, using, 114
Marine CH-53E helicopter, 109
Marine Corps CH-53 helicopter, 104
market research, conducting, 218
marketing, reserving funds for, 219
Masai warriors photo, 155
Mazyck, Damon, 27
McGarva, Duane, 141
McNally, Joe, 145, 232
medical alert bracelet, wearing, 37
medical records, maintaining, 37
medical staff, photographing, 6
medications, packing, 61
memory cards, 75
menstrual periods, dealing with, 60
Merrell hiking boots, wearing, 41
metering modes
 Center Weighted Metering, 110
 Spot Metering, 110
Mexican in America, 168–170
Miconazole, 60
microphone, using with story
 subject, 171
military customs and courtesies, 27

Military First Aid Kit, carrying, 47
military photojournalism. *See*
 combat photography
Military Photojournalism Program,
 202
minipod, using, 81
mirror, packing, 59
mission statement, creating, 218
Mizelle, John, 101
modes
 (A or AV) Aperture Priority, 108
 (M) Manual, 107
 (S or TV) Shutter Priority, 109
Mohrwinkel, Bill, 152
moneymaker, protecting, 42–43
Monistat cream, packing, 60
Monk, James, 54, 59
monochromatic color, 122
monopod, using, 80–81
Monrovia, Liberia, 159
Moore, Kim, 181–183
Moore, Zachary, 181–183
motion, perceiving, 46
motivation, maintaining, 236
multiframe burst, 102–103
multimedia
 competition, 193–194
 innovation, 193–194
 making final edit, 198–199
 shooting video with DSLR,
 195–196
 significance, 192–193
 team effort, 195
 time management, 194
 video exposure modes, 197
multitasking, streamlining home
 life, 11–13
muscle tone, increasing via cycling,
 16

N

nail clippers and file, packing, 56
nails, removing artificial, 57
narrative photo essay, creating,
 188–189
navigating locations, 44
NBC Nightly News, 9–10
negotiation, mastering art of, 231
networking, 235
news captions, formulating, 176–177
news photography, requirements of,
 5, 141–142